Progress
in Art

Suzi Gablik

Progress in Art

with 162 illustrations

Published in the United States of America
in 1977 by:

*R*IZZOLI INTERNATIONAL PUBLICATIONS, INC.
712 Fifth Avenue/New York 10019

PAPERBACK EDITION 1979

© 1976 by Suzi Gablik

Library of Congress Catalog Card Number: 76-62549
ISBN: 0-8478-0168-3

Printed in the United States of America

Contents

Acknowledgments

The concepts advanced in this book are a theoretical synthesis of present knowledge in several disciplines. Together they constitute what may be characterized as a general theory of art history, as it is related to the more general problem of 'cultural dynamics'. My own formulation of the processes by which art changes and new cultural forms emerge would not have been possible without the work of Jean Piaget, Claude Lévi-Strauss, Sir Ernst Gombrich, Sir Karl Popper, Thomas S. Kuhn and Ludwig von Bertalanffy. Their ideas have helped to form the intellectual climate within which my own point of view has developed. In addition, I have drawn freely from the observations and research of many other people involved in cognitive and perceptual psychology, philosophy of science, systems theory, child development and art history.

Several people have been kind enough to give me their comments on various portions of the manuscript, and in this regard I am especially indebted to Professor Meyer Schapiro, Department of Art History, Columbia University; Professor Christopher Cornford, Department of General Studies, Royal College of Art; Professor Claude Lévi-Strauss, Department of Social Anthropology, Collège de France; Professor Marx Wartofsky, Department of Philosophy, Boston University; Howard Gruber, Center of Genetic Epistemology, University of Geneva; Charles Jencks, Architectural Association, London, and Kim James. I am also indebted to Christopher Johnston and to Jane Bell Davis for letting me see their work on the French art theoretician Pierre Francastel.

I should also like to acknowledge the kindness of all those persons, galleries and institutions who so generously supplied me with photographs, and to extend my thanks for the frequent personal help given me by Nicholas Logsdale, Manuel Gonzalez, Linda Shearer, Ealen Wingate, John Weber, Leo Castelli and David Johnson.

Part I: The Historical Dynamic

Movement implies a mover. In the evolution
of painting, what is it that moves?

ORTEGA Y GASSET

The artist . . . is the point at which the growth
of the mind shows itself.

I. A. RICHARDS

Whatever Happened to the Art Object?

For many people art today seems to have run its course and to have no future. Developments in contemporary art are considered nothing less than a disaster – a sign of eroded sensibility. Whatever our view of the situation is, we cannot miss seeing that what is being done today in art appears, on the whole, to be unlike anything that has been done in the past. Neither a mere rethinking of certain artistic problems, nor a perfecting of elements that remain unfinished in the art of the past, contemporary art appears to present itself as something entirely new. But is this really the case? Or is there some way of placing these seemingly anomalous developments in an enlightening relation with the art of the past?

Whereas the art of the past tends to be viewed as part of one continuous history, modern abstract art (to say nothing of conceptual art) is usually treated as an independent entity that requires a whole new system of reference. A continuity that is freely acknowledged between a Parthenon frieze and a painting by Leonardo is no longer universally acknowledged or understood when we come to the work of Mondrian or Malevich, to a painting by Jackson Pollock or Frank Stella, or a wall-drawing by Sol LeWitt. For many historians, as well as for the man in the street, abstract art is a distinct anomaly in which a hitherto comprehensible pattern or system of rules breaks down. No longer the careful, cumulative, experimental discipline it once was for Leonardo, and still was even for Cézanne, art in our own time has become something much more speculative, anomalous and disturbing.

The confusion is not altogether surprising, when we consider how much the very concept of what art is has been radically modified over the past fifty years. For one thing, its function as representation has been virtually abandoned. The evolution of modernist painting, which begins just before Cubism, has removed art further and further from traditional principles of composition, and from the deep, illusionistic space perfected by the Renaissance. The most recent tendency of art to function as a terrain for independent philosophical speculation is such a radical reordering of the artistic premise that its consequences appear in some ways to challenge art's very existence, since for the conceptual artist there is often no visible or physical art object, and there may not even be an image: what matters is the idea.

All this points to more than just a crisis in subject matter. Contemporary art diverges so much in matters of principle from the thinking of the past that we must ask ourselves whether such changes are indeed not genuinely and qualitatively new. Yet most people, like the character in Solzhenitsyn's novel *The First Circle*, claim that it is not in the nature of art to 'progress':

> In the seventeenth century, there was Rembrandt, and he's still with us today, and nobody can improve on him, whereas seventeenth-century technology now looks very crude to us. Or take the great inventions of the 1870s. We now think nothing at all of them, but has there been any advance on *Anna Karenina* which was written at the same time?[1]

In a similar vein, E. M. Forster once remarked that history evolves but art stands still. If this were really the case, however, how should we interpret the revolutionary stream of events which has so changed the face of art since about 1900?

Whereas most people readily accept the idea that the history of science demonstrates progress, in art they are unwilling to accept the idea of anything but change. Science, it is claimed, continually outgrows its older ideas, but the validity of great art remains permanent.

Since it often pays to fish in troubled waters, I have been led (like Marcel Proust) 'to ask myself whether there was indeed any truth in the distinction which we are always making between art, which is no more advanced now than in Homer's day, and science with its continuous progress'.[2] I propose to consider the very basis of our notions of progress – or the alleged lack of it – with regard to the history of art. In his book *The Structure of Scientific Revolutions*, Thomas S. Kuhn asks, 'Does a field make progress because it is a science, or is it a science because it makes progress?'[3] What I shall try to determine is whether or not we can find evidence of a process which can legitimately be called progressive in a non-scientific field like art. I shall examine the possibility of discovering some kind of pattern or order to artistic events: is art history merely the patchwork sum of random stylistic mutations, or are there discernible laws to this history? What, if anything, has propelled and guided art's development?

While I hope, on the one hand, to provide a framework for seeing the whole history of art as one continuous history, I shall argue, on the other, for some notion of progress within that history. But I must immediately state that in my claim for 'progress', I do not mean to imply that the historical course of art shows a move towards something better or more beautiful: the question of quality is not what is at stake here. *Differences in form are not to be confused with estimates of worth*; especially since, in the final analysis, aesthetic judgments must remain highly subjective.

I am aware that to consider historical development as following any rational pattern of change – as in any way a directed evolution – immediately exposes one to a tangle of problems connected with the word 'historicism'; for some people, to claim that there is any logical or rational course to the events of history is to suggest the determinism, and therefore the predict-

ability, of history. It is to settle under the tempestuous umbrella of Hegel and Marx, both of whom have been accused of informing history with invisible powers, or some mystical process that determines the course of the future. This attitude appears to shift the responsibility for events from individuals to inevitable 'trends' or 'vast impersonal forces' that drive relentlessly on, like a river flowing towards the end of its journey. Or so claim the anti-historicists.[4] Is there any basis, then, for what is to be my assertion: that artistic development does have a necessary order and structure? In what sense, if any, can we speak of 'progress' in art?

So far, there has been no reasonable explanation of why art should have a history, of why men's artistic abilities should have flourished and been extended within certain situations but not within others. Why, at particular moments in history, should entirely new capacities or concepts or directions have emerged? Why is it, as Wölfflin put it, that 'not everything is possible in every era' and certain things could not be done? Why, for instance, were artists in the Renaissance able to construct an organized spatial system which artists before then had been unable to do, and which appears to us now so simple, so clear, so plausible, and even self-evident? Where did this ability, which was not there at the start, come from? Why was it not there at the start?

I believe that if we want to understand why styles change, we must relate the history of art to the dynamics and structure of mental processes, as these have been investigated and understood in recent years by cognitive and developmental psychologists. I also believe that we can discover within the history of art the genesis of certain kinds of thought processes – I refer specifically to the evolution of logical and rational thinking from more primitive and imagistic modes of thought.

In opening up the possibility of considering the history of art against a background of cognitive psychology, and cognitive psychology against a background of art, I hope to suggest ways in which they may mutually illuminate each other. I should like to initiate a dialogue that others will wish to examine and explore from different points of view. The thesis I am putting forward for examination is that art has evolved through a sequence of cognitive stages and may be viewed as a series of transformations in modes of thinking; and I shall argue that the dynamics of stylistic change can be explained, at least in part, by patterns of cognitive 'growth'.

Until now, there has been no history of art within the general terms of structure, intellectual organization and system-formation, which treats art as a form of knowledge of the world. Instead of a multiplicity of limited range theories such as we have now, each applying to a small domain of art history but saying nothing about the dynamics of history as a whole, I propose to construct an integrative theory which will seek order and inter-connection at levels of greater generality than those of the specialist. The purpose of this study, then, is not to provide an historical background or survey, which can be found in many other works, but to make use of an abstract model which will function in an interdisciplinary and integrative

manner. I wish to argue for a developmental pattern of growth which can be discerned in the evolution of all knowledge. The assumption I am making is that art not only relates to the development of knowledge but presupposes it.

My intention is to examine the history of art in the light of a general cognitive model put forward by the Swiss experimental psychologist Jean Piaget. I shall not consider the history of art in the usual way, as an aggregate of individual styles which have simply been added to one another, but as an integrated system manifesting an ordered structure of events. This ordered structure of events will refer to the unfolding of 'laws of development' within the cognitive processes. The word 'cognitive' refers to the way in which our picture of reality – what we actually perceive – changes, as both perception and representation become progressively more structured by thought processes and concepts. My thesis is that historical development in art reflects a changing relationship between man and the environment, and that the evolution of human cognition has led to changes in the way in which we experience and represent the world.

Although Piaget is best known for experiments designed to infer the cognitive capacities of children, he has spent many years trying to achieve a general theory of structure which would show how the human mind is an active, forming participant in what it knows, and which could be applied to different areas of knowledge, such as science, mathematics, sociology and psychoanalysis. He has discovered that a close relationship is to be found between research on the genesis of intelligence in the child (or 'developmental psychology'), and what has been called 'genetic epistemology', or the genesis of systems of knowledge. The evolution of conceptual frameworks must be accounted for both in the individual and, by extension, historically as well. For this reason Piaget sees his developmental model as extending far beyond the study of individual child development. He considers that it should lend itself to being transferred, like General Systems Theory, from one realm of knowledge to another. His model operates on the principle that common 'laws of development' (or rules of formation) characterize the evolution of knowledge in fields which may have little or nothing to do with each other.

The advantage of a general cognitive model is that we can pass back and forth between different fields of investigation, without losing one system of reference and having to adopt another. This is useful in trying to determine whether any parallel development exists between stylistic change in the arts and paradigm shifts in the sciences. It will also help in trying to answer one of the central questions raised by this book: is there progress in art which is comparable to progress in science?

The concept of stages of development refers to 'competence' levels, or phases in the development of problem-solving capacities. Piaget's view is that learning is not the same at different developmental levels but depends essentially on the evolution of 'competences', upon which hangs the capability of giving certain responses and the ability to integrate informa-

tion. Different developmental levels correspond to different ways of seeing and thinking about the world, and each level, or stage, in cognitive development is characterized by a number of related skills and capacities to manipulate, describe and make inferences about the world. I shall use Piaget's model to show that art reflects a distinct cognitive process linked with the acquisition of knowledge, and that there are stages of development in the growth of this knowledge. These stages in the development of art correspond to learning processes and to transformations in concepts of self and society (fundamental transformations, that is, from one picture of the world to another). The emergence of more complex perceptual and logical schemata lead to mental organizations increasingly dominated by scientific, rationalistic and conceptual modes of thinking, in contrast to the more mystical mentalities of earlier historical periods. (This is not to say that mystical and rational thought are not both present in varying degrees at all stages in human history, but that there is a distinct predominance of rational, objective modes of thinking in later periods.)

There are many different histories within the history of art, and it is open to more interpretations than just one. By being attentive specifically to cognitive processes, I do not mean to exclude the complementary necessity of other factors in art which are not cognitive, and I am aware that what one perspective eliminates as inessential may be very important from another. It will be a matter here of tracing the specific line of development that sheds most light on the problem to which we are restricting ourselves, that of *objectivity* – a development in art which, I hope to show, in many ways parallels that in science.

It is this increasing differentiation between subject and object which Ortega y Gasset declared in 1925 was the single most important characteristic of modern art: its 'dehumanization', that is to say, its development towards a purely formal content without any expressive purpose; its avoidance more and more of the content of living forms, human objects and personal sentiments.[5] To put it another way, among the different lines which give shape to the history of art, there is a clear and unbroken line of development – a formal, constructivist, conceptual line – that has a distinct physiognomy of its own and is linked with transformations of space and the elements of geometric form: flat planes, deep space, proportion, regularity, symmetry, progression and the structuring of measured relations. The language of painting has slipped through the 'radiant node' of geometry, persistently transforming its invariant properties and restructuring them at new levels of abstraction. With greater or less explicitness, with more or less divergence of meaning and intention, Frank Stella, Don Judd, Robert Mangold and Sol LeWitt are as much geometrists as Piero, Leonardo or Fra Lippo Lippi, but their art comes from a differently directed mentality and from a different mode of thinking. Geometrization is a process which starts with tentative schemata and concepts drawn from Graeco-Roman antiquity and medieval scholastic traditions, proceeds to the highly mathematicized art of the Renaissance, and ends with the propositional and

deductive logic that characterizes the more conceptual forms of recent art.

There is a sequential line of development in all this which will be my subject here. I have chosen it, rather than other sorts of developments which exist, because this particular set of events allows the rational mapping of a developmental pattern in art history which may be defined by the slow transition from primitive, religious and mystical mentalities (governed primarily by emotion) into the modern abstract-conceptual mentality (governed primarily by rational and scientific thought).

To establish that the history of art can be described in terms of stages of development, we must first of all establish criteria for what we mean by 'stages'. There are certain historical periods during which intellectual development seems to have taken a giant step and cognitive acquisitions of considerable importance – such as the ability to represent depth on a two-dimensional plane surface in a way which maintains the relative heights and distances of objects – have emerged. The essential difference between medieval and Renaissance art, for example, is the introduction of the third dimension, and the ability to render space, distance, volume and mass. The late appearance of the principle of perspective, which was unknown before the Renaissance and is a relatively recent feature of Western art, is evidence that some difficulty in the representation of spatial relations existed, and we shall need to explain why this was the case.

We shall also need to explain the gradual shift in art from iconic modes of representation (which are essentially figurative and are linked to immediate perceptual experience, where the image closely resembles the concrete objects to which it refers) towards non-representational, non-mimetic modes which are conceptual in organization and exhibit linguistic and syntactic features. Language, unlike imagery, is non-representational; its structure is determined (as is the structure of much contemporary art) by the internal relationships which prevail among its component parts and by generative rules, *not by iconic resemblances*. In what follows, I shall argue that we can speak of the trends which have led to this development as progressive, and what I shall try to show is that they are explicable in terms of the evolution of thought processes.

Chapter Two

From Static to Dynamic Imagery

Drawing is not simply an extension of ordinary perception; it involves mental reconstructions and comparisons of what has been observed. The ability to represent volumetric solidarity, or a group of objects at various distances and heights so that they do not appear out of proportion or distorted in shape, is a complex cognitive achievement, and we cannot explain all collective representations by a psychological and logical machinery that is always the same. Perspective, for example, presupposes transformational relations and an operational system of 'putting in relation'; it is just such an ability to order relations relative to a point of view which we do not find in Greek art. Despite their sublime conquest of sculptural form, despite the quite sophisticated foreshortenings achieved by some Athenian vase painters (for instance, Euphronios and Exekias, *c.* 520 BC), the Greeks basically did not represent objects relative to each other. As one writer on Greek art has put it:

> I have happened on no evidence to show that any Greek ever sat down and drew a view, or a group of figures, or a congeries of objects, such as his tables and chairs, as they appeared relatively to each other in their respective shapes, sizes and positions, as seen from a single point of view.[1]

The transition from representing isolated figures to interrelations between figures, and of figures to environment, involves coordinating a large number of factors. Consider in this regard the group of *Three Goddesses* from the east pediment of the Parthenon. The figures themselves are of a dazzling beauty, each one posed in an attitude of sheer expectancy, but they do not really interact. There is an undertow of isolation; despite the grouping, each figure remains in a private space of its own. This is true for all Greek representation; it assembles and juxtaposes but it does not coordinate in terms of reciprocal relationships and points of view.

If we compare the same *Three Goddesses* with, say, Michelangelo's *Adam*, or with Francis Bacon's *Studies of the Human Body*, we can see how each work in its turn manifests a denser and more authoritative manipulation of bodily movements and gestures. The images cluster, ramify and

precipitate progressively towards greater corporality, fluidity and tangibility.

Compare in this respect the Egyptian *Daughters of Akhenaten* with the 7
recumbent figure of Titian's *Danaë* and the *Seated Blue Nude* of Matisse. 8, 9
Once again, the more static attitudes are overcome by the invention of new formal combinations, by an increasing ability to anticipate the dynamic movements of the body, its twisting axes and rotating planes, its overlappings and entwinings. Each of these three stages in the history of art manifests some kind of advance from previously established directions. These advances obey a rule of gradual differentiation, so that Matisse's animated figures possess an unequivocal solidity and natural spontaneity, *even though they are completely flat*. They occupy time and space differently from the *Daughters of Akhenaten*. Although Matisse inclines, in one sense, towards the flatness of archaic art, his images reflect an implicit cognitive grasp of the rotating surfaces of more volumetric representations which emerged later in the history of art. He incorporates two distinct modes of seeing (flatness and volume) in a new synthesis. Here we can see, not only how a cognitive system maintains its already attained level of organization, but how new qualities can emerge in the hierarchy, because of the fact that each new level contains the system at earlier levels plus their combination with the whole at that level. Picasso, in *Les Demoiselles d'Avignon*, achieves 6, 18
a similar fusion, combining the features of two different styles of representation in a single image. There are traces in *Les Demoiselles* of the flatness and angularity of, say, Egyptian tomb painting, but there is also an implicit understanding of the rotund volumes of, say, Raphael's *The Three Graces* 17
from a later stage.

Although I hope to show that cognitive theory may provide a language and a framework for describing and explaining the pattern of this development in art, and for seeing it as a linked progression, I cannot stress sufficiently that no special virtue or prestige attaches to any particular style. The question of aesthetic judgments is a separate one and will not concern us here. Rather I shall endeavour to set up, if not a type, at least a collection of characteristics common to what I take to be three cognitive stages in art, and thus to define the essential traits of the mentality peculiar to each. In this manner, I hope to reveal the existence of an inherent structural order in art's development which should become more apparent as we proceed. Even though the human figure is not our subject here, I hope this momentary cross-section on the following pages will demonstrate the sense in which each of these different images represents a concrete form of experience, in some sense a kind of knowledge, an activity of the cognitive mind:

FROM STATIC TO DYNAMIC IMAGERY IN THE FIGURE (*3 Stages*)

Each stage in the history of art manifests a denser and more authoritative manipulation of bodily movements and gestures; the images cluster, ramify and precipitate towards becoming more corporal, fluid and tangible. Modern artists achieve a synthesis of experience, movement and perception over time which is unknown in earlier art.

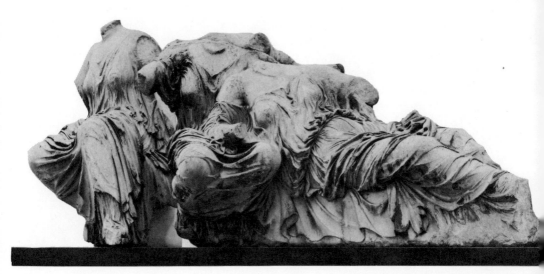

1 Group of Three Goddesses from the East Pediment
of the Parthenon. Athens, *c.* 435 BC

2 MICHELANGELO *Creation of Adam* (detail), *c.* 1511>

3 FRANCIS BACON *Triptych – Studies of the Human Body*
(detail of right-hand panel), 1970>

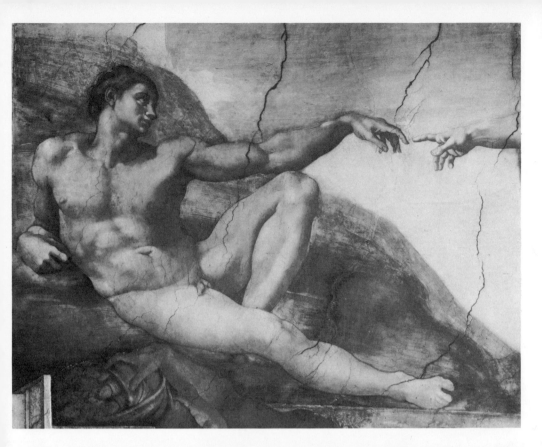

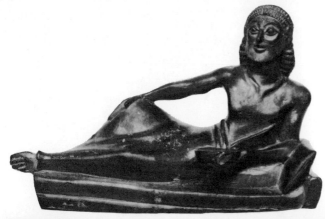

4 *Banqueter*, late 6th
century BC. Probably
Peloponnesian

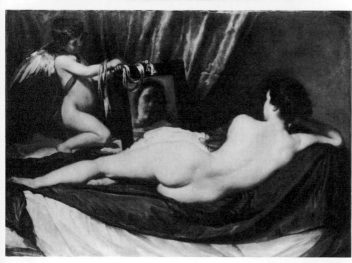

5 Velasquez *The Toilet
of Venus (The Rokeby
Venus)*, c. 1649–50

6 Pablo Picasso *Les
Demoiselles d'Avignon*
(detail), 1907

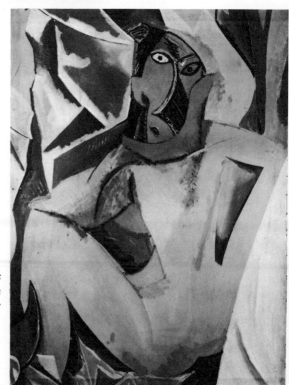

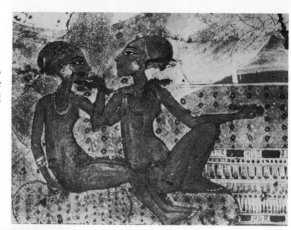

7 *Daughters of Akhenaten*,
Fresco fragment from the
Tel-el-Amarnah period

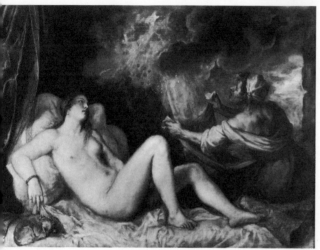

8 TITIAN *Danaë*, 1554

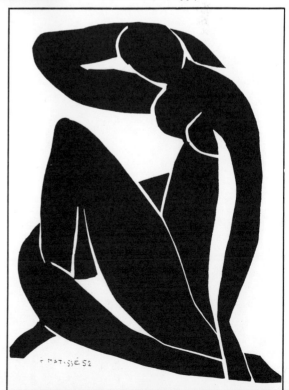

9 HENRI MATISSE
Seated Blue Nude II,
1952

10 *Eos carrying off Kephalos, c.* 460 BC

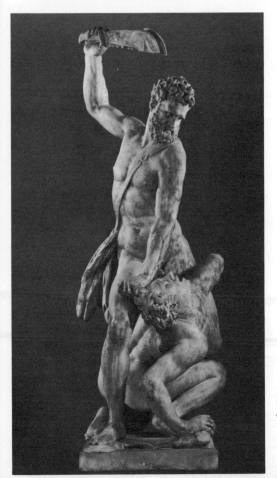

12 UMBERTO BOCCIONI *Unique Forms of Continuity in Space,* 1913

11 GIOVANNI DA BOLOGNA
Samson Slaying a Philistine

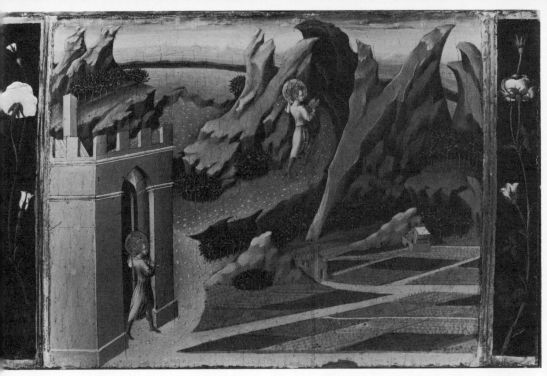

13 GIOVANNI DI PAOLO *St John the Baptist Returning to the Desert*

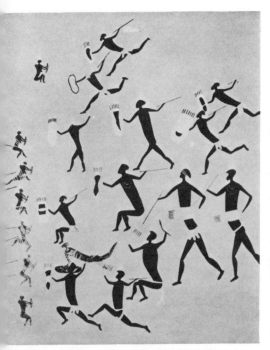

14 Transcription of a rock painting of a
Bushman cattle raid (detail)

15 MARCEL DUCHAMP
Nude Descending a Staircase, No. 2, 1912

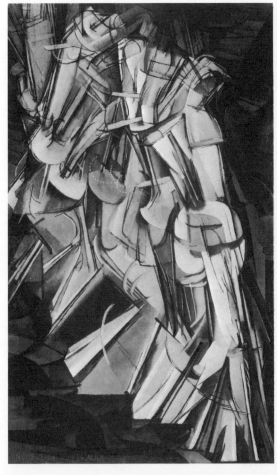

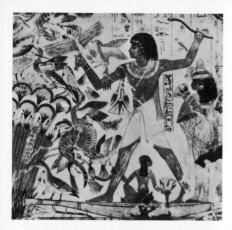

16 *Fowling Scene, c.* 1450 BC, from an Egyptian tomb in Thebes

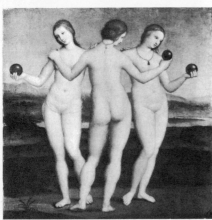

17 RAPHAEL *The Three Graces, c.* 1500

18 PABLO PICASSO
Les Demoiselles d'Avignon, 190[]

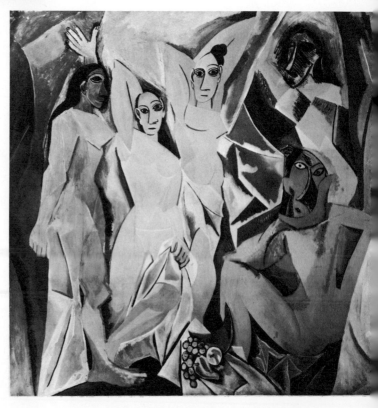

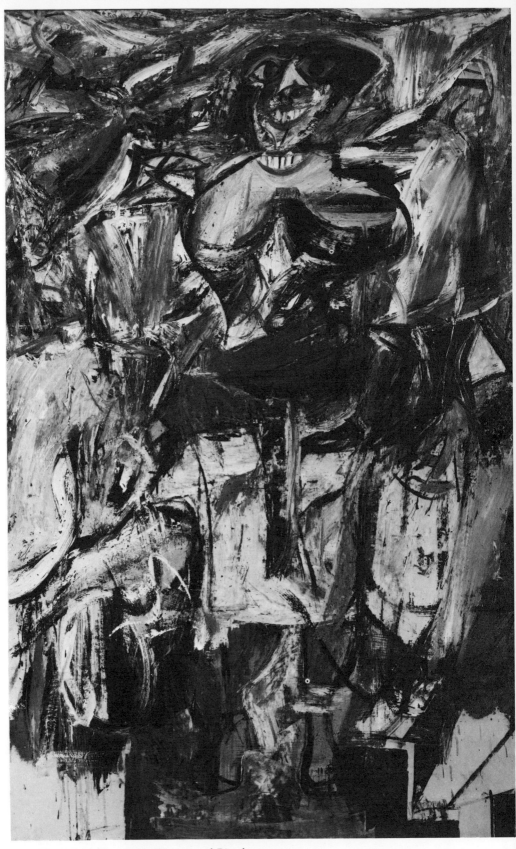

19 WILLEM DE KOONING *Woman and Bicycle*, 1952–3

What is immediately apparent from the first group of pictures is that the trend in representing the human figure manifests an increasing capacity to think of the total volume of the figure as a continuous whole. New strategies continually emerge, leading towards greater synthesis and flow, towards a changeover from semi-static or semi-continuous configurations to continuous and kinetic configurations. Whereas in the Egyptian figures there is a lack of synthesis between profile and frontal views, in Picasso's or de Kooning's or Bacon's figures the forms converge and deflect themselves around the surrounding space. Single perceptual acts, rather than being scattered and disconnected, coalesce with each other into one sustained process; multiple appearances not only succeed but confirm, continue and complement each other. The fact is that modern artists achieve a synthesis of experience, movement and perception over time which is unknown in earlier art, and which transcends the single, fixed point of view.

In all movement, there is a parting from somewhere, a passage somewhere, a going somewhere. In Giovanni di Paolo's *St John the Baptist*, movement through time is depicted by a succession of unintegrated, episodic sequences. St John is repeated in different parts of the landscape in a series of isolated but uncoordinated interim positions, in order to convey an event taking place in time, like walking up a hillside. The movement in time may thus parallel or continue movement in space, but it is not quite identical or synchronous with it.

Contrast this episodic movement with Duchamp's celebrated motion study, *Nude Descending a Staircase*, an image steeped in transience and centred on the coordination of states and transformations. Duchamp analyses and synchronizes each second of action as an infinite process of subdivisions performed by the moving body, whose transience is all the more total because there is nothing whatever fixed that we can see. Similarly, if we compare the relatively static sculpture of Eos as she carries off Kephalos with the movement in Giovanni da Bologna's *Samson Slaying a Philistine*, or with Boccioni's pulsating *Unique Forms of Continuity in Space* as it springs richly forth, the same recognizable progression towards intensified mobility is again apparent in three distinct stages.

It is my view that only an epistemological view of art history – one which has taken into account how knowledge of reality is achieved and how conceptual thought develops – can adequately explain why, for instance, volume and movement emerge so late in the history of representation. I do not subscribe to the commonly-held notion that this pattern of emergence is entirely explicable in terms of the different intentions and interests of earlier cultures that earlier cultures could perfectly well have made Euclidean perspectival representations had they but wanted to. I believe rather that as long as certain mental constructs, which are predominantly relational and mathematical in character, are lacking, pictorial imagery will remain too limited and too static to be able to represent even the most simple movements and changes.

The Subject-Object Relation

Before the value of any *rapprochement* between art and cognitive psychology can be profitably pursued, it will be useful to explain those aspects of Piaget's work which are relevant here. This will involve a brief departure from our course, but we are not, despite appearances, flying off at a tangent, since the discussion is intended to provide information necessary to follow the argument.

We can begin by considering some of Piaget's experiments in which he investigates the cognitive development of children. Their basic purpose is to reveal the organizing principles and cognitive concepts that make experience possible. Piaget himself believes we can account for the development of intelligence in man through the study of its unfolding in the child. By observing children at different ages, he has been able to demonstrate how logical and rational thinking grows from one stage of adaptation to the next, and how the child's concept of reality changes according to stages of development. These changes may be accounted for by the fact that cognitive systems, in the course of their development, map the many features of their environment into increasingly complex and organized sets of concepts.

Basically, what Piaget's experiments reveal is an increasing ability in the child to distinguish between appearance and reality – between how things *look* and how they really are – as his perceptions become more and more activated and structured by thought processes which guide its observations. For example, in one famous experiment, water is poured from a short, wide container into a tall, narrow container. When this activity is observed by a child before the age of five or six, he will claim that the quantity of liquid has increased when the water level appears higher – even though he will have seen that no water has been added or taken away. Piaget's explanation is that the thinking process of such children is *pre-operational*: this means that the capacity for logical inference, which would permit the recognition that a change in appearance does not necessarily mean a change in amount, has not yet developed. The child's judgment is dominated by the way things 'look' – in this case by the tallness of the container – rather than being based on an 'operational' correlation between height and width, or on any intermediary system of transformations which would offer the relation 'higher but narrower'.[1] Transformations, according to Piaget,

are those aspects of reality which are understood by the intelligence, not what is perceived or pictured.

If the same child is shown a round ball of clay which is subsequently rolled into a sausage, he will once again interpret the longer shape as meaning there is now more clay. Or, if ten pebbles are placed in a row, he will think there are more of them when they are spaced widely apart than when they are close together. Unable to coordinate changes in relation between two interdependent variables, or between two differing aspects such as length and width, he will not understand that one of the two changes compensates for the other.

The notion of *compensation* (or what the liquid gains in height it loses in width) only evolves in the course of a progressive ability to take both variables into consideration simultaneously. The same is true for the notion of *conservation* (or the fact that none of the liquid has been lost, in respect of its quantity, despite the fact that it 'looks' like less). All these are examples of cognitive forms which, once acquired, can be transposed from one situation to another.

Similarly, if the child counts the pebbles and discovers that there are always ten, even when he changes the order, he is abstracting characteristics based on his own actions of order and enumeration. He sees that the number of pebbles remains the same however he lays them out, whether in a circle or a straight line, whether he counts from right to left or from left to right. He thus discovers what is known in mathematics as *commutativity*, that is, the sum is independent of the order.[2] His actions, according to Piaget, have enriched the object with characteristics it did not have by itself, for the collection of pebbles had neither order nor number independent of the child's arrangements.

In this way Piaget distinguishes between *figurative* thinking (the row of pebbles is longer so there are more) and *operational* thinking, based on mental comparison or compensation. In figurative thinking, what is given in perception remains essentially a given and does not lead on to deductive reconstructions or to any system of transformations. Operational thinking, on the other hand, incorporates specific constructions of a logical character in addition to perceptual data. Basically, what developmental psychology has shown is that perception and cognition are not passive responses to stimuli coming from physical things, but are active processes of organizing experience into a stabilized universe.

In the absence of any inference process, thinking remains figurative. It relies exclusively on perception, reasoning only about static states or configurations, and not about transformations. With the development of cognitive structures – that is, of the logical and mathematical schemata that structure perception – a system of regulations evolves that enables the mind to compensate internally for an external change.

By distinguishing the different types of interaction between perceptual and intellectual functioning, Piaget demonstrates that perception is not a mirror image of the world. *To know is to assimilate reality into systems of*

transformations: it is to transform reality in order to understand how a certain state is brought about.[3] By emphasizing the cognitive character of perception, Piaget wishes to show that the reality behind appearance is never perceived by the senses: it is *conceived* by the intelligence. Our notion of reality is not an empirical given but is a continuous mental construction, an interaction between the knower and the known. Understanding is thus constitutive of the world. It is a characteristic of all such organizing activities, however, that the individual is unaware of his own part in constructing what he sees.

One of the most pronounced characteristics of figurative, or pre-operational, thought is its tendency to *centre* attention on one feature of an object to the neglect of other important aspects. The pre-operational child centres solely on one aspect of a changing relationship – the height of the container or the length of the sausage – instead of dealing with the transformation 'higher but narrower'. At this stage in development, according to Piaget, children are unable to *decentre*, that is, to take account of features which could balance and compensate for the distorting effects that result from fixing on a single aspect of a changing relation. 'Decentration' is the coordinating process which informs perception and allows both width and height, for example, to be considered simultaneously. It is also the ability to take another's point of view – to see one's own point of view as one of many that are equally possible and to try to coordinate it with these others. It is this coordinating process which leads to the construction of more complex transformational systems, and these lead in turn to a more complex picture of reality.[4]

The logic which develops in the child is above all an operatory system – a system of regulations within which perceptual data are interrelated, incorporated and often corrected. Logic, in the Piagetian sense, refers to the structuring and organizational properties of intelligence; it is not logic in the sense of axiomatization, or a closed system which does not increase information. Comparing two changing aspects of an object presupposes the establishment of a relation, and therefore the construction of a logical form. *It is only by being acted upon in a mental operation that perceptual data become objects of knowledge. Actions transform reality* rather than simply dis-covering its existence. All knowledge derives, in Piaget's view, not from perception nor from objects, but from our way of acting upon objects. These actions are subsequently internalized, in the form of implicit mental activity (actions of combining, ordering and putting into correspondence). Eventually, they form schemata which can be transposed from one situation to another. The symbols in mathematics, for example, refer to actions which could be realized, but have in fact become internalized as operations of thought: the sign $(=)$ expresses a possible substitution, the sign $(+)$ a combination, the sign $(-)$ a separation, the square (x^2) the action of reproducing 'x' x times.

Initially, operations are *concrete*, that is, they refer to the manipulation of concrete objects. Later, they become increasingly schematic and abstract, broader in range, and what Piaget calls reversible (like addition, which is

derived from the action of bringing together and which can be reversed in the form of subtraction), and are organized into systems that are structurally similar to logico-algebraic systems.[5] Reversibility, according to Piaget, is the keystone of logic: $A + B$ is the same as $B + A$; and the operation $A + B = C$ is reversible by the operation $C - B = A$.

At this stage, the mind becomes capable of dealing with generalizations about numbers, with systems of relations and algebraic symbols – *in the absence of concrete objects*. *Formal-operational* thought is able to use abstract symbols that have no 'concrete' application, to manipulate propositions or hypotheses as sets of pure relations. (I shall discuss each of these stages separately in Part II, with respect to the historical development of art.)

Thus, what Piaget shows is that the roots of logical thought are not to be found in language, as is so often assumed, but in a general coordination of actions which have become internalized, reversed and coordinated into systems. The concept of a mental operation is obtained, not by deriving properties from *things*, but from our way of acting on things. Logic and mathematics, according to Piaget, do not result from the *form* of objects to which one can apply them, but from a general coordination of actions – *irrespective of the nature of the objects to which these actions are directed*. This fact will be of great importance in pointing out the need for an *epistemological* model of art history, which is based on cognitive theory, rather than on a *neurophysiological* model of perception, such as that found in Gestalt theory. I shall elaborate on this question shortly.

Meanwhile, what inferences concerning art are to be drawn from these observations? What can Piaget's account of cognitive development in the individual tell us about art, which is, after all, a problem in historical development?

Piaget's theory of knowledge, as will become increasingly clear, reflects a changing relationship between subject and object, between the knower and the known, which produces various structures and systems of transformations. The history of art, too, reflects a changing relationship between the artist and the world. The artist always finds himself in a given historical and social situation, which largely determines his attitudes and limits his actual projects. I believe it can be shown that (just as in individual cognitive development) this interaction between the artist and the world passes from an undifferentiated phase to one of greater coordination. This phenomenon makes for increased objectivity, and is often dependent on the evolution of society itself.

The particular meaning of progress in art, therefore, which I wish to put forward is in this sense a necessary feature of the human mind in its relation to the world. It corresponds to the fundamental character of mental processes:

> Mental development occurs in an ordered, multi-stage sequence, analogously to organic morphogenesis. The assimilation of gestalts, of logical structures, and the many other 'schemata' of human cognition,

represents an ongoing self-organization of cognitive systems, as the patterns of empirical knowledge not only change, but expand, differentiate and intensify.[6]

When we speak here of progress in art, therefore, it will be in the sense of trying to show that the artist's ability to structure relations and to deal with transformational systems has evolved at the same time as, historically, society's interaction with the environment has become more complicated. It is worth stating once again, however, that in describing artistic development as a self-organizing cognitive system which presupposes interactions between the system and the environment, it is not at all my intention to introduce aesthetic evaluations through the back door. As between one stage and another in the history of art, I merely wish to point to cognitive-structural differences in their mode of operation.

As I have already stated, Piaget's experiments concern the development of logical knowledge and concept-formation in children, but they are intended to have epistemological implications and relevance to larger issues concerning the growth of knowledge in general. Indeed, the fundamental hypothesis of genetic epistemology is that there is a parallelism between the progress made in the logical and rational organization of knowledge and the corresponding formative psychological processes in the individual.[7] The development of operational thought is linked with the development of intelligence, and with its transforming and structuring capacities. The whole process of development, according to Piaget, starting out with perception and culminating in intelligence, demonstrates that transformations continually increase in importance, as opposed to the original predominance of static perceptual forms.

My wish to emphasize the logical rather than the perceptual character of art will require my giving battle to certain theories of art heavily larded with concepts taken over from Gestalt psychology. In some cases these concepts have been expanded into a set of aesthetic principles and, by discussing them, I hope to throw light on my own views.

To take but one example of the Gestalt approach – Rudolf Arnheim believes that the development of pictorial form relies on basic properties of the nervous system. For him, the decisive phase of visual processing occurs at a neurophysiological level.[8] He writes that 'the cognitive operations called thinking are not the privilege of mental processes above and beyond perception but the essential ingredients of perception itself':[9]

> So great is this similarity between the elementary activities of the senses and the higher ones of thinking or reasoning that psychologists have often been tricked [*sic*] into attributing the achievements of the senses to secret aid supposed to have been rendered them by the intellect. . . . It seems now that the same mechanisms operate on both the perceptual and the intellectual level, so that inevitably terms like concept, judgment, logic, abstraction, conclusion, computation have to be applied to the

work of the senses. . . . Perceiving achieves, at the sensory level, what in the realm of reasoning is known as understanding. . . . *Eyesight is insight.*[10]
(Italics mine.)

These statements lose ground, it seems to me, under the weight of Piaget's experiments which establish over and over again that eyesight is *not* insight, that perception alone does not furnish us with immediate knowledge of external reality. Arnheim's difficulty is that he does not get to grips with the subtle problems of structure posed by the interaction of perception and intelligence. This is because Gestalt psychology proposes an altogether different model of perception from Piaget's. Basically, it reduces both perception *and* intelligence (in the sense of 'learning' or 'understanding') to *one type of neurophysiological structure* defined by the notion of 'good Gestalt', the organizational properties of which are more or less fixed and permanent.

The difference between Arnheim and Piaget – which is, I believe a crucial one – is that Piaget sees the 'understanding' which occurs in perception as having a structural development, and as constituted of mental events rather than of neurophysiological processes, while Arnheim, in principle, does not. The Gestaltists reduce the operations of intelligence to a simple extension of perceptual structures, whereas Piaget shows that perception never functions alone but is always structured by an operatory schematism – by a logico-mathematical organization – *which is increasingly influenced by the progress of intelligence.* The critical factor here is that this influence leads in time to the development of logical and abstract concepts in the mind. The transition from the structures of perception to those of intelligence cannot, according to Piaget, be explained simply as an extension of, or an increased mobility in, perceptual structures. Intelligence transforms perception, so that perception is not only a matter of a visual Gestalt but includes an active organization: pre-inferences, decisions and 'perceptual acts' (like relating, comparing, and so on) intervene and modify the perceived Gestalts and must also be taken into account. Mental life thus exhibits irreversible structures (*Gestalten*) and reversible ones (operational intelligence), *the latter being irreducible to the former*, according to Piaget. New levels of knowledge may be reached when the aspects of a situation which are available to perception (x and y) lead to the perception of another aspect (z) *which is not directly registered by the senses*, but results rather from the employment of more complex forms of relations which in turn bring about the resulting perception.[11]

Arnheim, on the other hand, characterizes visual thinking and the laws of perception in terms of 'well-structured shapes and relations',[12] or a 'tendency to simplest structure in the brain field',[13] which makes the artistic process sound as if it were a circle straining to approach or recede from its centre. It is much too simple a picture of the actual situation. The fact is, however we juggle Gestalt concepts around – examining pictorial imagery in the light of various optical illusions, figure-ground reversals and duck-

rabbit 'switches' – I do not think artistic development can be cast in these terms. How can we possibly explain the recent emergence, for example, of a totally non-visual and non-morphological art in terms of 'well-structured shapes and relations'? As one critic put it, 'you can't talk about a picture plane if there isn't any picture plane, or the significance of a form if there is no form.'[14]

If we are not to end up in a blind alley over the question of recent art, we must put the problem of artistic development in terms of cognitive transformations and not in terms of perceptual Gestalts. Propositional and conceptual art simply cannot be elucidated in the language of perceptual theory, whereas by introducing a model based on developmental processes into the history of art, we immediately restore to it a possible unity. This is the advantage of a theory which is firmly anchored in the activity and development of intelligence: it allows us to account for the fact that, in the twentieth century, art suddenly transcends the bounds of concrete sense perception, and begins to operate, in the manner of twentieth-century physics and mathematics, on the basis of sets of purely abstract and formal relations. What Piaget's model shows us is how the influence of perception becomes progressively less important as the logical and mathematical schematizations of perception become more and more important. (For this reason, Piaget considers perception as both developmentally subordinate and structurally inferior to intelligence as a class of adaptation.[15]) On these grounds, it is possible to describe the evolution of art in one sense as a retreat from the static images of perception. But I wish to claim even more. I wish to assert that *it is the transformational element in thinking that is actually the source of art's development*. It has led pictorial imagery on the one hand towards greater mobility; and on the other, it has brought about a complete independence from figurative or representational elements.

Perception and Representation

In *Art and Illusion*, a book which relates the history of art to the psychology of visual perception, E. H. Gombrich describes how he asked his eleven-year-old niece to copy a reproduction of Constable's painting *Wivenhoe Park* (1816). Observing that the child's version lacks the modifications which things like cows, trees and swans undergo when seen from various angles or in different lights, he draws attention to the fact that the figures are flat, that the space around them lacks depth and that there are no shadows. Gombrich then states, provocatively, that the child's way of drawing trees is more like that of Sassetta (a fifteenth-century Sienese painter whose work she had never seen) than like that of Constable, whose picture she had before her eyes.[1] It seems to me that Gombrich has thrown a significant egg on the pan here, but that he doesn't make the omelette: he never offers any explanation as to what might be the determining factor in such a resemblance. On the contrary, he firmly dismisses its possible implications with the statement: 'One thing we can be sure of: neither Duccio nor Sassetta had a childish, undeveloped mentality.'[2]

It seems to me worthwhile, in view of our present concerns, to pick up what Gombrich has so categorically dismissed. In trying to account for this resemblance, I shall argue that, in Western painting, the human mind has systematically built up its picture of the world in a manner which resembles the pattern of a child's learning. Let me state immediately that, in arguing thus, I am not trying to formulate any 'law of recapitulation' which would suggest either that man's cultural and artistic development recapitulates, on a collective plane, the cognitive development of the child, or the other way around. But neither am I merely drawing an analogy. What I wish to assert is that certain correspondences or isomorphisms do exist between the two developments, and that the history of art exhibits a pattern of developmental change which in many ways parallels cognitive development in the individual.

The irreducible core of such an assertion bears the mark of Piaget's concept of cognitive development as a hierarchical organization of abilities which achieves higher and more complex levels of functioning over time. Intelligence develops in the individual, according to Piaget, in a sequence of stages, and each stage sees the elaboration of new mental abilities which set the limits and determine the character of what can be learned. I hope to establish that this principle is equally valid in terms of artistic development –

that the evolution of any cognitive system is always in the direction of merging some characteristics, differentiating others, and developing partially autonomous subsystems in a hierarchical sequence.[3] I hope to show that the history of art follows the tendency of all cognitive systems to complexify in response to inputs from the environment, and intermittently or continuously to evolve towards more highly organized states.

It is here that we move into the knotty part of the wood (and against the grain), since to claim that developmental principles which are characteristic of cognitive growth in the child are common to the history of art is also to claim that the way in which human knowledge is built up has a collective as well as an individual nature, and that neither is ever free of a progressive organization. That there is a cognitive development to the cultural productions of mankind is a thesis many people will find difficult to justify, no doubt because of its somewhat Hegelian overtones.

Just what sort of relationship exists between individual cognitive development and the evolution of knowledge at a collective level, or between child, primitive and adult thought, remains a crabbed issue for many people. To take one instance of the disagreements which exist, where Lévi-Strauss concedes that an evolution in intelligence does take place in the *individual*, he is reluctant to accept that a similar evolution in intelligence also takes place collectively in the history of mankind. Lévi-Strauss believes that, as between one period and another in history, or between one society and another, it is not the cognitive structures of the mind which differ, but the problems which men raise for themselves.[4] For Lévi-Strauss, the fundamental structures of the mind are the same everywhere and do not undergo any structural development.

According to Piaget, on the other hand, two sorts of intellectual development need to be recognized: one is organic (referring to individual psychology) and the other is genealogical (referring to collective systems of knowledge). Piaget's view is that cognitive structures are built up progressively *from the historical as well as from the psychological point of view*: historically speaking, these structures may be either invented or discovered by particular individuals, but they then become integrated into a single intellectual organism to such a point that 'the succession of seekers is comparable, as Pascal said, to one man continuously learning throughout time'.[5] Seen in this way, history makes definite progress: acquired skills are transmitted from one generation to another, so that, as the eighteenth-century French philosopher Fontenelle put it, 'an educated mind is, as it were, composed of all the minds of preceding ages; and we might say that a single mind was being educated throughout all history'.[6]

Problematic questions are immediately evident in all this. Can it be said, for instance, that children and primitives actually see the world differently from the way we do? Do they employ different modes of perception and reasoning, or do they merely have different ways of representing experiences which are identical to our own? What is the nature of the differences between these modes of thought and our own?

Gombrich claims that 'a certain kinship between child art and primitive art had suggested to the unwary the false alternatives that either these primitives could not do better because they were as unskilled as children or that they did not want to do anything else because they still had the mentality of children'.[7] Both these conclusions, since they suggest that primitive artists must have thought in a childish way, are in Gombrich's view patently false. All the same, he does concede that we have a right to speak of 'primitive' modes of representation, and even states that these modes will assert themselves unless deliberately counteracted.[8]

Piaget maintains, on the other hand, that the child's world, like that of the 'primitive', reflects a different grasp of reality and pattern of thought from that of the modern Western adult. And the fact is that a strong affinity is to be found between aspects of ancient and medieval art and the pictorial representations of children. In what, then, does their 'primitive' quality consist? One obvious characteristic they share is the predominance of emotional, or affective, factors which determine pictorial organization, rather than any rational or objective mode of organizing space. As we shall see in Chapter Five, in all art before the Renaissance, the organization of space is consistently dominated by topological relationships rather than by geometrical or Euclidean ones.

If, within the history of art, modes of thinking do exist which are developmentally more primitive, there may well be a 'pre-logic', in the sense that Piaget suggests, of a pre-operational level of thought.[9] This would explain why the Greeks, for example, never achieved a geometry of central projection and section in their drawing and appear to have had only a naïve idea, in their representations, of a logically unified space. They were not yet at a stage of development in the organization of their knowledge where they could make such coordinations. (Piaget has commented on the inability of the Greeks to construct a dynamic mathematical physics for a similar reason: they lacked an operational treatment of motion and time.[10])

One of the most significant findings of Piaget's work is that geometrical projection is not a 'primitive' intuition; the notion of a developed solid does not have its source in ordinary perception but is the product of an intellectual construction. It is not a mere reflection of, or translation from, perceived reality, but is the result of a restructuring process that takes a considerable time to develop in the mind. This would account for the fact that neither children nor 'primitives' ever spontaneously render objects in space according to the principles of geometric perspective. The fact is that it is considerably more difficult to translate three dimensions onto a two-dimensional plane surface than it is to represent an object directly in three dimensions, and neither Greek, Roman nor Egyptian cultures ever completely achieved it, although all were highly skilled at representing three-dimensional forms sculpturally.

Panofsky states that, until the Renaissance, space was conceived as an aggregate or composite of solids and voids, both finite, but not as a homo-

geneous system within which every point, regardless of whether it happens to be located in a solid or a void, is uniquely determined by three coordinates perpendicular to each other and extending into infinity from a given 'point of origin'.[11] Thus, the depiction of space in all art before the Renaissance lacks continuity, measurability and infinity.

Infinity was not visually implied in painting until the Renaissance invention of a single 'vanishing point' towards which any set of objectively parallel lines could converge. Despite their highly evolved mathematics, the Greeks were unable to resolve the geometrical postulate that parallel lines meet at infinity – infinity being a concept which is outside the realm of the concrete and the visible – and the parallel axiom making an assertion about infinitely remote regions of space. For this reason they never developed a fully systematized theory of perspective.[12] It is entirely possible, in Piaget's view, that a formal-operational level of thought may be reached in certain specialized areas but not necessarily across the board in all others.

The crucial question that arises from all this, and that remains still to be answered, is as follows: by what strategy, then, did artists eventually succeed in constructing an objectivized space? If the concept of geometrical space is not innate but derives from a logical construction – and if perception alone does not furnish us with that concept – how did it ever come into existence? These are the issues at stake if we are to succeed in answering the central question raised (but never, in my view, satisfactorily answered) by Gombrich in *Art and Illusion*: why did it take artists as long as it did to learn to represent the world illusionistically?

What Piaget's theory helps us to understand is how artists finally did succeed in passing from simple intuitive spatial continuity to the conceptual or operational continuity of geometrical perspective. Piaget demonstrates that the idea of spatial measurement has a psychological development connected with the operations of thought. The evolution of spatial relations proceeds at two different levels in the mind – a perceptual level and a representational one. The ability to *perceive* space in Euclidean terms precedes the ability to *represent* it, and this discrepancy at the level of reconstruction causes representational thought at first to appear to ignore metric and perspective relations, proportions, etc.[13] Representational concepts are much slower to develop than are abilities to perceive, although even the perception of space involves a gradual construction and does not exist ready-made at the outset of mental development. Adults assume that perception involves coordinate systems right from the outset, but Piaget's evidence indicates that such systems are extremely complicated and are only fully developed by the age of eight or nine.

Moreover, even though spatial *perceptions* may have achieved a Euclidean level, their reconstruction at the level of *representation* may still be at a more primitive level. The convergence between picture and model, between thought and world, is not easily attained. The mind does not jump directly from the perceptual notion of spatial continuity to a conceptual or representational schema able to express this. Images of spatial relations become

Euclidean only when the operational notions necessary for representing those kinds of relations have been acquired. Thus, a representational image may correspond to our perception, but Piaget shows that *it does not actually derive from perception.*

Although the development of representational forms has been an objective in the art of many cultures, the overwhelming majority of cultures have not produced such conceptual coordination in their spatial representations – even though, as Meyer Schapiro has pointed out, their solutions present not only similar features in the devices of rendering but also a remarkable parallelism in the successive stages of their solutions.[14] In fact, these stages are recognizable from epoch to epoch and from culture to culture by their utter unity of character. Despite a plurality and diversity of artistic intentions, a single, uniform mode of spatial organization is consistent in Persian, Indian, Egyptian, Greek, Chinese and Western medieval pictorial art, in which, as we shall see, objective size and depth relations are lacking. What accounts for these uniformities, then, and why is the structural development of each so strikingly similar, or 'homologous'?

'Influence' is not the relevant term here, since it is unlikely that these corresponding structural and organizational traits originate in any way from a single prehistoric centre or from a common ancestral source. They appear in styles so geographically separate and so distant in time that there can be no question of mutual borrowing. On the other hand, resemblances of such a kind, since they constantly recur, cannot be entirely fortuitous either. Organizational principles must exist which are formally invariant, that is, independent of content. What seems most likely is that all forms of representation arise from a single syntax and grow, like an oak tree from an acorn, by controlled transformational process.

In Chapter Five, I shall elaborate the sense in which I take pictorial art prior to the Renaissance to be 'pre-logical' – as lacking the cognitive operations for a logically coordinated Euclidean space. Pre-logic, in Piaget's system, is anterior to explicit logic and is preparatory for it: *some cultures develop beyond the pre-logical stage and others do not.* In this regard Piaget has written:

> . . . it is quite possible . . . that in many societies, adult thought does not go beyond the level of 'concrete' operations, and therefore does not reach that of propositional operations which develop between the ages of twelve and fifteen in our milieus.[15]

Thus, higher level cognitive skills may be evidenced, in Piaget's view, only in particular environmental settings.

This evolutionary aspect of Piaget's thought Lévi-Strauss definitely rejects in his claim that the primitive mind is logical in the same sense and in the same fashion as our own. In contrast to Piaget, Lévi-Strauss believes that, although the mind exhibits different contents at different times in history, its structures do not vary: the fundamental activity of imposing form on content is the same for *all* minds, archaic and modern. Science and

magic require the same sort of mental operations and we should not think of them as two different stages in the evolution of knowledge.[16] We have thus not progressed beyond the primitive: we have merely turned up a different roll of the dice.

Piaget, however, considers that nothing is innate or 'pre-figured' in cognitive or perceptual structures, and he believes that new structures evolve in the course of development which have been gradually constructed out of earlier ones. He rejects, for instance, the Gestalt principle that the structures of perception are biologically predetermined, that they exist prior to any kind of functioning, acting out their role, as it were, independently of the subject. On the contrary, he considers that new structural patterns are continually introduced which are the product of interactions between the system and the environment. All mental operations, according to Piaget, cannot be reduced to a single type, since the possibilities for diversity of structure and function increase with changing levels of development.

These are critical issues which have already been posed in a sense by Jack Burnham's book *The Structure of Art*. Burnham's thesis that 'art "evolves" without really changing'[17] is rooted in a Lévi-Straussian non-evolutionary model of the mind. Contrary to what is being asserted here, Burnham considers that all the relevant cognitive factors have been present throughout the history of art and that an invariable cognitive structure traverses all of its changes. He asserts further that modern abstract art represents a regression from the semiotic complexity of the Renaissance. Thus, although there may be novelty in the content of ideas, *there is none in the actual thought processes*. My own view is that art history presents us, not with a *substitutive* evolution, *à la* Lévi-Strauss, in which styles merely replace each other, but with a *derivative* mode of development, in which earlier stages are integrated into later ones. Changes are thus both successive and continuous, with each innovation dependent on the previous ones. My own developmental model of art assumes that higher levels of cognitive organization may evolve and that different levels of functioning in the thought processes do exist.

The essence of the stage concept, and whether it stands or falls in relation to the history of art, hangs precisely upon the possibility of demonstrating that the logical mechanisms of thought *have* evolved – *and that it is their gradual modification and development which entails changes in artistic form.* Are there not some episodes within the history of art, like the decisive change of vision between medieval and Renaissance mentalities, which have been mediated by actual changes in underlying cognitive organization and structure? Are not certain changes in experience, and in modes of representing experience, more than just the function of possible combinations and permutations – or of choices made among several possibilities – as Lévi-Strauss suggests?

My own claim is that certain historical changes reflect qualitative transformations in the thinking process. (Lévi-Strauss does concede that at the

problem level the dynamic perspective remains valid, since problems are a function of one another, and since each new problem presupposes the resolution of an earlier one.[18])

To summarize, then, Piaget sees mental structures as dynamic rather than static, and as manifesting a progressive evolution. There are no pre-formed structures which have been 'fully operative' in the same fundamental pattern since the creation of human society, because the mind is continually in the process of self-construction. His concept of 'genetic' structures (used in the sense of genesis rather than inheritance or gene function as such) contains a historical time dimension which is absent from the mathematical view of structure espoused by Lévi-Strauss, in which there is no idea of process or development. Piaget believes that we do not inherit cognitive structures as such: it is through functioning, and only through functioning, that cognitive structures are formed. Functioning not only creates structures, but it causes them to change continually.[19] Commenting on this question, he has written:

> . . . we must admit that we do not really understand why the mind is more truly honored when turned into a collection of permanent schemata than when it is viewed as the as yet unfinished product of continual self-construction.[20]

It remains now for me to show how the history of art reveals, on its own plane, a distinct chronology of cognitive stages, and how it manifests a capacity for transformation in the categories of thought. On these grounds, I shall therefore enter that hazardous area in which I shall try to show that there is 'progress' in art, in this sense at least, that it reflects a progressive development in the cognitive processes and in the logico-mathematical structures of intelligence.

Part II: The Three Stages of Art

Our senses have a developmental age which is
not that of the immediate environment, but
that of the period into which we were born.
We are born with the sensibility of that
period, that phase of civilization, and it counts
for more than anything that learning can give
us.

HENRI MATISSE

Only after it occurs does progress become an
obvious characteristic of a field.

THOMAS S. KUHN

Stages in the Development of Art

Cognitive structures are the organizational properties of intelligence. They refer to the internalized maps or schemata by means of which we mentally organize and represent the world to ourselves. All our experience of the world is mediated by these schemata. They determine what we actually perceive, and all our knowledge and descriptions of the world depend on them. Indeed, our very perception of the external world is made possible by the mind possessing such an organizing capacity. These structures are manifestations of an unconscious mental process which, according to Piaget, follows a distinct pattern of development, and which aims at the achievement of particular thought forms.

The significance of Piaget's research for understanding historical development in art lies in the way in which it helps us to grasp the processes by which experience is organized and differentiated into an 'outside world' and a self. One conspicuous result of this process is that our representations become increasingly objective, as mental development proceeds from a stage of relative globality and lack of differentiation to a stage of increasing differentiation, articulation and integration. As we have seen, the 'object-ivity' of experience is not given to us at the start. The 'I' and objects must both be constructed. What we take to be the habitual aspects of things – our knowledge of the external world – is in fact the product of an unconscious cognitive activity, which forms the world into a coherent structure that is substantial and spatial, causal and temporal. From a stage in which all things (psychical and physical) are equally real, higher degrees of differentiation are established, whereby the world comes to contain several distinct sorts of reality.

Stages in the development of art entail just such a progressive separation of outer from inner world. According to this principle, a stage involving a relative lack of differentiation between subject and object is developmentally prior to one in which there is a clear differentiation, or polarity, of subject and object.[1] In Piagetian terms, there is a progressive splitting up of a previously undifferentiated 'I' and the external world into two complementary universes – the objective and the subjective – from an initial stage in which the whole content of consciousness is on the same plane, and reality, as Piaget puts it, 'is overgrown with subjective adherences'.[2] For the 'pre-logical', or mystical, mentality, the visible and the invisible world form one, everything is fluid, categories are not separate, the individual

does not experience himself as separate from the group. The fact that there is no line of demarcation between natural and supernatural worlds, between the material and the spiritual, results in a very different picture of the world from that which our modern scientific world-view gives us.

Starting from an initial stage of egocentricism, in which the self does not yet possess a clear idea of itself as distinct from other surrounding beings and objects, and in which subjective and objective are still inextricably inter-mingled, cognitive development leads to a twofold movement in the mental processes: an externalization which tends towards greater physical objectivity, and an internalization which tends towards greater logico-mathematical coherence.[3] Wherever conceptual thought has developed, there is more attention to objective and logical relations than to affective and emotional ones.

The 'objectivity' which, in painting, we equate with a particular mimetic skill – with what Constable called 'the pure apprehension of natural fact' – has, correspondingly, not been present from the beginning in the history of art. The question we need to ask, therefore, is: if perception alone did not lead to the illusionistic representation of objects in painting, by what means has representation evolved from a state of insufficient knowledge to a state of greater competence in order to achieve more 'objectivity'? It seems to me, by way of an answer, that we can discover in art the same slow process of *decentration*, or coordination, in the mental processes that Piaget describes, by which the world of things becomes separated from the world of the mind and objectivity is gradually built up.

On the one hand, Piaget shows that knowledge of the world involves an *assimilation* of reality to existing cognitive schemata and, on the other, that it is an *accommodation* of these schemata to the actual situation, a transforma-tion of an already existing structure in response to the environment.[4] Once a dynamic equilibrium has been struck between assimilation and accommodation, it persists for a time and is called a stage of intellectual development. Schemata accommodate to things by adapting and changing their structure to fit reality: 'It is by adapting to things', according to Piaget, 'that thought organizes itself and it is by organizing itself that it structures things.'[5] The objectivity of experience is thus an achievement of assimila-tion and accommodation combined. It is through this interactive process of assimilation and accommodation between the physical world and cognitive structures that schemata are modified and that development occurs. Piaget writes:

> . . . the prerequisite for objective systematization is decentering away from the personal point of view that was dominant at the start . . . to the point where knowledge becomes amenable to a variety of reference systems.[6]

The chief decentring action consists in ceasing to take individual thought as the source of collective reality. This phenomenon, which makes for increased objectivity, is impossible to arrive at, according to Piaget, without a logico-mathematical framework.

Let us see what actually happens if we subdivide the history of art into three 'megaperiods', or historical durations, which might correspond, roughly, to Piaget's stages of cognitive development. The key factor in demarcating these stages from one another will be certain transformations in modes of representing space. The progressive structuring of space relations illustrates what appears to be, in a striking way, one of the most general laws of cognitive development, as it is evidenced in painting, which is that knowledge is reconstructed at successive levels of integration by means of new, richer and more comprehensive structures. All this will become clearer, I hope, in the following chapters, but meanwhile let us try to show schematically the connections between the historical development of art and Piaget's cognitive stages (see facing page).

From a bird's eye view, these megaperiods of art history refer to stylistic traditions that designate the terminus of one cognitive mode and the beginning of the next. They depict historical durations whose contours are defined by epochs in which qualitative socio-cultural transformations have occurred. Despite certain regressions and diversions, I believe these strands of art history constitute a progressive overall development in the evolution of art's thought-structure.

It is not so much a question of finding 'proofs' that the history of art has actually followed such a course – like so many other of life's questions, it does not quite admit of a clear yes or no. These correlations cannot be proven directly; I offer them as approximative truths (until such time as other researchers are able to go beyond them) and as a way of connecting things which have not been connected before, towards a way of 'seeing things whole'. It goes without saying that the fruitfulness and importance of this approach could be much advanced by subsequent concrete analyses that would exceed the limits of the present study.

If my account here is even approximately adequate, however, it should lend support to Piaget's basic premise of the existence of stages in cognitive development, over which much disagreement still prevails. As to whether or not such stages of development actually exist, Piaget himself has this to say:

> ... stages of development appear to me to be a reality, but differ from one field to another; they are more or less defined, more or less precise and accentuated according to the fields. As regards general stages common to all fields of development, I am in some doubt. I can neither affirm nor deny their existence. One can only decide by successive approaches which would consist in establishing a series of correlations, correspondences and parallelisms – work which is almost entirely still to be done.[7]

The assumption of a developmental pattern which has directed the evolution of art towards progressively more ordered states and towards higher organization (or complexification) does not conflict with individual differences or with the multiplicity of actual representational forms. A stage concept merely implies the necessity of a fixed order of succession in

	STAGES OF COGNITIVE DEVELOPMENT	SPATIAL CHARACTERISTICS	MEGAPERIODS OF ART HISTORY
(Enactive mode)	*Pre-operational Stage* The stage at which representations are characterized by static imagery and space is subjectively organized. Psychical and physical ideas are not yet dissociated.	*Topological Relations* Distance between objects is based on their proximity to one another on a two-dimensional plane which only takes height and breadth into account. Absence of depth, no unified global space which conserves size and distance.	*Ancient and Medieval* including Graeco-Byzantine, ancient Oriental, Egyptian, archaic Greek and early medieval.
(Iconic mode)	*Concrete-operational Stage* The stage at which representation can arrange all spatial figures in coordinate systems. Representation is still attached to its perceptual content, however. The emergence of perspective as a formal logic, applicable to any content whatsoever, but still confined to empirical reality and to the concrete features of the perceptual world.	*Projective and Euclidean Relations* based on the static viewpoint of a single observer. Separation of observer and world.	*The Renaissance*
(Symbolic mode)	*Formal-operational Stage* The stage at which hypothetical-deductive, logico-mathematical and propositional systems emerge, constructed and manipulated as independent relational entities without reference to empirical reality.	*Indeterminate, Atmospheric Space* (late Monet, Cubism, Rothko). Space as an all-over extension in which all points are of equal status and are relative to each other. No dominance of volume over void. (Pollock)	*The Modern Period* including late Impressionism, Cubism, Formalism, Serial art, art governed by logical systems and by propositional thinking.

43

the acquisition of certain cognitive forms, even under varying cultural conditions. Nor does the notion of a universal sequence, with regard to the order in which, for instance, certain spatial concepts are attained, preclude individual variations – given that the terms of the problems may vary from culture to culture. There is also the possibility that, just as with individual development, the peculiarities of a certain cultural or social milieu might prevent a particular stage from appearing. (One obvious example of this is the way that the evolution of Greek art parallels that of Italian art in the Renaissance, but stops short of achieving a fully-developed perspectival system.) Although maturation with respect to cognitive functions determines what is possible at a specific stage, it does not itself cause the actualization of structures. Maturation simply indicates whether or not the construction of a specific structure is possible at a specific stage. It does not itself contain a pre-formed structure, but simply opens up possibilities – the new reality has still to be constructed and must encounter the relevant conditions in the environment.[8]

According to our own cognitive map (p. 43) which is now beginning to take shape, it would seem that a fully developed formal-operational stage has not appeared in the art of any culture except that of post-Renaissance Western art. It is only in the art of our own time that the logical mechanisms of intelligence have come to their fullest maturity – in the sense of becoming entirely separated from perceptual content and acquiring an independent value, prestige and authority of their own. In the modular and serial constructions of Dan Flavin, Sol LeWitt, Don Judd, Robert Smithson, Carl Andre and Robert Morris, abstract variables are refined to the last degree. Modular methods are intended to eliminate any subjective choices from the artist's method of composing. Systems are carried out by formal deduction, independently of their application to concrete perceptual objects, and they are expressed in propositional language, much as Boole constructed his algebra of propositional logic.

141–6, 148

Now, if defining the history of art in terms of cognitive stages is of any value, it is to the extent that it may contribute to explaining to us the importance of this development – specifically, of an increase in the autonomy of forms to the point where even abstract forms devoid of content can be constructed and manipulated. (Compare, in this regard, Uccello's drawing of a chalice with Sol LeWitt's open modular cubes, or Leonardo's *War Machine* with Malevich's *Suprematist Elements*.) The question which must be put at this moment is: in what way can these abstract works, which appear to be monolithically *simple*, be said in any way to represent a move towards greater complexity?

56
58, 108
109

Let me put forward, then, as clearly as I can, the lines of the argument. In making the seemingly paradoxical assertion that these contemporary works, which when viewed on their own appear to be visually much simpler than a Renaissance painting, are in reality *more complex*, I refer to the complexity which is occasioned by the Modern paradigm viewed as a whole, and to the infinite number of systems which it is able to generate. The

Renaissance paradigm derives from a single, closed logical system – perspective – which is repeated over and over again in every picture in much the same way, so that every picture is rigidly bound and dictated by the rules of the system. The Modern paradigm is characterized by its openness and by the infinite number of possibilities and positions which can be taken. What is important are the many ways in which entities join and separate, since abstract variables do not have a meaning on their own but become meaningful only in relation to one another. Geometry, as it was inherited from the classical world, was a logical system which could be applied to any set of objects, but it remained linked to the objects of perception: its elements were never used autonomously.

Compare in this respect Vincenzo Foppa's *Tabernacle with Flagellation*, 53 within whose vaulted recesses an all but invisible flagellation scene is taking place, with Dan Flavin's fluorescent light construction, whose increasingly 54 long perspectives proliferate with flute-like purity; or compare Masolino's *The Dispute of St Catherine* with Sol LeWitt's homonymous cubes that main- 55, 58 tain a logician's or grammarian's detachment from human forms; or compare tile floors in a Renaissance picture, the marble index of a converg- 50, 52 ing series of human interactions, with the pedantic austerity of Carl Andre's 139 floor sculptures, which consist simply of tiles arranged in basic geometric units. In a sense, the difference at the level of formal identity between these Renaissance works and the contemporary ones is the difference between geometrical construction and algebraic systems of equations. And indeed, in the recent conceptualism of artists like Sol LeWitt, Barry LeVa, Dorothea 58, 111, Rockburne and Mel Bochner, art has become increasingly a 'logic of 115, 65, propositions', deriving its content, not from objects, but from actions and 98, 99, from the artist's operations. If we are struck by the abstract character of the 113, 117 latter – a world in which all combinations are equally available and propositional thinking takes over more and more – we are also struck by the empirical and concrete character of the former.

What we are pointing to is a trend in art away from iconic modes of representation and towards the development of formal logical systems dealing with sets of pure abstract relations. Viewed in this way, the history of art can be seen as a process which has entailed the slow and laborious liberation of forms from their content. The trend originates in Cubism, since the Cubists began to combine forms according to a pictorial logic that did not necessarily coincide with perceptual reality; indeed, from 1911 on, they categorically refused to make use of external models. In Cubism, the elementary idea of visual shape gives way to abstract organization. Form is no longer the fixed and finite characteristic of objects with clearly defined boundaries; space is no longer the empty container which surrounds solid objects. Closed contours are avoided; edges are dissolved and objects in quite different planes melt into each other. For the Cubists, pictorial reality was built up, or constructed, from a combination of elements, in much the same way that sentences are generated from basic grammatical units. The invention of 'collage', a method of combining and pasting elements, of

ordering and putting them into correspondence, allowed painting for the first time to approach the conditions of language, which is characterized by a set of generative rules. Collage served painting as a kind of transformational grammar, in Chomsky's sense: it was a method of generating, not sentences, but images, from sets of pure relations. Cubist elements act like phonemes in linguistic theory, in that they are relational entities and not absolutes. In Cubism's final phase, Juan Gris would begin with entirely abstract shapes and colours and planes, from which references to reality were generated or synthesized (hence the term 'synthetic' Cubism).

What makes modern art 'progressive', then, is its capacity for doing infinite things with limited means. Modern art (like generative grammar) works by transformations. The square, circle, cube, rectangle and triangle form a natural grammatical unit, a 'kernel sentence' out of which all combinations become possible. Whereas *iconic* systems depend on a *figurative* correspondence between picture and model – between the object and the symbol used to represent it – the symbols in more complex symbol systems convey information that varies in meaning according to the context and lend themselves, in the manner of language, to increasingly high levels of abstraction. Propositional thinking has become more and more the instrument of contemporary art, as it has in mathematics, where set theory and algebra have replaced the more visual and concrete geometries with formal logical systems that are independent of the demands of external reality. The move towards formal-operational thought is simultaneously a move away from the grip of the image. In the same way, Piaget claims that rational and scientific thought needed to get away from the grip of the image: one does not do modern theoretical physics with images. The tendency in both science and art is towards more condensed, succinct and abstract formulae for describing the essence of reality, its skeletal structure, the ultimate to which it can be reduced.

Despite radical changes in both form and content, I wish to assert that there is logical continuity between classical and contemporary art. There is something stable within the flux that maintains historical continuity – an internal transformation which ascends to higher levels of complexity, revealing ever new comprehensive features, the study of which requires ever new powers of understanding. The fact is that all these new and old relations form one family derived from a single system of possible relations. Each stage carries the seeds of the next phase, and each new cognitive structure includes elements of earlier structures but transforms them in such a way as to represent a more stable and extensive equilibrium. Frank Stella's
136, 135
Cato Manor, and Josef Albers's *Homage to the Square*, for example, in a sense repeat and contain the old illusionism of perspective and even identify with it (in the sense that non-Euclidean geometries contain Euclidean geometry as a special case, but not the inverse). But they also reassemble the components of prior positions in a way which transcends them, and may even shift from one level to another and back again. Both these pictures combine the deep space of the Renaissance and the two-dimensional space

of earlier art, and bind together surface and depth in a new dynamic synthesis. They are examples of how new qualities emerge in the form of transformations, and of how the possibilities for diversity of structure and function increase with the changing levels.

What we have tried to map out so far is the moment in artistic thinking when a structure opens to questioning and reorganizes itself according to a new meaning *which is nevertheless the meaning of the same structure*, but taken to a new level of complexity. In the chapters which follow, the distinctive characteristics of constructivist, minimal and conceptual art will be seen to emerge by continuous stages from the progressive modification of the methods used in Renaissance art with its structural elements reinforced and enriched.

Chapter Six

Ancient and Medieval Periods

Modern linguists now agree that there is a 'ground plan' for all the languages of the world – that language in every society has the same fundamental properties. In a sense, I have put forward a similar kind of ground plan for the structure of art, by directing interest to its syntactic and organizational aspects rather than to its descriptive aspects or to its subject matter. To continue the analogy with linguistics, I believe we can distinguish the 'deep structure' of art from its 'surface structure', and that this 'deep structure' reflects certain fundamental properties of the mind.

In previous chapters, I put forward the hypothesis of a cognitive development in art which has passed through three major phases. I shall now consider each stage individually, demonstrating the successive strategies which have been applied by artists in different historical periods to the solution of representing space, since I believe that the formation of spatial notions, and their degree of structuration, reflect the different cognitive modes in which they have been acquired and employed.

The most elementary spatial notions, such as those found in ancient and Oriental art, Graeco-Byzantine and medieval art, are, in Piaget's sense, 'pre-operational'. This means that space is elaborated simply, without any operations of measurement. No line of demarcation exists between objectively 'real' space and the supernatural world. Figures and background are not consistently integrated in such a way as to make them inseparable; there is a medley of viewpoints, and the various pictorial elements do not present themselves to the eye from a given standpoint but appear in the order in which they happen to follow one another into consciousness. Size is determined, not by the relative distances between objects, but by the emotional importance of the figures, and by their distinction of rank. A nobleman in an Egyptian hunting scene is much taller than his boatmen, as is the Virgin in *The Glatz Madonna*, who looms over the surrounding figures and angels. Not until the Renaissance do we find the main figure of Christ, as in Piero's *Flagellation*, depicted as a small accessory figure in the background. (Piero was sufficiently close to the medieval mentality, however, to be able to revert to the earlier principle of 'hierarchic scaling' in the *Madonna of Mercy* (not illustrated).) Ortega y Gasset has remarked on the 'feudal composition' of pre-Renaissance art,[1] but a corresponding 'overemphasis of meaningful parts' is to be found in

48

Oriental art as well, where 'a spiritual table of precedence was used to represent human beings commensurately with their importance as symbols'.[2]

Meyer Schapiro has remarked that 'the dominance of the human figure over the environment appears independently in the art of many cultures and among our own children in representing objects',[3] and it is a fact without exception that, prior to the Renaissance, emotional value or importance is consistently more decisive in pictorial organization than is the relative size of objects. And whereas size is overemphasized, the intervals between objects are often ignored. Since this is true of cultures so absolutely remote from each other in time and space, the explanation for it can only lie in something other than convention. It implies some basic pattern to the organization of mental processes which must be constant.

According to Piaget, certain cognitive forms must first become stabilized (types of conservation, overcoming shifts in viewpoint, distance, parallelism, angularity, measurement) before spatial concepts develop away from what he calls 'egocentric coordination' towards more objective coordination. 'Egocentricism', as we have seen, signifies an absence of both self-perception and objectivity. It is the distortion of reality to satisfy the emotional needs and desires of the subject. When, in the history of art, artists became conscious of their subjectivity and learned to control shifts of orientation (rather than fixing on one aspect of a changing relationship to the exclusion of other aspects), they were able to 'place themselves' with respect to a world of external objects and persons, and to deal with objects relative to some point of view.

Projective space implies an awareness of the relations which link the object with the subject; it begins psychologically at the point when the object is no longer viewed in isolation but begins to be considered in relation to a point of view. The fundamental process which underlies the whole of mental development is precisely this increase in distance between the observer and his world: indeed, *it is this co-existence of object and observer which actually defines space*. The essential feature of projective space involves the entry of the observer, or point of view, in relation to which figures are projected. Depth only comes with the introduction of the observer's point of view, since the 'I' orients itself in space according to three coordinates: above and below, left and right, and before and behind. It presupposes the same setting face-to-face of subject and world, in which the objects perceived exist at the same time as the observer.[4]

Only with the development of perspective did the picture become an extension of the spectator's world. The medieval cosmos is a world which did not change in relation to an observer whose eye was the focus of orientation for objects in space. (It is significant that, before the fourteenth century, there does not seem to have been any conception of space as a thing on its own; the very word 'space', in the sense of the interval or emptiness between objects, did not come into common use in the English language until then.[5]) It is the lack of any observer (indicating an awareness of self as distinct from things, and a differentiation of self and world) which

accounts for the lack of depth in pre-Renaissance art. Figures move about freely between natural and visionary spaces, but they only move *up* and *down*. Renaissance space, by contrast, is architectonic and environmental. Objects are disposed from a fixed point of view, relative to an ideal observer, in a single moment of unified action.

Perspective is a way of relating observer and objects to each other. The vanishing point provides, as the focus of the observer's gaze, a systematic means of unifying the whole scene with reference to the eye of the spectator. It introduces, in addition to the relationships 'left–right' and 'above–below', the third dimension of 'before–behind': these, together with the perspective viewpoints, give rise to projective spatial dimensions and result in the concept of the plane – as distinct from a surface or three-dimensional space.

The true significance of Piaget's research for understanding the development of pictorial representation lies in his discovery that spatial concepts develop by successive levels and stages, and that topological, or two-dimensional, models of space are the first to develop. 'Objective' co-ordination only emerges as space becomes increasingly stripped of subjective elements and structured by the operations of thought. Only then does spatial representation embrace both projective and metrical relationships, and last of all embark upon the construction of a comprehensive space of coordinates and coordinated perspectives.[6]

The genetic primacy of topological relations – and the fact that the mind does not jump directly from the perceptual notion of spatial continuity to a conceptual or representational schema able to express this – have also been confirmed by other kinds of cross-cultural studies. Pictured opposite is one of a series of drawings devised by William Hudson for studying pictorial depth-perception, and it illustrates very well how topological and projective modes of representation are radically different means of conceptualizing space. Among those tested by Hudson were adults of differing educational and occupational backgrounds, including black South African mine workers, and children of different ages. The results demonstrate that the properties of a given spatial field may be perceived in quite different ways according to a learned ability to coordinate the different axes and directions within it. Projective and Euclidean models of space only develop later and are often confined to particular cultural settings.[7]

The two-dimensional (or topological) viewer perceives the objects thus arranged as lying only in one plane. The elephant is thought to be nearer to the man than the antelope, since distance is judged in terms of proximity (nearness of boundary contours to each other and of elements belonging to the same perceptual field) and not in terms of diminution in depth. Put in another way, the element of depth (or before–behind relations) is lacking. What is adjacent is judged as nearer, since breadth and height are the only dimensions in which objects are experienced as being juxtaposed. Egyptian painting, for example, functions in just this way, with all elements parallel to the picture plane, and with no convergence, diminution or foreshortening.

The three-dimensional (or Euclidean) viewer, on the other hand, since he sees the objects in a number of planes, attends to differentials in size, overlapping and linear convergence, and therefore judges that the antelope is nearer to the man.

Topological relations express the simplest and most primitive coordinations of actions – such as that of following a contour step-by-step. Topological relations may be regarded as spatial without yet being mathematical, since they do not take metric relations into account. (In this sense Piaget shows how the conceptual knowledge of space is rooted in a tactile knowledge rather than a visual analysis – in the physical coordination involved in the exploration of objects, in handling or walking around them, which becomes internalized as implicit mental activity.) Transposed to the domain of painting, the eye travels from angel to donor to Virgin in a linear extension, revolving about each figure individually, as a set of neighbouring elements in several separate spaces, just as in topology a line is viewed as a system of interlocking neighbourhoods or open sets, with the neighbourhood of a point consisting of all the points that surround it. No single frame of reference prevails, as, for example, in the *Birth of Bhéma*, a painting from the Kangra School which flourished in the Western Himalayas. Here space is conceived on the basis of a linear order formed through the progressive combining of proximities: five distinct groups of figures exist as a set of neighbouring elements in five separate spaces. The eye revolves around each group individually, whereas in a fully developed projective system the eye of the observer is established as the central point around which revolve the form of objects. In a topologically ordered spatial system, there is nothing outside the given configuration to act as a reference frame, and consequently there is no conservation of size or distance. If we look at Giovanni di Paolo's *The Annunciation*, or Broederlam's *The Presentation in the Temple and the Flight into Egypt*, we will see how several partially integrated scenes

<div style="text-align:right">26</div>

<div style="text-align:right">31, 30</div>

are depicted but, since the glance is not subordinated to any one point of view, the figures are not located in relation to each other according to a general plan which has taken objective distances into account. The resulting space is fragmentary, episodic and uncoordinated; there is not yet a global comprehensive space which embraces all objects.

It is only when topological notions have become linked with points of view that a threefold relationship develops between the object, the pictorial plane and the spectator's eye. The introduction of a viewpoint transforms topological relationships into projective ones. Essentially, what enabled artists to pass from elementary topological relations to Euclidean ones in their representations was the building up of notions of distance (or length of an interval between objects), by imposing a network of calculable angles and notional straight lines on a scene, and by the ordering of interval relations. The two-dimensional plane ceases to be a flat surface when distance between objects is introduced. Distance heralds the construction of a coordinate system and the organization of the spatial field by referent axes. Implicit in the understanding of depth is that I am here and that things are over there; depth belongs to perspective, to the link between subject and space. Apparent size, as Merleau-Ponty has pointed out, is not definable independently of distance; it is implied by distance and it also implies distance. Convergence, apparent size and distance are read off from each other, and signify each other.[8] Where the concept of distance is absent, space as a medium common to several objects will be uncoordinated.

The notion of distance, then, is crucial both to the development of measuring and to the elaboration of coordinate systems.[9] The two fundamental mechanisms of Euclidean thinking, according to Piaget, are the conservation of size and its measurement:

> With the construction of projective space through coordination of viewpoints, and the development of reference frames through Euclidean comparisons, continuity comes to be applied to the whole of space, regarded as a universal framework valid for all objects and all observers.[10]

Only when the intervals that separate objects are themselves considered as so many potential positions does space lose the character of elasticity and inconsistency inherent in topological relations, and become a rigid and stable structure in which distance and size are conserved. This makes measurement not only possible but necessary.[11] Until this happens, however, objects are depicted without regard for the intervals which separate them. Both the Greeks and the Egyptians used superimposition to indicate depth in their pictorial representations, but they did not order the intervals between figures. (Here again cross-cultural studies establish that superimposition as a cue to depth-perception is acquired earlier than object-size.) 32 Pictures like *Death of the Virgin* by an unknown Bohemian master, and 33 Simone Martini's *The Road to Calvary* typify a transitional stage between two modes of spatial organization. In these pictures, the projective mode exercises a formative role but has not yet been mastered as an operational

system; it is still somewhat unstable. The figures are crammed and huddled together without regard for the space between them, despite efforts to suggest depth by means of architectural forms.

Measurement demands that several reference points are linked in a systematic whole, implying as it does 'coordinate axes' that are increasingly stable. In Piaget's words:

> [Topological space] is merely a continuous collection of elements which may be expanded or contracted at will, and conserves neither straight lines, distances, nor angles. Consequently, topological concepts do not lead to the construction of a stable system of figures, nor to fixed relations between such figures. . . . Topologically, each continuous domain constitutes a space and there is thus no universal space operating as a frame and enabling objects or figures to be located relative to one another.[12]

In short, projective relations (perspectives, shadows, sections, plane rotations) presuppose a growing number of increasingly complex coordinations between different actions. The determination of a straight line, of an angle, of parallels or coordinates, entails not only a simple observation but a process of overall coordination and the precise adjustment of one action to another.[13] The concept of spatial continuity is a complex notion which involves the evolution of a stable system of figures, and of fixed relations between such figures. Taddeo Gaddi's *The Virgin Presented at the Temple* 35 is a perfect example of projective space at a level where these coordinations have not yet become stabilized.

The solution to the problem of representing deep space gains only a precarious foothold at first, being loosely consistent and not completely coordinated. Before the Renaissance, there are only partial solutions. Flux and instability gradually give way in the fifteenth century, however, to a cognitive structure which forms a tightly-knit, organized and stable whole. During the Renaissance, 'coordinate axes' finally determine and preserve the true relative positions of figures and overcome the medley of viewpoints and spatial inconsistencies of the topological stage. At this point the spatial relations between figures are expressed by fixed laws. Space is no longer a network of 'aggregates', but becomes organized and 'systematic'; the discontinuity of separate aggregates is overcome. In short, the evolution of deep space in painting is intricately connected with an increasingly rationalized architectural space which separates interior from exterior. Only during the Renaissance, when an analogy was made between architecture and the scale of a human being, did space become sufficiently mathematicized to achieve the rational organization of form in terms of 'just proportions'. Proportion is a relation among relations, and thus constitutes a bridge to the Modern period which is characterized by formal-operational thought.

In pre-Renaissance Western and all Eastern art, the representation of space is pre-logical, in the sense of being subjectively rather than objectively organized. Size is determined, not by the relative distances between objects, but by the emotional importance of the figures. There is no unified global space which takes objective sizes and distances into account.

20 *Hunting Hippopotami in the Marshes*, Egyptian, 4th and 5th dynasties

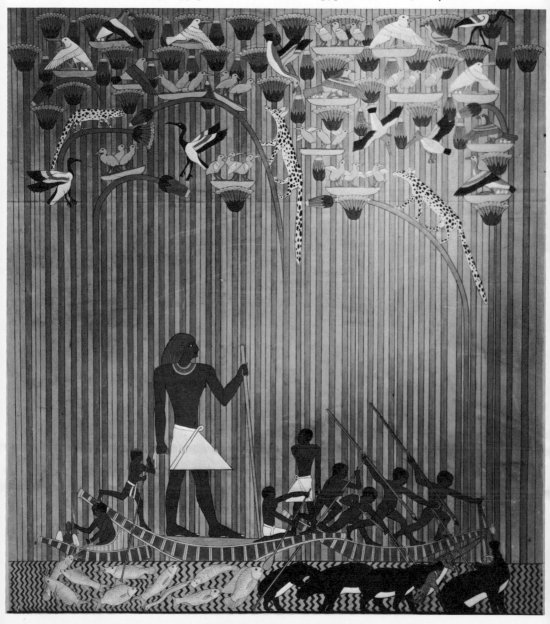

21 BUNDI *Month of Sawan*, Indian, *c.* 1735

22 BOHEMIAN SCHOOL *The Glatz Madonna*

23 *Agricultural Scenes*, Egyptian, 4th and 5th dynasties

24 School of Giotto *The Church Militant and Triumphant* (detail)

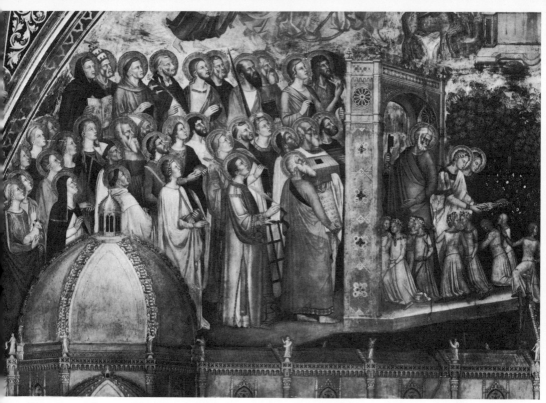

25 SCHOOL OF GIOTTO *The Church Militant and Triumphant* (detail)

26 KANGRA *Birth of Bhéma*, Indian, *c.* 1810–25

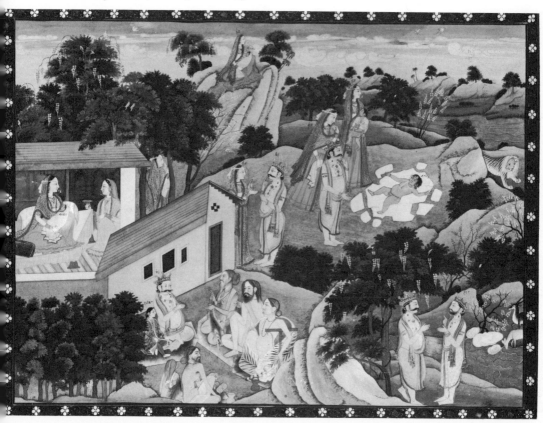

27 *St Benedict and St Desiderius,*
11th century

28 BUNDI *Radha and Krishna*
Surrounded by Girl Companions
Beaneath a Canopy, Indian, *c.* 1735

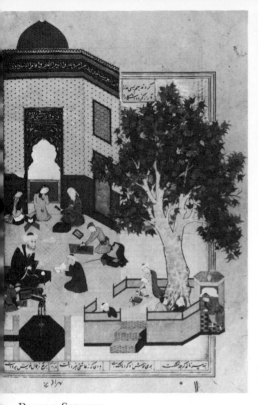

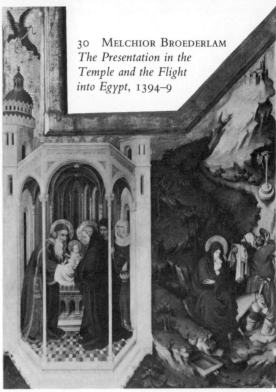

30 MELCHIOR BROEDERLAM
*The Presentation in the
Temple and the Flight
into Egypt*, 1394–9

) BIHZAD SAFAVID
Layla and Majnun at School, Persian, 1494

31 GIOVANNI DI PAOLO *The Annunciation*

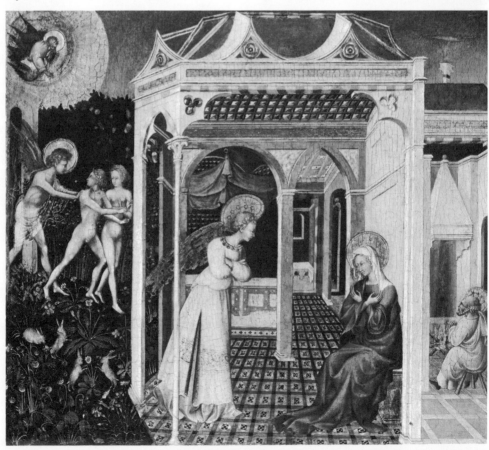

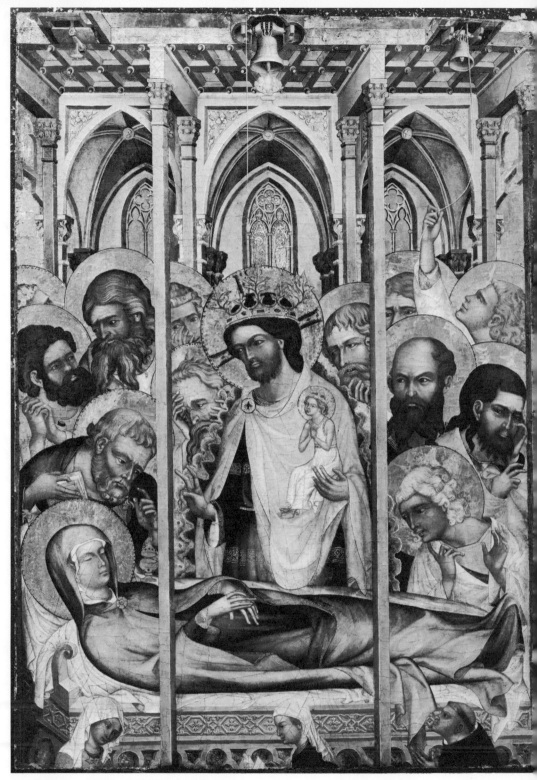

32 BOHEMIAN SCHOOL *Death of the Virgin,* 1350–60

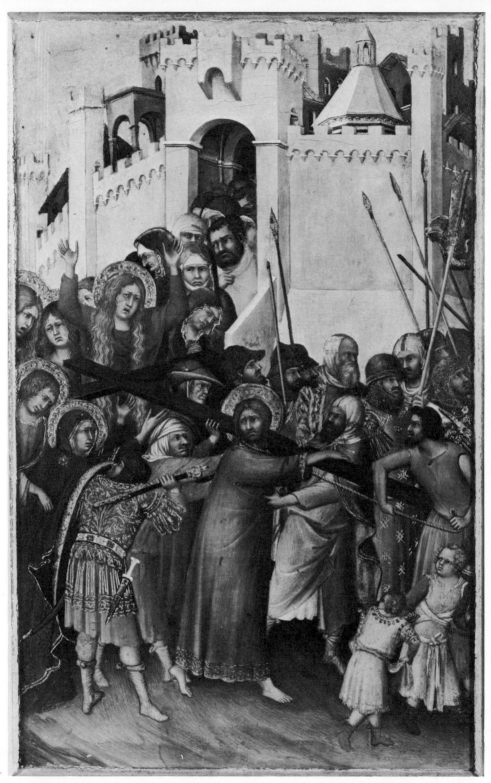

33 SIMONE MARTINI *The Road to Calvary*, 1340

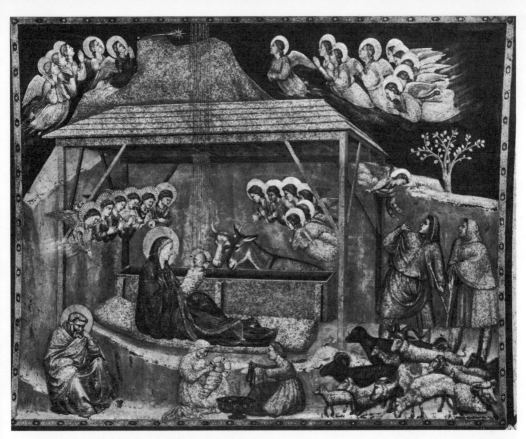

34 GIOTTO DI BONDONE *The Birth of Jesus*

35 TADDEO GADDI *The Virgin Presented at the Temple*, 1332-

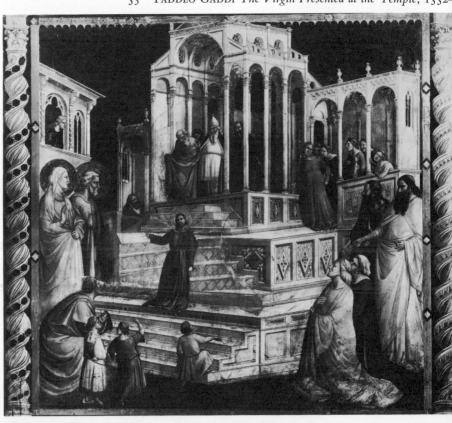

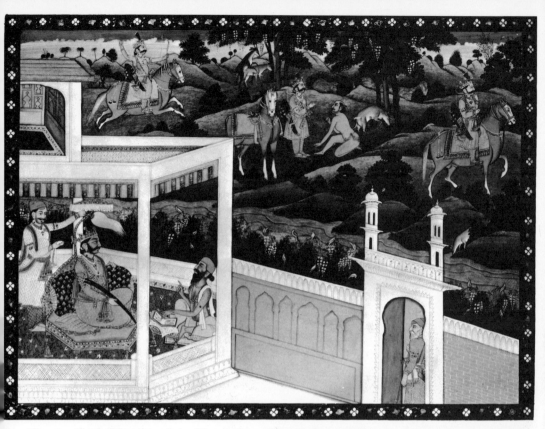

36 KANGRA *Pandu Shooting a Saint Disguised as a Deer*, Indian, *c.* 1820

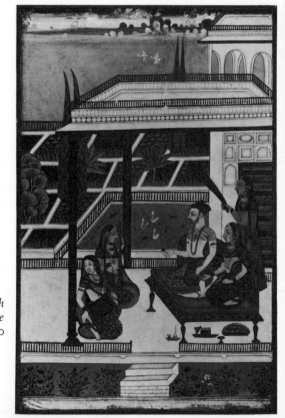

37 GULER *Princess with a Hookah
Listening to Girl Musicians in a Palace
Garden*, Indian, 1770

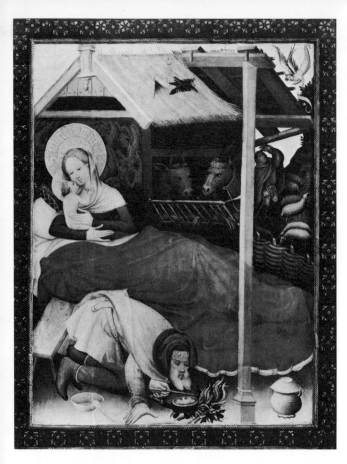

38 KONRAD VON SOEST
Nativity, 1403

39 DUCCIO *The Annunciation*, from *Maesta*

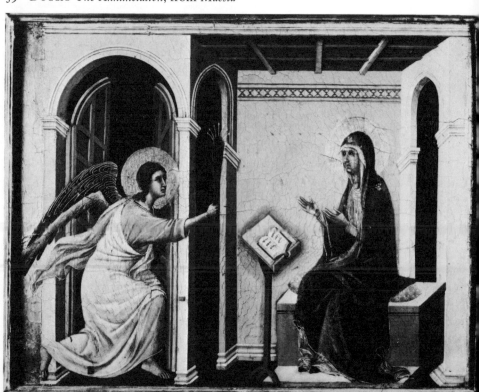

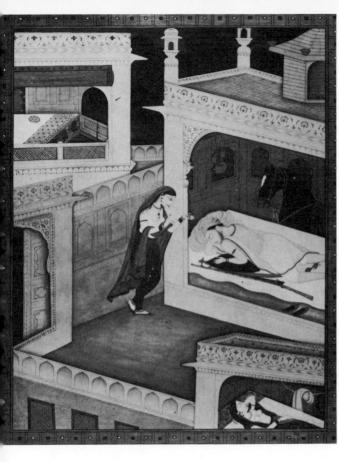

40 KANGRA *Nobleman Asleep*,
Indian, late 19th century

1 BENOZZO GOZZOLI *The Dance of Salome*

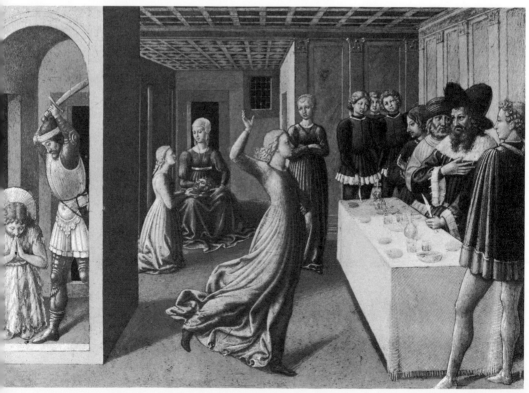

The Renaissance

Diverse orders of experience have cooperated in the knowledge of geo-metrical space, both physiological and metrical. The fact that perspective spontaneously provides us with an illusionistic representation of reality is not the result of its 'innate pictorial qualities' but of a particular develop-ment in our mathematical and visual faculties. Traditional aesthetics has long been hobbled by the notion that the concept of geometrical space is an intuitive perceptual 'reading' of the external world. This is to misunder-stand its character as an operational construction. In previous chapters, we have seen that geometrical knowledge has a psychological development connected with the operations of thought, and that it develops in a sequence of stages. The order of this development is that topological relations (involving proximity, order and enclosure) precede projective relations (involving points, lines, horizontality) as well as Euclidean relations (involving angularity and proportion).

We are so accustomed by now to the concepts and principles which form the basis of perspective that it is nearly impossible for us to appreciate either the obstacles that had to be overcome for their establishment, or the difficulties that they imply and encompass. The fact that we now perceive space in a certain way does not mean that we have always perceived it in that way, however; the whole implication of Piaget's work indicates that geometric optics do not describe, for instance, the relativities of the space world of the child. Our seemingly effortless seeing is really the end-product of a long and slow developmental construction, and Piaget has shown that this construction is itself more dependent on mental operations than it is on perception.[1] The history of art demonstrates how long artists had to struggle before they achieved a rational and coherent representation of geometrical space based on initial perceptual and empirical intuition: even great minds like Duccio or Giotto failed to reach that goal. Can we really say, then, that perspective expresses an invariant law of the human mind?

Gombrich gives the following reply to critics who have tried to claim that 'the methods of mathematical perspective only represent a "convention", a fortuitous code that differs from the way we really see the world': 'We know very well', he writes, 'when a picture looks right. A picture painted according to the laws of perspective will generally evoke instant and effort-less recognition.'[2]

We have already seen that, on the contrary, the conventions of the Renaissance, with its particular framework derived from geometric optics, are not so pervasive as we think they are. Perspective is not immediately accessible to the uninitiated. The eye accustomed solely to Oriental painting, for example, does not immediately understand a picture in perspective.[3] As we have seen, perspective has also been found to present difficulties in depth-perception to members of a culture in which perspectival representations are not used. Among tests made with African children, unskilled Zambian mine workers and South African Bantus, it was found that they were unable either to integrate pictorial elements organized according to the laws of perspective, or to perceive the third dimension in photographs.[4] Like the Eskimos, African cultures have little acquaintance with such elementary concepts as straight lines and right angles. The same question has also been examined in a study of Zambian and Scottish children who were required to sort three-dimensional models of animals, colour photos of the models, and black and white photos. The performance of both groups of children was equivalent when sorting the three-dimensional models but not when sorting the photos: the mode of representation was clearly shown to affect the ability of the Zambian children to sort.[5]

Other experiments suggest that experience with drawing is necessary before depth can be perceived at all in two dimensions. Unfamiliarity with the conventions which offer the observer depth cues leads to an inability to interpret these cues and therefore to a misunderstanding of the meaning of the picture as a whole.[6] It has also been established that persons who are born blind, but who later gain their vision through an operation, manifest similar difficulties in interpreting depth cues and seem to have no comprehension of the three-dimensionality of space.[7] This would indicate that such persons have no *a priori* awareness of space but must learn to judge distances and size and direction, and to master spatial relations. (The words '*a priori*' mean 'not derived from experience'.) Without vision in early life, the idea of three-dimensionality simply does not develop; such persons must learn to distinguish two-dimensional shapes, and often become confused between solid objects and their representations in paintings, photographs or mirrors. All these observations attest to the fact that the eye is not like a camera and that perspective is not an innate law of perception. Moreover, Euclidean structures would appear to be established *after* and not before topological structures in all environments.

In Latin, *perspectiva* means a view through something, and the basic idea of perspective is that, when a man sees something through a window, he can get a correct image of it by tracing its outlines on the window pane provided that while he does this he only uses one eye and does not move his head. Perspective demands the reference point of an immobile eye, with the result that it discounts the natural scanning process involved in perception. Our habits and prejudices favour Euclidean geometry as a 'natural geometry', because our world of rigid bodies possesses a structure which approximates the Euclidean one to a high degree. We are used to it in the

way that we are used to a native language, but it is only one of the many ways man has invented for projecting before himself the perceived world. Geometric optics and perspective drawing are developments in our cultural history which have only recently become an integral part of our visual understanding and our visual 'common sense'. They are developments, however, which have significantly affected the way that we now see.[8]

Commenting on the results of some of his own perception experiments, the experimental psychologist Sir Frederic Bartlett observes:

> In several of the perception sequences it seemed that there came a stage when something like a stored pattern or standard representation took charge of the observer's response and principally settled what he was to allege that he perceived. Moreover, observers from much the same social group were very likely to use the same stored standard representations.[9]

According to Hans Reichenbach, it is logic, and not *a priori* visual forms, which directs the laws we read in perspective, by 'smuggling tacit assumptions into the images'.[10] This is a very Piagetian idea, and it brings us back, once again, to the question we have been trying all along to answer: if it is really the case that Euclidean geometry is concerned with *a priori* forms and with pure intuition (rather than with logic), why do such forms appear at such a late stage in artistic development? Why did it take artists as long as it did to discover Euclidean methods in the first place? What is the relationship between geometrical intuition and logic?

If we once accept that the formal structures of geometry are already implicit in the organization of our visual experience, a number of difficulties present themselves. These have been concisely summarized by Stephen Toulmin:

> . . . either we shall have to suppose that the entire system of Euclidean relations sprang into existence all at once, as a complete 'cognitive structure', or we shall have to assume that the men of pre-Euclidean times, who applied cruder rules in their measuring operations, were in some sense misunderstanding the formal patterns already implicit in their own mental activities.[11]

The dilemma is ultimately resolvable, I believe, within a Piagetian framework which distinguishes between notional, or operatory, space and perceptive, or sensori-motor, space, and which introduces 'new gradations between intuition and logic, the chief of which is the logic of concrete operations, superior to pre-logical intuition and inferior to formal logic'.[12] In geometrical reasoning, according to Piaget, there always remains some link with intuitive experience, and from the outset of experience intelligence is operative in organizing intuition and in giving it a definite structure.[13] All this would seem to establish that Euclidean space is not a concept which the mind inherently possesses independent of experience, as certain philosophers have claimed. Our spatial notions are subject to cognitive

transformations, and these are marked by a new form of thought qualitatively different to the previous one.

Does this mean we are justified in claiming, therefore, (along with the mathematician Poincaré) that geometrical space is, after all, only a convention? If so, then linear perspective would be only one phase in the history of ideas about space – an assumption which allows for subsequent developments within the history of art (as well as for radical changes which have also occurred in science and mathematics in relation to concepts of space). On this view, perspective is a discovery which belongs to its own age, but it does not repose upon some set of absolute values.

If, on the other hand, linear perspective represents 'true' space by some sort of *a priori* necessity, what, then, about other kinds of pictorial space? The Impressionists claimed, for example, just as much as Renaissance artists, to depict the world 'as it looks', but they used only a shimmering texture of light, patches of colour, and virtually no straight lines at all. As a result, we are confronted, not with an empty space that contains solid objects, but with an all-over, dense continuum of events, and an equal degree of surface density. The canvas is once again a flat surface rather than a transparent plane or 'window'. And what, then, about Cubist space, which is space contemplated, not from a single point of view in one frozen instant of time, but from multiple and shifting viewpoints – from a 'rotating point of view'?

That perspective is no longer the only valid model for spatial relationships has been hammered hard, so to speak, into the continuous body of art history by the art of our own time. The geometric grid which the Renaissance, with its Euclidean turn of mind, imposed on the process of representation was systematically dismantled and 'de-constructed' by the Cubists; the tendency since then, in the twentieth century, has been to use the elements of geometry abstractly, in the manner of a 'universal grammar', exploring and permuting its internal relationships.

Can we still justify the claim, then, made by Gombrich and others, that perspective is not a mere convention like the others but that it provides an objective standard for the optically correct rendering of objects in space, because 'within the orthodox perspective arrangement, we deal with tangible, measureable relationships'?[14] 'One cannot insist enough', Gombrich writes, 'that the art of perspective aims at a correct equation: it wants the image to appear like the object and the object like the image.'[15] Put in another way, can we separate the validity of certain representational norms from their particular historical embodiment?

In his belief that mathematics is an unassailable collection of truths, Gombrich follows the inventors of perspective, who themselves held a Platonic conviction that nature is fundamentally mathematical, and that perspective contains within itself the true principles of nature.

The belief that the universe is ordered and rationally explicable in terms of geometry was part of a deterministic world-picture which viewed nature as stable and unchanging, and considered that mastery over it

could be achieved by universal mathematical principles. The spatial illusionism of one-point perspective reflected a world which was permanent and fixed in its ways, modelled on an absolute space and time unrelated to any outward circumstance. One has only to look at the Piero della Francesca or the Bellini to sense this immutability of things; a world is portrayed in which chance and indeterminacy play no part. From this vantage point, we can see how a totally mathematicized philosophy of nature was the dominant influence on the course of Western painting, and how these processes of mathematics offer themselves as a bridge from one stage in the development of art to the next.

42
43

In the Renaissance, geometry was truth and all nature was a vast geometrical system. (The book of nature, Galileo wrote, is written in geometrical characters.) Perspective images were based on observation, but they were rationalized and structured by mathematics. For Alberti in 1435, the first requirement of a painter was to know geometry; and Piero, in *De Prospettiva Pingendi*, virtually identified painting with perspective, writing three treatises to show how the visible world could be reduced to mathematical order by the principles of perspective and solid geometry.

In the twentieth century, we have come to distinguish the inner consistency of mathematical systems from truth about the world. The question of whether actual experience corresponds to the products of geometrical thought and construction does not arise within any *geometric* context: relations between the elements of a 'figure' established by geometrical reasoning are valid, *whether or not such a figure is ever encountered in the perceptual world*. Among mathematicians, Lobatschewsky and Gauss were the first to destroy the Euclidean concept of fixed space, and to demonstrate that it is only *one* instance in an unending succession of spaces. (Gauss considered the three-dimensionality of space, not as an inherent quality of space, but as a specific peculiarity of the human soul.) With the creation of non-Euclidean geometries, it became clear that mathematicians were not recording nature so much as interpreting it, and that there were no *a priori* means of deciding from the logical and mathematical side which type of geometry does in fact represent the spatial relations among physical bodies.

At the time of its creation, however, Euclidean geometry was *the* geometry; it was unquestionably the one to be used in describing physical space. Among physicists and mathematicians today, however, no such certainty exists; statistical laws and indeterminacy have replaced the mathematical view of nature. Concepts of space structure are still highly controversial, and no satisfactory solution to the problem of dimensionality has yet been found.

According to a somewhat heretical view put forward by the French art theoretician Pierre Francastel, the fact that the Renaissance should have produced a geometrization of the arts does not mean that artists of that time discovered and then used a permanent law common to both nature and the human mind. It only means that they adapted their art to certain principles

of mathematical knowledge of the time.[16] Francastel rejects the assumption that Renaissance painting reflects the natural vision of man and that it is a decisive step forward on the path to the 'true' representation of nature. It is an illusion, he argues, to believe that some kind of formula exists ready-made in nature, or in man's brain, for creating an exact imitation of the external world, and that this formula simply had to be brought to light. The Renaissance painters did not describe space more accurately than their predecessors; they *invented* their space.

The unending debate over perspective, represented at the two extremes by Gombrich and Francastel, is better replaced, in my view, by the developmental problem of explaining how geometrical thought, at a certain point in its history, *becomes independent of objects and grows increasingly deductive in character*. The illustrations in this book have been arranged in formal sequences intended to demonstrate that what begins, in the work of artists like Duccio and Giotto, as a perceptual and empirical geometric intuition (unstructured by any logico-mathematical framework), and emerges in the Renaissance as a rationalized and coherent construction, is restructured once again, in the art of our own time, in the form of propositional and deductive logic. The fact that all these levels are conserved at the same time as they are superseded is what gives history its integrative character and its continuity. A content that has been used on one level with respect to a certain kind of structure can be transposed onto another, by being restructured in a new mode of thinking. The resulting pattern appears as a succession of repeated differentiations, specializations and reintegrations, with a distinct progression from simple intuition to more complex logical and rational structures.

In this sense, I think we can claim, with some justification, that the development of perspective in the Renaissance *is* an advance over prior modes of spatial representation, insofar as it can more successfully coordinate changes of position. And, on Piaget's account, the spatial schemata that emerge in the course of development do accommodate more and more to the characteristics of physical reality. But the real issue, or so it seems to me, lies elsewhere. Knowledge is not a simple approximation to 'truth' or 'reality', and the evolution of art does not stop with the emergence of perspective – whatever its degree of accuracy or its standard of fidelity to the observed world. The problem which confronts us now, in the light of twentieth-century developments in art, is more pertinently posed by the following question of Piaget's:

How can consciousness confront the external world so directly as to appear its perceptual or symbolic image, and then proceed to loosen all ties with externality so completely that it is able to replace it by concepts belonging entirely to the subject himself?[17]

In other words, what has made it possible for man's cultural forms to evolve beyond the demands of perceptual reality and to develop purely abstract

systems of thought? The answer to this question lies hidden, I believe, in the dynamic and operational processes of intelligence:

> It is precisely because it enriches and develops physical reality instead of merely extracting from it a set of ready-made structures that action is eventually able to transcend physical limitations and create operational schemata which can be formalized and made to function in a purely abstract and deductive fashion.[18]

In itself, space has no limits or boundaries. It is a relational structure which we impose on the world, a coordination of changes of positions and not, as Newton believed, an autonomous entity existing independently of things. Man constructs a geometry, Euclidean or non-Euclidean, and decides to view space in those terms.[19] Although the space of physical experience lends itself to measurements of length or distance, the concept of length or distance is foreign to the amorphous continuous manifold and has to be put in, or 'impressed', from without. 'Length' and 'distance', as we have seen, are operational concepts which find their mathematical counterpart through epistemic correlations.[20]

The twentieth century saw a metamorphosis of thought in many domains and twentieth-century mathematical ideas have played a distinct part in the ultimate rejection of perspectival representation. Duchamp, for one, has openly acknowledged the influence of non-Euclidean geometries on his work, particularly in the *3 Standard Stoppages* which represents his attempt, under the influence of Riemannian geometry, to change the picture of the straight line.[21] Riemann claimed that the geometry of physical space depends on the physical meaning we attach to the concept of the straight line. If a straight line is taken to be a stretched string, Euclidean geometry applies very well, but Riemann showed that this may not always be the case. Since Riemann's geometry is based on curved and not on plane surfaces, the shortest distance between two points is not a straight line but a curve, and parallel lines do not exist. Impressed by this, Duchamp set out to invent 'a new style yardstick' in *3 Standard Stoppages*, by dropping stretched strings of one metre in length three times from a height of one metre. The strings are shown in the positions in which they landed, from which three yardsticks have been constructed out of wood and placed to the right of the strings.

Mathematicians in the twentieth century are not the only ones to have found no fixed or absolute interpretations of physical space; similar conclusions have been reached by cognitive psychologists and by anthropologists. They too claim that our experience of space (and time) are not uniform but depend on the cognitive organization of the perceiving organism. People not only have different 'programmes' for interpreting reality, but they inhabit different sensory worlds. In the opinion of Benjamin Whorf, for instance, universally shared, *a priori* categories of space and time do not exist but are created and imposed on the universe and transmitted by a particular culture's view of reality. Human perception is culturally in-

159

fluenced, and different people organize the world differently in different cultural settings. Whorf in particular considers that our spatial concepts derive from culture and from language, so that experience as it is perceived through one set of culturally patterned screens is quite different from experience perceived through another.[22]

Piaget, of course, also rejects any a priorist position which asserts that space (or time or causality) is a category of mind with a permanent and necessary structure, and proposes instead that our way of representing the world is regulated by cognitive processes of different degrees of development. In his view, as we have seen, our spatial notions do not derive directly from perception but imply a logical construction and stages of formation.

On the whole, Piaget's view contrasts sharply with current opinion, according to which spatial notions – particularly the constants of Euclidean metrics (conservation of dimensions, distances and systems of coordinates) – are a direct extension of perception, as if the representation of space (or 'geometric intuition') were no more than a mere 'cognition' of perceptual data. (It is from this vantage point that most of the problematic philosophical discussions about perspective have been conducted.) As we have seen, however, the 'intuition' of space is not a 'reading' or apprehension of the properties of objects, but is from the very beginning an action performed on them. The physical order found in the object is not a directly abstracted quality, but is reproduced in a step-by-step process of increasingly co-ordinated actions, so that a whole series of 'virtual relationships' will be brought into play which go beyond the data recorded by pure sense-perception. It is completely wrong, according to Piaget, to reduce spatial intuition to pure perception, or to a system of images, since intuition is incapable of dealing with even simple transformations, unless it has been stabilized and reinforced by operational thinking.

Representation is richer in content than perception precisely because it incorporates knowledge of the object's possible transformations. The ability to represent an object transcends its perception since its image is not a simple copy but comprises an element of mental reconstitution:

> What lies between the perception of a solid and the image of its plane rotation is an action, a motor response to perception. . . . The image is a pictorial anticipation of an action not yet performed, a reaching forward from what is presently perceived to what may be, but is not yet perceived.[23]

Representation, then, presumes internal mental activity over and above perception: it involves the anticipation of actions such as the unfolding and rotating of surfaces, the traversing of lines, bringing parts into relation with one another, etc. To perceive a structure is not enough to be able to copy it or imitate it in a drawing. The image merely provides a schema of action for the manipulation of objects (classifying, combining, putting into correspondence) and *until these actions are embodied in operations, they will remain relatively uncoordinated.*[24]

During the Renaissance, a formal logic emerges which can arrange all spatial figures in objective coordinate systems. Art is still iconic, however, being confined to concrete situations and perceived relations. It is not given to abstraction. Perspective is a 'logic of concrete objects', a closed logical system that is repeated over and over again, so that every picture is rigidly bound and dictated by the rules of the system.

42 PIERO DELLA FRANCESCA *Perspective View of an Ideal Town*

43 GENTILE BELLINI *Corpus Christi Procession in Piazza S. Marco,* 1496

Leonardo da Vinci *Study for Flight of Steps and Horses*

Jacopo Bellini *Jesus before Pilate*

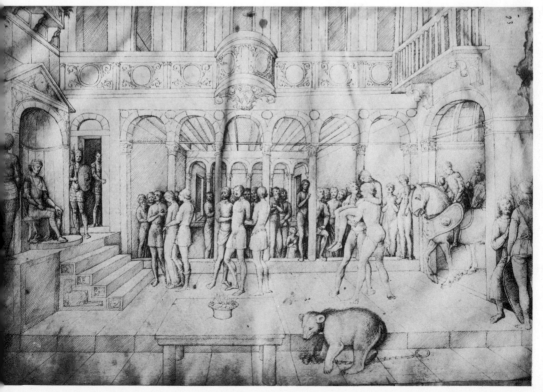

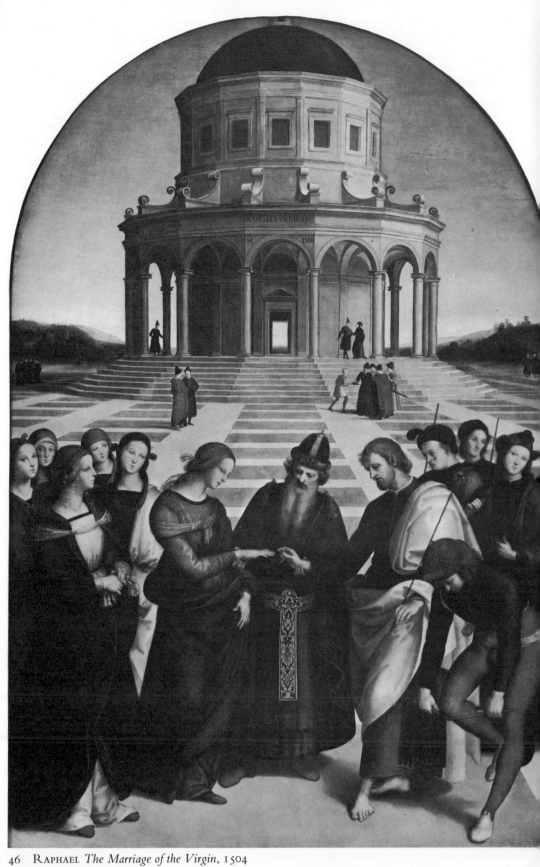

46　Raphael *The Marriage of the Virgin*, 1504

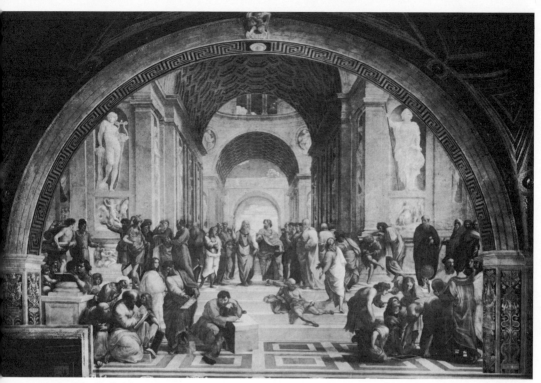

Raphael *School of Athens*, 1510–11

Pietro Perugino *The Delivery of the Keys*, 1482

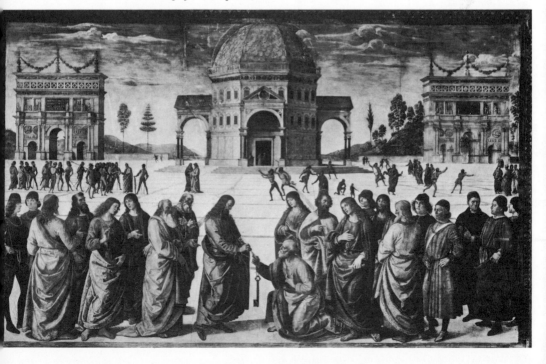

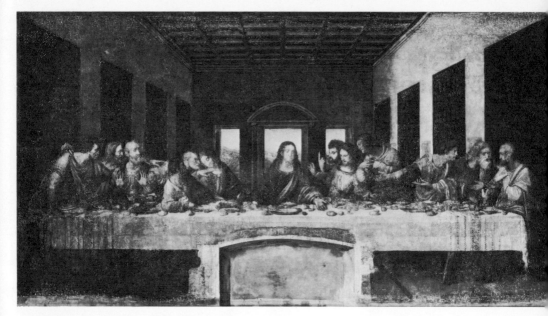

49 LEONARDO DA VINCI *The Last Supper, c.* 1497

50 FRA FILIPPO LIPPI *The Banquet of Herod*

51 PIERO DELLA FRANCESCA *The Flagellation of Christ*, 1456–7

52 GIOVANNI BELLINI *Sacred Allegory: The Virgin and Saints*

The Modern Period

We have seen that our criteria of truth and reality are, to a large extent, examples of 'modal logic': they change with cognitive growth. They also change with the progress of science, and every culture has its own norms which enter into the perception of reality. Developments in both science and art can always be linked to a certain conception of the world, to a homogeneous complex of ideas which dominates and influences beliefs about the structure of nature in any period. In this sense, both science and art are multiple expressions of a single cognitive orientation.

In the past, fuzzy and metaphysical postulates like the 'spirit of the age' were invoked to explain this organic unity which would seem to be discernible in all aspects of a culture. 'Spirit of the age' is a sweeping notion which basically derives from Hegel, and which Gombrich, for one, sternly resists. 'It is this belief in the existence of an independent supra-individual collective spirit which seems to have blocked the emergence of a true cultural history,'[1] he has written. Forever on the prowl against historians who try to explain the convergence of independent works or ideas by some invisible force at work in history (which would make the artist the mere instrument of such a force), Gombrich dismisses the notion of the 'spirit of the age' in much the same way as Freud dismissed many of Jung's ideas as humbug. 'As long as we have no better hypothesis to offer, the existence of uniform modes of representing the world must invite the facile explanation that such a unity must be due to some supraindividual spirit, the "spirit of the age" or the "spirit of the race".'[2]

The somewhat retrograde notion of 'spirit of the age' has been taken up recently in a new form by the French structuralist Michel Foucault, who provides it with the new and more fashionable name of *episteme* in his book, *The Order of Things*. The *episteme*, as conceived by Foucault, is 'an epistemological space specific to a particular period', a unifying ground of common presuppositions which connects widely differing theories and concepts – but which has never been consciously formulated. It is a 'positive unconscious of knowledge' that is common to all forms of mental activity in a period.[3]

In his search for unconscious forms common to all mental activity in a period, Foucault seeks to provide a contour of structuralist rationality to history. He thinks of cultures atomistically, each as a self-contained or closed system governed by a set of underlying, unconscious rules. What he

offers is, in a sense, a typology of world-views. Piaget has already pointed out, however, the weakness in Foucault's structuralism. The sequence of his *epistemes* is incomprehensible, in that they follow upon, but not from, one another.[4] One *episteme* has no affiliation with another, either genetically or historically; indeed, according to Foucault, historical periods appear and disappear fortuitously, and he shows no concern for the transition between them. He fails to tell us either how a change in *episteme* occurs, or under what conditions we may speak of a new one.

The view being put forward here is that cognitive-structural transformations in the ongoing transactional relationship between man and the environment are what give rise to cultural transformations in our mode of conceptualizing reality. Stylistic changes in art do not reflect a mere jumble of divergent impulses across time. They are part of an integrative pattern of development which reflects the fundamental character of cognitive systems and the historical development of conceptual frameworks.

Classical art, for instance, accepted ideas concerning space and time which derived directly or indirectly from Euclidean geometry and from Aristotelian and (later) from Newtonian physics. From a Piagetian point of view, the absolutism of Newtonian space and time remains 'egocentric' when compared with Einstein's relativity, because it envisages only one perspective on the universe among many other perspectives which are equally possible and real. To recognize the existence of a plurality of perspectives, as one does in relativity, is to be already in some sense beyond all of them. The transcendence of the self over the here and now – the capability of conceiving other points of view – is, as we have seen, one of the primary characteristics of formal-operational thought.

Modern theoretical physics has given up the notion of an ultimate reality – of finding 'a thing in itself' (Heisenberg). Relativity is the understanding of the world not as concrete events but as abstract relations. The tendency of modern physics to view things in terms of the total relativity of all points of view appears simultaneously in the art of the Cubists, who acted intuitively on the realization that an object is never seen from one perspective only but that there are many spatial frames and points of view which can be applied to it – all of which are equally valid. With Cubism, there are no more fixed points or isolated moments of perception. By depicting objects in terms of the spectator's mobility and change of relative position (rather than his fixity), the Cubists destroyed Euclidean space as a pictorial reality. For, once binocular vision is discounted, there fades with it the illusive stability of Euclidean space.[5] The Cubists found perspective too mechanical; one of Cubism's major spokesmen, the poet Apollinaire, referred to it as 'miserable' and 'tricky', as 'that infallible device for making all things shrink'.[6] And in the words of Braque:

> The acute angles in the paintings I did at L'Estaque in 1908 were the result of a new conception of space. I said goodbye to the 'vanishing point'. And to avoid any projection towards infinity I interposed a series of

planes, set one on top of another, at a short distance from the spectator. It was to make him realize that objects did not retreat backwards into space but stood up close in front of one another. Cézanne had thought a lot about that. You have only to compare his landscapes with Corot's, for instance, to see that he had done away with distance and that after him infinity no longer exists. Instead of starting with the foreground I always began with the centre of the picture. Before long I even turned perspective inside out and turned the pyramid of forms upside down so that it came forward to meet the observer.[7]

Similarly, the 'all-over "decentralized", "polyphonic" picture' which, as described by Clement Greenberg, 'relies on a surface knit together of identical or closely similar elements which repeat themselves without marked variation from one edge of the picture to the other',[8] also reflects the tendency of modern painting to evolve in this direction. It is a kind of picture, according to Greenberg, that dispenses, apparently, with beginning, middle and end. Every element and every area of the picture is equivalent in accent or emphasis. The 'all-over' tendency, which first emerges in

151 Impressionist pictures like Bonnard's *The Garden* and particularly in Monet's *Water Lilies* (not illustrated), is pushed to its logical conclusion in the drip
152 paintings of Jackson Pollock and in the all-black paintings of Robert
153 Rauschenberg. Here, space has become an all-over extension in which all points are of equal status and there is no dominance of volume over void.

The discovery of non-Euclidean geometries, Einstein's special theory of relativity (1905), Minkowski's formulation of the space–time continuum (1908), Niels Bohr's model for the hydrogen atom (1913), all dealt a series of mortal blows to the system of ideas concerning the nature of matter, space and time that had been axiomatic until then. And although these scientific ideas virtually coincided with the Cubists' rejection of Euclidean space as the only true pictorial space, no connection can be traced between their emergence and what happened in painting. To the contrary, it has been more or less established that popularizations of the new theories did not come into existence for quite some time, and the Cubists had little or no knowledge of them. What explanation is there, then, for this peculiar convergence of objective events? Can we claim any connection between them merely because they happen to occur together? What would account for the fact that diverse aspects of a culture, which are totally disparate in nature, seem nevertheless to advance with a sort of pre-ordained harmony?

Jung asserts that coincidence is meaningful, that it has psychological foundations and is due to something more than mere chance: 'Synchronicity is a phenomenon that seems to be primarily connected with psychic conditions, that is to say, with processes in the unconscious,'[9] he says. I would claim even further that such parallel developments in two completely different fields of culture allow one to suspect the existence of a general principle which has operated on the entire evolution of culture: this concerns the unfolding of 'laws of development' within the cognitive processes.

Straddling, as they do, an art of representation and appearance on the one hand, and a more formal, conceptual art on the other, the Cubists' 'planes in relation' help us to shuttle across the dividing line which, like a frontier, separates art's 'outside' from its 'inside', its outer image from its innermost essential condition. Cubism's formidable achievement was to have opened up the way for painting and sculpture to pursue their own intrinsic concerns.

By renouncing the descriptive value of line and its necessity to define the contours of objects, by freeing colour from the requirements of naturalistic description, Cubism opened the way for an autonomous art of pure relationships. From this point in the twentieth century, a new *episteme*, or paradigm, emerges which is far broader in the open-endedness of its 'combinatorial' possibilities than is Euclidean perspective. (In Cubism, it is the combination of elements, and not the elements themselves, which provides the significant data.)

The Modern paradigm begins with a number of independent movements throughout the world towards abstraction – movements whose styles resembled but did not necessarily derive from each other. Simultaneously they announced that representational art was over and done with. It was suddenly assumed that representations of nature could be learned by any artist who was in good health and not colour-blind. 'In every art I can think of,' Ezra Pound wrote in 1912, 'we are dammed and clogged by the mimetic.'[10]

The dream of breaking with representation was succeeded by a dream of a very different lure, that of an art which explored new visions of time, space, logic and chance, and which could construct forms from nothing.

In Holland, a group formed under the name of De Stijl (1917–31), towered over by the figures of Mondrian and Theo Van Doesburg. For these artists, the straight line, the plane and the angle became the dominant source of art. It was out of such frugal resources that the paradigm of modernism was born. Mondrian was the real link between Cubism and Neoplasticism; his first strictly post-Cubist compositions, consisting almost exclusively of broken horizontal and vertical lines, appeared in 1914. Eventually, he reduced his vocabulary of form to the straight line and the 61
right angle, and restricted his colour to the three primary colours, red, yellow and blue, and the three primary non-colours, black, grey and white. (Later, Jackson Pollock took the autonomy of line a step further, synthesizing drawing and painting in his drip technique. Whereas line had traditionally indicated the edge of a plane or surface – and was used as outline – Pollock's continuous and unbroken line did not describe even abstract forms.) For Mondrian, however, the primordial relation, which contained all other relations, was the right angle, and when, in 1925, he saw Van Doesburg's compositions which included diagonals, he denounced them as 67
personal and subjective and left the movement.

The De Stijl development in Holland paralleled the Bauhaus movement (1919–33) in Germany, and the Suprematists (1915–19) and the Constructivists (1913–22) in Russia. In 1915 Malevich showed his first abstract 82, 86

canvases in St Petersburg, including the famous black square painted on a white canvas. According to Malevich, 1914 was 'the year when the square appeared'. Never to be found in nature, it was the basic Suprematist element. The white plane became the expression of infinite space. In the same year, Rodchenko produced non-objective drawings constructed with compasses and rulers; and in 1920, El Lissitzky (who joined the De Stijl group in 1922) invented his non-objective 'Proun' style.

Kandinsky painted his first non-objective pictures in 1910, and during 1923–6, he painted the circle almost exclusively and lectured on it for a year at the Bauhaus. 'I love the circle today as I once, for example, loved the horse,' he wrote. 'It has more inherent possibilities.'[11] A triangle, on the other hand, also had 'its particular spiritual perfume', and 'the impact of the acute angle of a triangle on a circle produces an effect no less powerful than the finger of God touching the finger of Adam in Michelangelo'.[12]

In 1912 Robert Delaunay, and before him Kupka, had arrived at an autonomous art of pure prismatic colour in a series of paintings called *Simultaneous Discs*. 1913 even saw Léger experimenting with pure abstract volumes, and in the same year Tatlin made his first hanging geometric 'reliefs' in Moscow, using materials like tin, wood and glass, for which he coined the term 'Constructivism'. The Russian Constructivists, particularly Tatlin and Naum Gabo, were the first to apply engineering techniques to the creation of sculpture and to endow modern industrial materials with aesthetic value.

Léger, Mondrian, Duchamp and Delaunay were all, at one point (just preceding the outbreak of the First World War), peripherally attached to the Cubist movement. In 1916 Arp, together with his wife, Sophie Taeuber, was arranging rectangles according to the laws of chance, tearing up papers and letting them fall to the floor, as a way of avoiding traditional means of composition and disregarding everything that could be considered imitation or description, in order to let the elemental and spontaneous have free reign. The Constructivist movement soon became international, and in 1922 a link was formed with the Dadaists under the auspices of a congress held in Weimar. Just as Arp became the connection between Non-objectivism and Surrealism, Schwitters served as the link between the Dadaists and Constructivists. Schwitters believed that an artist should be allowed to make a picture out of nothing but blotting paper if he wanted to; however, his *Merz* collages adopted many of the formal, geometrical features of Bauhaus composition.

All these converging trends have since crystallized into a single broad cultural climate. The principles of balance, harmony, order and regularity, which derive from the Renaissance, are retained, but they now function autonomously as abstract relational structures. Something new has been incorporated, however: the notion that art should be detached from all material needs and from any useful purpose. It was a notion, first put forward by Malevich, that became a fulcrum for change, and it set in motion a process which has led, ultimately, to the increased autonomy of art.

The marginal reference numbers appearing in the left margin: 89; 73, 79; 100, 116; 2; 125; 77; 76, 87

Since prototypes of the Constructivist image can be traced all the way back to archaic art, the question that will certainly arise at this point is: in what way do concentric rings decorating an ancient Cyprian or Egyptian vase differ from, say, a Jasper Johns target, a target painting by Kenneth Noland or a drawing by Eva Hesse? Since the same abstract vocabulary of circles, squares, checkerboards, stripes and chevrons also exists in the patterns of Oriental carpets, in geometrical mosaics on the floors of Roman baths and early Christian churches, in Islamic lattices and tiles, in stone and wood architectural carvings, in woven textiles, and so on, how can we justifiably speak of its modern manifestations as being in any way 'progress' in art? 122, 118 121, 126 123

To answer this we must push back our inquiry one step further. All ideas are but the reflection, in intellect and consciousness, of social actions. Although such imagery is undeniably abstract, it differs from modern abstract art in being applied as decoration to *objects of use*, whose purpose is always over and beyond the purely aesthetic. What is both unique and exceptional in modern art is that the aesthetic impulse emerges to consciousness *as a thing on its own*; prior to the twentieth century, it seldom if ever stood alone but was always bound to magical, religious or utilitarian functions. Nowhere do we find the construction of pure forms, or of arrangements which are independent of content, within the history of art until after Cubism. Nowhere do we find an art based on pure propositional thought, *which is entirely abstract in intention*. Twentieth-century culture, for the first time in history, produces artifacts which are relatively free constructions, made for purposes other than their concrete use: modern art is *art about art*, and about the intellectual activities of man. An art of conceptual and deductive logic, it is distinct from craft and from the integrated structure of society.

The difference, then, between a group of concentric rings painted on a jug and a Noland target is that of an art form which has been detached from practical use. Contemporary abstraction, as distinct from abstract pattern-making in the art of the past, is to be taken, not as decoration added to some functional object, but as *a mode of thinking*. 'Art no longer cares to serve the state and religion,' Malevich wrote. 'It no longer wishes to illustrate the history of manners, it wants to have nothing further to do with the object as such, and believes that it can exist, in and for itself, without things.'[13] Twentieth-century non-objective art is a definite break-away from concrete objects and images towards the construction of formal logical systems which are autonomous, and function independently of content. They are the pure expression of the artist's mental operations.

My thesis has been that the emergence of a fully developed system of formal-operational thought has brought about the autonomy we now find in artistic processes, and has caused modes of representation to become detached from all concrete use. The move towards abstraction is a natural development of the cognitive process, as conceptual modes come to dominate and then to transcend those of perception. Contemporary art seems

imbued with greater semantic mobility, in the sense of extending itself be-
yond objects to a series of possibilities, alternatives or speculative hypo-
theses; and in this, it reflects the onset of a new mode of thought. This new
mode of thought, whose primary characteristic, according to Piaget, is a
reversal in the direction of thinking between *reality* and *possibility*, is reflected
at all cultural levels. There is no longer one single, unquestioned repertory
of opinions, one undisputed tradition; there is instead a broad selection
among different ways of seeing, with the constant possibility of choice.
Art is no longer concerned with a set of descriptions of nature, or even of
man or society. It involves hypothetical constructions not referable to
direct observation (e.g. tracing an ideal perpendicular) or theoretical
propositions, used as generative means, which do not refer back to actual
objects or phenomena.

 A concern with hypothetical constructions has led to the study of
distortions, particularly deviations from geometric regularity, among a
number of modern artists. The exhilaration of distortion was initially
discovered by Malevich. We can observe with hindsight how a picture like
86 *Supremus No. 50*, one of a series in which Malevich experimented with
warped rectangles and squares, slightly varying the corner angles, is really
a 'prime object', in Kubler's sense of acting as a point of departure for new
possibilities, and of setting off the chain of events which followed it.[14]
Numerous other examples could be cited, among them Jan Dibbets's
94 *Perspective Correction* of 1969, in which a trapezoid has been drawn on the
wall and then photographed at an angle that makes it look like a square.
Dibbets's forms and angles strain geometrical probabilities: parallel lines
remain parallel, instead of converging. As the ambiguities increase, so do
the perplexities for the observer, for whom the square could *either* have
been drawn on the wall *or* have been added afterwards to the photograph.
Other artists who have explored deviations from geometric regularity are
90, 91, 93 Ellsworth Kelly, Richard Serra and Robert Mangold. Mangold takes the
central set of Euclidean symbols, the circle and the square, and pictures them,
not as compact entities following distinct laws, but as incomplete shapes
114 falling out of alignment. His circles and squares simply do not stay in place.
Sometimes using his arm for a compass, Mangold reiterates the analogy
between geometry and anatomy originally elaborated by Vitruvius who
claimed that all proportion derives from the human body and that the
perfect human figure could be contained within a circle and a square.
112 Leonardo took that proposition a step further and claimed that, if the
navel is made the centre of a circle, the outspread limbs will touch its
circumference, and the space between the legs will form an equilateral
triangle. Mangold alters the configurations of our world by a slight and
111, 115 mysterious slippage, a cunning lapse of the rule. The artists Barry Le Va
and Sol LeWitt have both worked with geometry in drawings, plotting
arcs and intersecting the circumferences of circles in various patterns
from a set of instructions, or reinterpreting certain mathematical notions
to do with points, lines and planes.

In *Untitled* (1973), one of two plywood works that are concerned with 92
perspective and the changing view as the observer moves past, Don Judd is
also involved with spatial ambiguity and distortion. The first work (not
illustrated) consists of seven four-sided, open-faced rectangular boxes,
constructed so that they are congruent with the planes of both wall and
floor and conform to the right angles of the room. The second consists of
seven rhombi whose angles deliberately subvert the perspectival view.
Judd's methodological doubt takes nothing for granted. The contrast
between what is and what appears to be is essential to his doubt. Doubt is
tied to possibility since, in order to doubt, we must be able to conceive of
the possibility that something may be different from the way in which it
presents itself to us.

In many ways, the propositional logic which distinguishes formal-
operational thought is a safer and less controversial ground for linking
many modern styles together than others that might come to mind. Its
distinguishing characteristic lies in its power to conceive of the possible, to
consider hypothetically relevant variables, to operate on sets of proposi-
tions and to invoke complex combinatorial rules. Activities such as these
characterize the work of many contemporary artists, for example, Mel
Bochner, Dorothea Rockburne, Barry Le Va and Sol LeWitt, all of whom
are concerned with finding structural and organizational principles based
on a set of logical operations for generating works that will replace tradi-
tional modes of composition.

'The artist who wants to develop art beyond its painting possibilities is
forced to theory and logic,'[15] Malevich wrote prophetically, and indeed the
nonrepresentational tendency of modern art has brought about a progres-
sive 'objectification' in modes of composing, so that many artists now order
elements according to a structure which is predetermined. Josef Albers 135
established a lifetime's work within the proscribed format of three con-
centric squares; these are transformed through variations in colour,
creating an illusory oscillation between surface and depth. Frank Stella,
in his early stripe pictures, devised a method of deductive structure where 105, 136
the placing of stripes was dictated by the enclosing shape of the canvas;
and Kenneth Noland, in his target pictures, uses centrality and symmetry 126
as an organizing principle. Here, the concentric circles result in a 'self-
cancelling structure': the formula is repeated from picture to picture, as
with Albers, with variations in the intervals between the rings and their
colours.

'The main virtue of geometric shapes', Don Judd has written, 'is that
they aren't organic as all art otherwise is. A form that's neither geometric
or organic would be a great discovery.'[16] In a series of drawings exhibited
in New York in 1972, Mel Bochner sets himself the task of inventing a
series of shapes which will be neither subjective and idiosyncratic in the 84, 85
way, say, that Arp's free forms are, nor based on some form of deductive 83
structure like Stella's stripes. Bochner's shapes result from the application 105
of a rigorous governing logic, and the precise placement of edges and points.

Starting with an initial pentagon, which he chose because it is the first shape not on the horizontal-vertical grid (like squares and rectangles), he then combines it with triangles and squares to form eight- and nine-sided shapes which are neither geometric nor organic.

65 Dorothea Rockburne's 'Drawings which make themselves' are also generated from a system of rules or procedures used as an organizing principle. Here, too, we have an art based on logical operations rather than on privately invented shapes. The drawing illustrated is produced by transferring the information contained within the sheet of carbon paper – such as its folds and creases, which create both lines and edges – to the wall. This is done by systematically flipping over the sheet of carbon paper, which is double-sided, so that the crease lines may be transferred from either side, symmetrically reversing each other; Rockburne is working in a mode analogous to the use of set theory in mathematics. It is like a genuine algebra of logic where formulae are manipulated without regard to their meanings. Sol LeWitt, in his wall drawings, is similarly concerned with mapping out the interrelations between points and lines and with the structuring of such concepts as 'lies on', or 'between' or 'towards', in relation to the centrepoints on the wall. Both these artists work in a mode of 'reflective abstraction' which derives its knowledge not from objects but from actions and from the artist's operations.

141–6, The concept of structure is relevant to the multiple modular method used by Robert Smithson, Robert Morris, Dan Flavin, Carl Andre and
148 Don Judd. Modular works are composed by the arrangement of identical units, whether of bricks or metal tiles (Andre), neon (Flavin) or rolled steel cubes (Judd, Morris, LeWitt, Smithson), which form simple and regular systems. The elements are arranged in a characteristic pattern through which the units are experienced as belonging together. The form of the work is its underlying structural pattern, which is based on progression, sequence and regularity. In order for the work to exist as an art object, it must be assembled together and exhibit this constant pattern. Otherwise, the units are not significantly connected with each other. They must become constituents of the system by distribution and arrangement, and by their positional value in the system. 'What I try to find', Carl Andre has written, 'are sets of particles and the rules which combine them in the simplest way, that is, I look not for objects but for parts.'[17]

Whereas for the Renaissance the rectangle was first and foremost a transparent plane – an open window through which to view the world – for the contemporary artist it is primarily a syntactical unit, a morpheme to be used in the building of structures or systems. 'The most obvious unit, if not the paradigm, of forming up to this point is the cube or rectangular block,' writes Sol LeWitt. 'This, together with the right angle grid as method of distribution and placement, offers a kind of "morpheme" and "syntax" which are central to the cultural premise of forming.'[18] In this kind of work it is necessary to neglect the parts for the Gestalt and attend to the core of its complexity: its patterned organization. We can distinguish

systems in which patterns with parts are arranged in accordance with some principle: unitary forms are stacked, equally distributed and presented as an organized plurality oriented with respect to the others. A system, then, behaves not as a simple composite of independent elements, but coherently as an inseparable whole.

By contrast, other contemporary works abandon all internal organization, which is replaced by acts of scattering, spilling, piling or heaping executed entirely at random. In scatter pieces such as Robert Morris's *Untitled* 1968–9, Barry Le Va's *Studio Installation* 1967–8, Andre's *Spill* 1966, 155, 157, Nancy Graves's accumulation of fossil bones, 1970, the result is a disorderly 147, 154 accumulation of elements without any regularity in their distribution. The difference between these scatter works and those with a highly patterned organization corresponds to the difference in perceiving a column of soldiers or a heap of apples. A heap transforms itself into a system by virtue of the components entering into systematic interactive relationship with one another, whereas, in the case of a heap, taking away one part, or substituting another, makes little difference to the character of its wholeness.

Somewhere between the austere and precise patterning of modular works, and the entirely hazardous arrangements of 'spilled' or 'heaped' works, we find the idea of relationships in a state of flux. This has been the central concern of the Australian artist Michael McKinnon, whose rotating disc, shown here in two sequential phases, adds movement to geometry. Inside 80 the disc, a series of geometric elements is suspended in transparent oil. As the disc, a sealed envelope of transparent acrylic sheet, rotates with a slow, almost invisible movement, the elements shift and create constantly changing patterns. Stressing the transformational aspect of the process allows the artist to feel that he has not made any final assertion as to the best arrangement of the forms he has chosen; he offers instead an equivalence of possible solutions.

This radical shift in art from objects to process thinking reflects a parallel shift in science from surface appearance to underlying structure and pattern. Atomic physics also deals in featureless units, in which only relationships and patterns of relationships are perceived. Atoms are like bricks in a building; the individual pieces have lost their meaning – what matters is the structured or logical pattern, the information or organization. At the quantum level an object does not have any intrinsic properties which belong to itself alone; it shares all its properties mutually and indivisibly with the systems with which it interacts. In painting, Cubism initiated the dissolution of the form of objects and isolated both line and plane. More recently, artists like Morris and Serra have gone a step farther in isolating the properties of volume, mass and weight, being preoccupied with the action of gravity on matter: Morris in his felt pieces, and Serra in works where ele- 161 ments hang, lean and balance against each other in a precarious way. 71

Is the 'formal-operational' stage final, then, and does history end here? I do not think it does, even though the stage of formal operations is presented by Piaget as the final stage of cognitive development in the individual – in

the sense that it is not modified further, although it may be integrated further into larger systems, or what Piaget has called 'polyvalent logics'.[19] Art does not have a static identity; its structure, which propels itself towards continuous transformations, contains, like language, its own inner principle of proliferation. Beyond this, we cannot provide a blueprint for the future; but since art now extends beyond objects to a series of conceptual possibilities, alternatives or speculative hypotheses, it would seem, at this point in time, to be infinitely extensible – just as on the evolutionary scale progress takes the form of an ever-increasing diversity and complexity. Since reflective abstraction is potentially an infinite process, there is no need to fear the end of art. Propelled by a tireless survey of possibilities, the contemporary artist rotates each syntactic permutation before the mind with the great calm of computation. Development does not end as a result of achieving structural integration: it is in the nature of open systems that integration and reintegration continue to occur as long as the system exists. A self-organizing system continues to undergo modification as long as its interaction with the environment is maintained.

THIRD STAGE

Higher order abstractions emerge together with a 'logic of propositions'. There is an increase in the autonomy of forms to the point where even abstract forms devoid of content can be constructed and manipulated. Art becomes syntactic in character, operating on sets of pure relations. The square, circle, cube, rectangle and triangle form a natural grammatical unit, a 'kernel sentence' from which all combinations become possible.

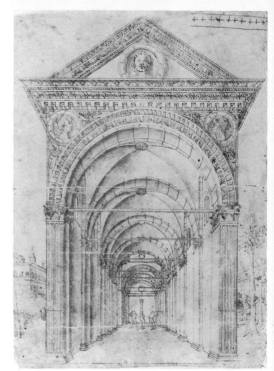

53 VINCENZO FOPPA *Tabernacle with Flagellation*

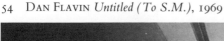

54 DAN FLAVIN *Untitled (To S.M.),* 1969

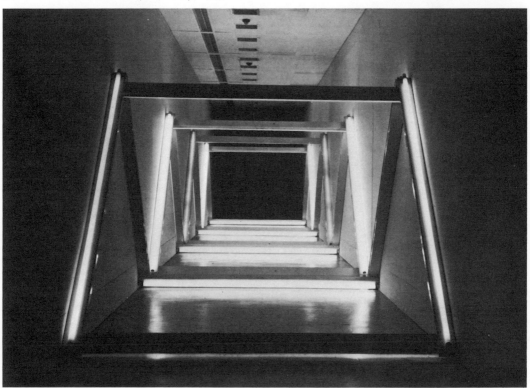

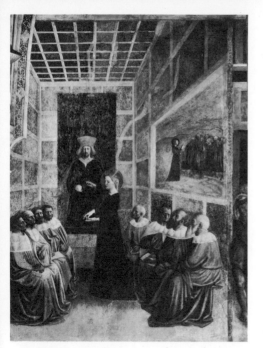

55 MASOLINO *The Dispute of St Catherine*

56 UCCELLO
Perspective Drawing for a Chalice

57 PIET MONDRIAN *Composition in Grey, 1919*

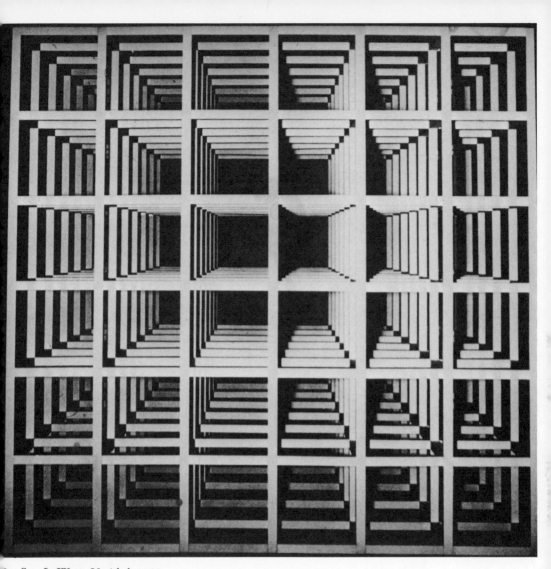

8 Sol LeWitt *Untitled*, 1966

59 ROBERT RYMAN
Classico V, 1968

60 JAMES BISHOP
Untitled, 1969

61 PIET MONDRIAN
Composition in Black and Red
(unfinished), 1938–44

62 ROBERT RYMAN
No. 2 of Five Parts,
1964

63 JASPER JOHNS *Disappearance II*, 1961

64 CARL ANDRE *Iron Piece*, 196

DOROTHEA ROCKBURNE *X's: Isomorphic Structure*
(part of series *Drawing which Makes Itself*), 1973

66 ROBERT MORRIS *Untitled*, 1966

67 THEO VAN DOESBURG *Simultaneous Counter Composition*, 1929–30

68 ELLSWORTH KELLY
2 Panels: Red Yellow, 1971

69 BRICE MARDEN
Untitled, 1974

70 LARRY BELL
Shadows, 1967

71 RICHARD SERRA
One Ton Prop
(House of Cards), 1969

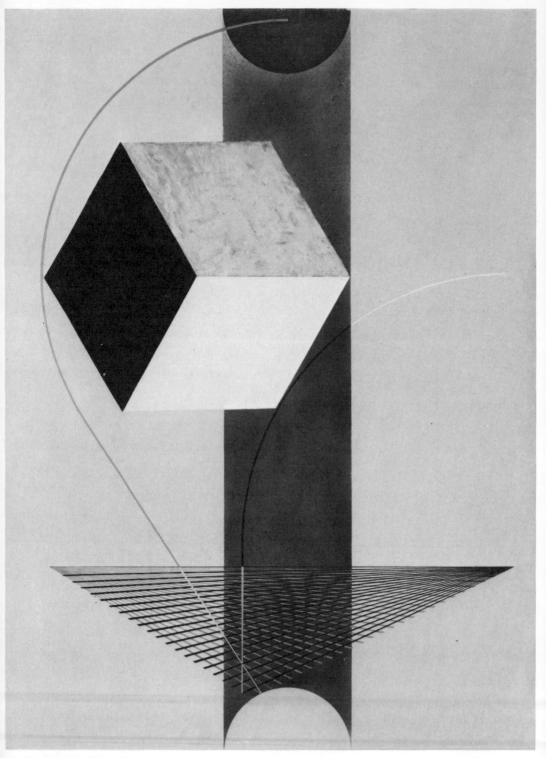

73 EL LISSITZKY *Proun 99*, 1941

74 ROBERT
RAUSCHENBERG
Renascence,
1962

75 ROBERT RYMAN
*Drawing with
Numbers,* 1963

76　KURT SCHWITTERS
Loose Rectangles, 1928

77　JEAN ARP *According
to the Laws of Chance, 1916*

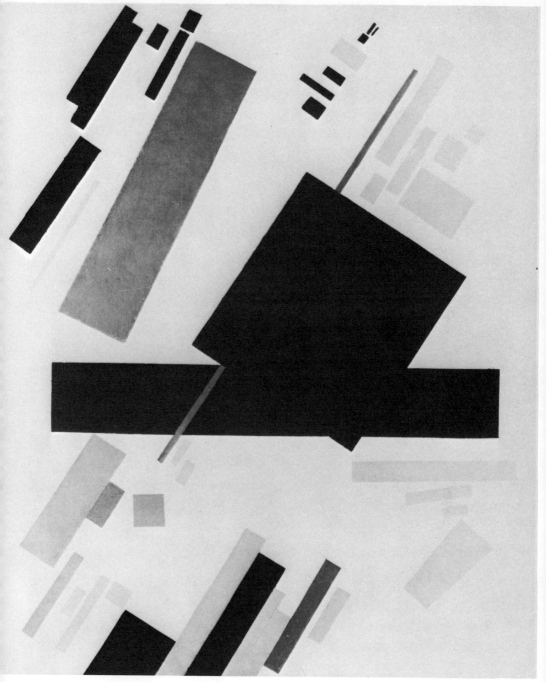

78 KASIMIR MALEVICH *Suprematist Painting*, 1916

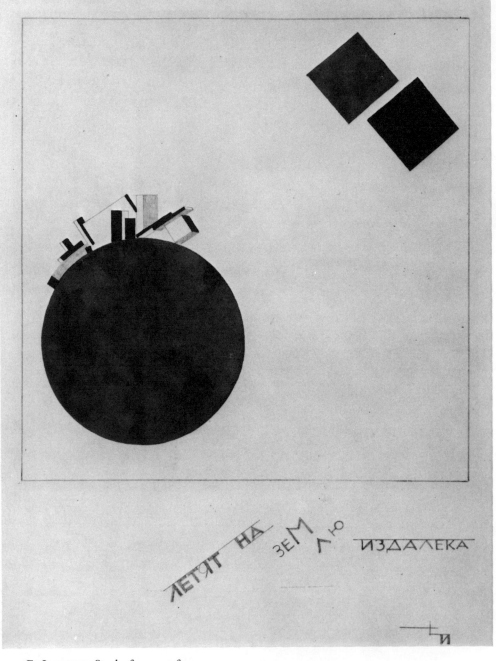

79 El Lissitzky Study for page from
A Suprematist Story — About Two Squares in Six Constructions, 1920

81 AL HELD *Mo-T-8*, 1971

80 MICHAEL MCKINNON Tumbledisc, 1968

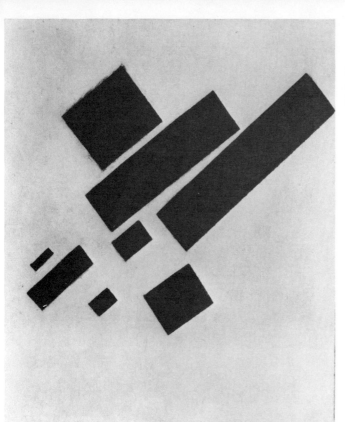

82 KASIMIR MALEVICH
*Suprematist Painting:
Eight Red Rectangles*, 1915

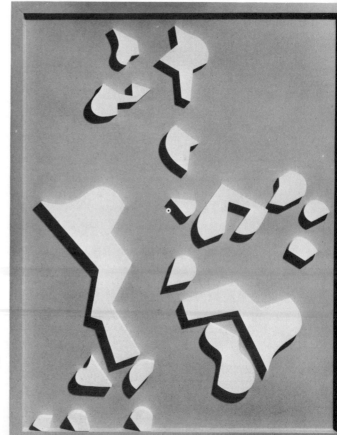

83 JEAN ARP *Tournoi*, 1949

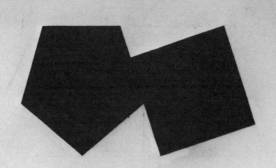

84 MEL BOCHNER *Five and Four*, 1973
85 MEL BOCHNER *Three Times Four*, 1973

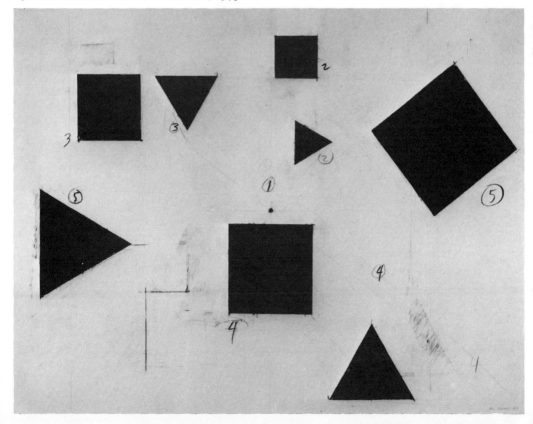

86 KASIMIR MALEVICH *Supremus No. 50, 1915*

87 KURT SCHWITTERS
Mz 600 Moholy, 1922

88 BEN NICHOLSON
Silver Relief, 1968

89 ALEXANDER
RODCHENKO,
Composition, 1919

90 ELLSWORTH KELLY
Black White, 196

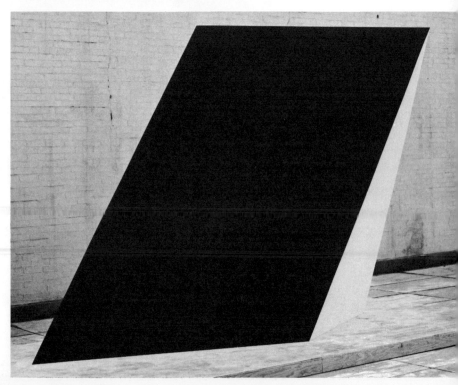

RICHARD SERRA *Untitled*, 4 Drawings, 1972

DONALD JUDD *Untitled*, 1973

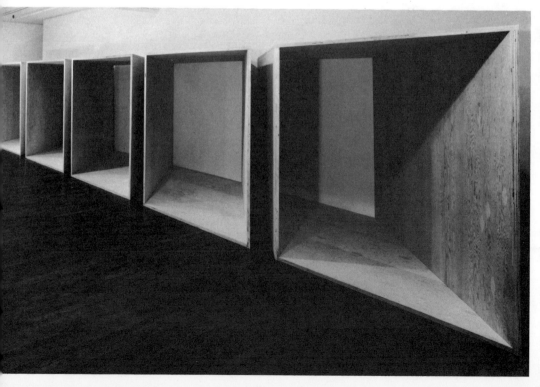

96 SOPHIE TAEUBER-ARP *Schematic Composition*, 1933

97 AGNES MARTIN *Starlight*, 196.

MEL BOCHNER *Meditation on the Theorem of Pythagoras*, 1972

99 MEL BOCHNER *Meditation on the Theorem of Pythagoras*, 1972

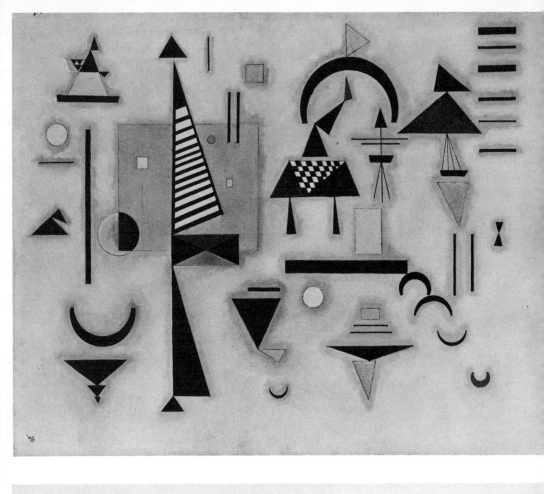

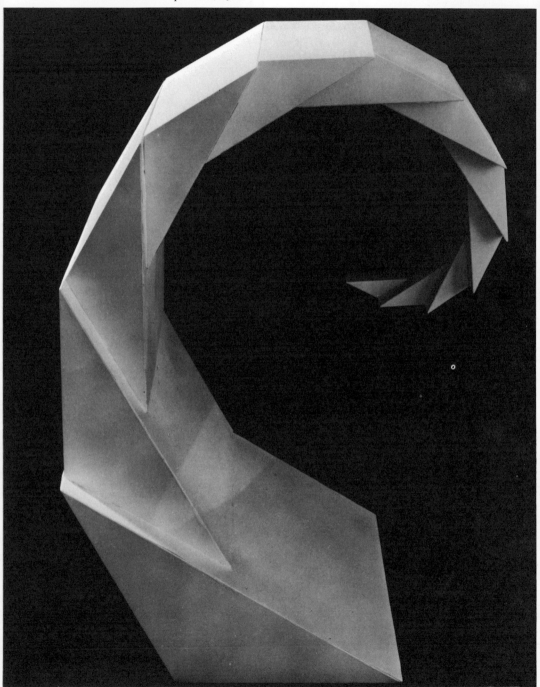

103 THEO VAN DOESBURG *Composition*, 1924–5

104 ROBERT MORRIS *Untitled*, 1965–7

105 FRANK STELLA *Quathlamba*, 1964

106 KENNETH NOLAND *Embrown*, 1964>

107 BARNETT NEWMAN *Jericho*, 1969>

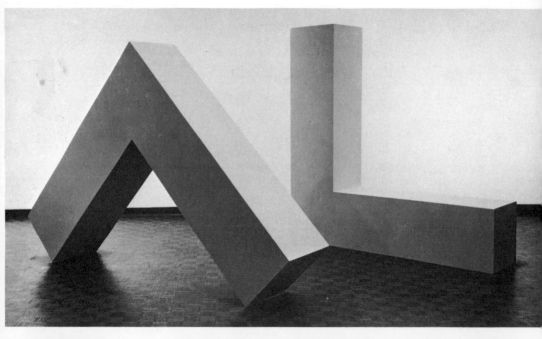

108 Leonardo da Vinci *A War Machine*

109 Kasimir Malevich *Suprematist Elements:
Two Squares*, 1913; (right) *Suprematist Element: Circle*, 1913

110 ROBERT MANGOLD $\frac{1}{2}$ X Series, 1968

111 BARRY LE VA Intersecting Circles Series, 1970

112 Leonardo da Vinci *Vetruvian Man,*
c. 1490

113 Mel Bochner
*Circle Measurement
(By Formula),* 1969

114 Robert Mangold
*Incomplete Circle No. 1,
Yellow Square,* 1972

5　Barry Le Va, *Untitled*, 1973

6　Wassily Kandinsky *Geometric Forms*, 1928

117　Mel Bochner
*Theory of Sculpture
No. 6*, 1972

118 Egyptian Vase, pre-Dynastic
(c. 4,000 BC or earlier)

119 Robert Smithson *Sod Spiral*, 1970

120 Richard Long *Untitled*, 1973–4

122 Ancient Cyprian Terracotta
Vase, painted in red

1 JASPER JOHNS *Broken Target*, 1958

3 EVA HESSE *Untitled*, 1966

124 Section of a screen or altar,
Tuscan, early 13th century

125 ROBERT DELAUNAY *Disc*, 1912

126 KENNETH NOLAND *Rocker*, 1958

127 ROBERT MORRIS *Labyrinth*, 1973

128 FRANK STELLA *Sinjerli Variation II*, 1968

129 Donald Judd
Untitled, 1971

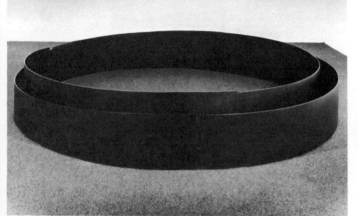

130 Jules Olitski *Redemption Secret*, 1973

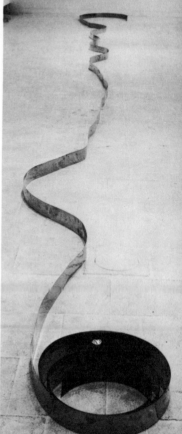

131 Carl Andre
Copper Piece, 1969

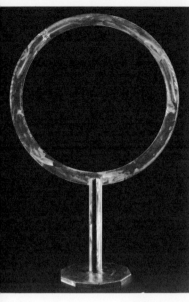

132 DAVID SMITH
Untitled, 1962–3

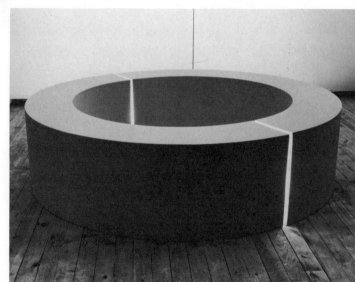

133 ROBERT MORRIS
Untitled, 1965

134 RICHARD SERRA
Untitled, 1970

135 JOSEF ALBERS
*Homage to the Square:
Silent Hall*, 1961

136 FRANK STELLA
Cato Manor, 1962

137 WASSILY KANDINSKY
Square, 1927

138 MEL BOCHNER *Isomorph Negative*, 1967

139 CARL ANDRE *Plain*, 1969

140 ANDREA DEL CASTAGNO *The Last Supper*

141 DAN FLAVIN *An Artificial Barrier of Green Fluorescent Light (To Trudie and Enno Develing)*, 1968–9

142 DONALD JUDD *Untitled*, 1968

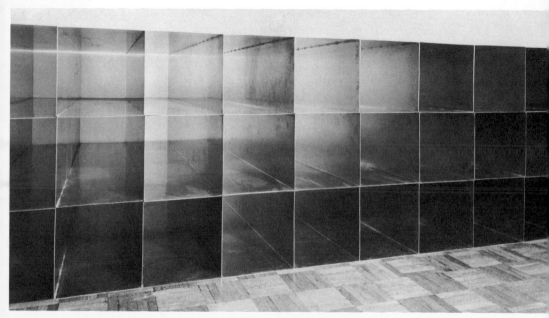

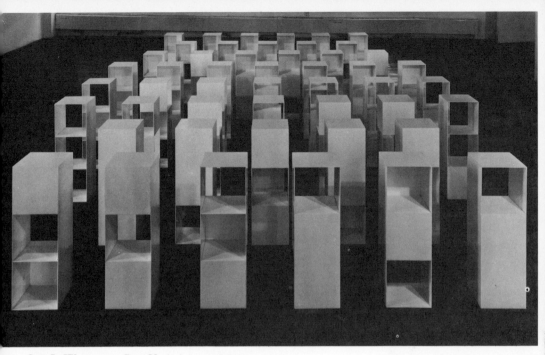

43　Sol LeWitt *49 3-Part Variations*, 1967–70

44　Robert Morris *Untitled*, 1967

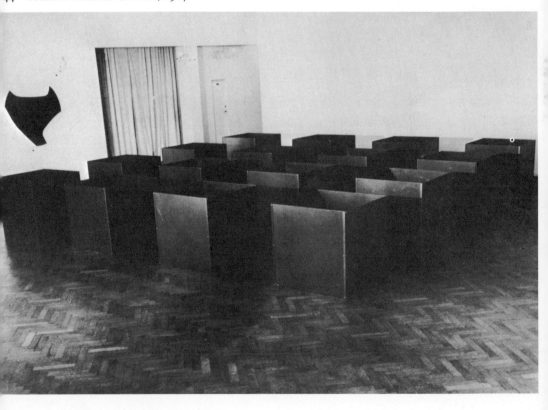

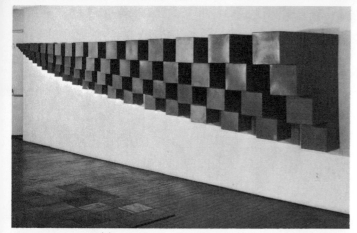

145 ROBERT SMITHSON
Alagon No. 3, 1967

146 ROBERT MORRIS
Untitled, 1969

149 RICHARD SERR
Casting, 196

150 EVA HESSE *Are*
(detail), 196

147 CARL ANDRE *Spill* (Scatter Piece), 1966

148 DONALD JUDD *Untitled*, 1970

151 PIERRE BONNARD
The Garden, 1935

152 JACKSON POLLOCK,
Mural on Red Ground,
1950

153 ROBERT RAUSCHENBERG
Black Painting, 1952

154 NANCY GRAVES
Fossils, 1970

155 ROBERT MORRIS *Untitled*, 1968–9

156 ROBERT MORRIS *Untitled*, 1969

57 BARRY LE VA *Studio Installation*, 1967–8

58 RICHARD SERRA *Untitled*, 1969

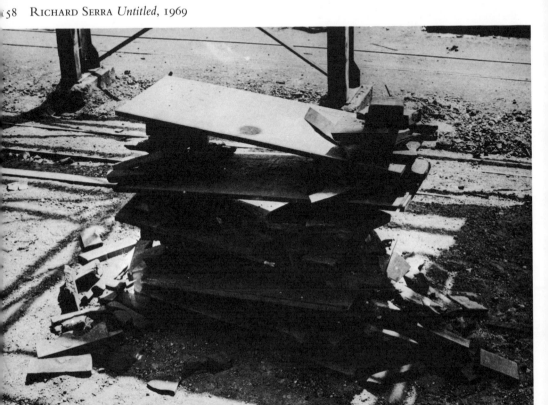

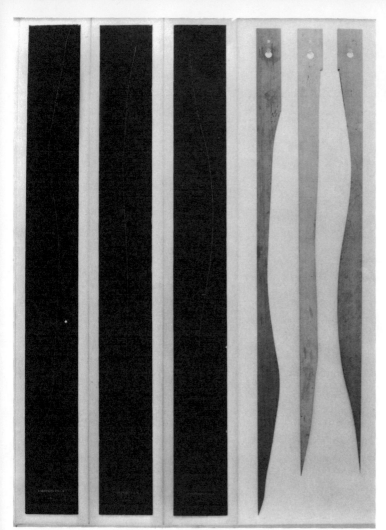

159 MARCEL DUCHAMP
3 Standard Stoppages,
1913–14

160 SOL LEWITT
10,000 Lines 3″ Long, 1972

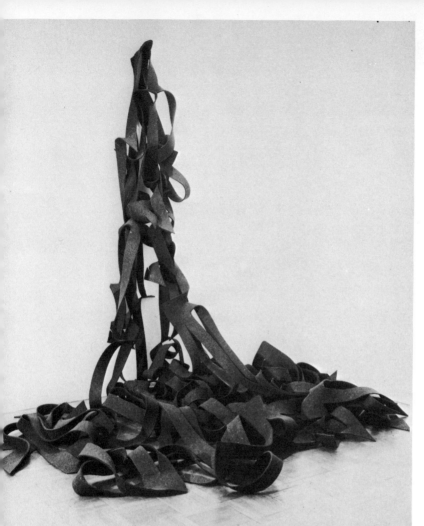

161 ROBERT MORRIS
Untitled, 1967–8

162 CY TWOMBLY
Untitled, 1970

Part III: Art, Knowledge and Science

If we really want to understand the origin of
signification – and, unless we do, we shall not
understand any other creation or any other
culture, for we shall fall back upon the
supposition of an intelligible world in which
everything is signified in advance – we
must give up every signification that is already
institutionalized and return to the starting
point of a non-signifying world.

MAURICE MERLEAU-PONTY

We end up with the supposition that it is the
task of art not simply to depict the world but
to constitute it.

BENJAMIN NELSON

Chapter Nine

Internal v. External Histories of Art

In this final section, I shall examine other attempts to construct theories of art history, and the answers which certain historians, especially Gombrich and Wölfflin, have given to the problem of why art changes and how new styles are generated. Animated debates have been held over the past century among art historians over the question of whether internal or external factors are the greatest influence on artistic development; and, indeed, one's convictions in this matter predetermine what groups of problems are seen as rightfully belonging to the study of art history. Gombrich, for example, directs attention to the social conditions under which styles change, as does Arnold Hauser; Wölfflin and Riegl, on the other hand, see art as conforming to an inner logic which unfolds spontaneously and automatically, according to its own inner laws of development.

Finally, in the last chapters, I shall examine these same problems in relation to the formation of new concepts in science, considering in particular the models of scientific change developed by Sir Karl Popper and Thomas S. Kuhn. The whole question of scientific change and innovation, which is encompassed by philosophy of science, contains much that is relevant to similar issues in art.

In his book *Principles of Art History* (1915), Wölfflin claims that there is an underlying mechanism of development, a self-activating process, operating within artistic phenomena, which is intrinsic to the system itself and not imposed on it from without. Stylistic development is subject to natural law in the same way as biological growth is; its transformations obey an 'inward necessity' and represent the unfolding of a 'rational psychological process'. 'Beholding is not just a mirror,' he writes, 'which always remains the same, but a living power of apprehension which has its own inward history and has passed through many stages.'[1] Vision (today we would say 'perception') has a history which develops according to immanent laws of its own, independently of external influences. The revelation of these substrata of vision – of the physiological and psychological conditions that determine different ways of seeing – should be regarded, in Wölfflin's view, as the primary task of the art historian.

This is not at all the case for Gombrich, however, whose approach to art history is more reductive and hygienic:

> The fact that all eighteenth-century landscapes or twentieth-century dream-paintings have enough in common to allow us art historians to

tell, on the whole, where and when they were made, is not due to some mysterious fluid or collective spirit that governs the modes of perception or the images of dreams but rather to the observable fact that symbols developed from a common stock will tend to have a certain family likeness.[2]

For Gombrich, the choice of formal possibilities open to an artist must be attributed to the specific conventions imposed by his time. But where have these conventions come from? Why, for example, should artists at the beginning of the fifteenth century suddenly have begun to organize space in a recessional instead of a planimetric way? How can we pass beyond the mere observation of certain sequences of art history and actually state why one particular phase should follow another? *What is it that ties art to its own specific age?*

These radical problems are inexorably linked to one another. But whereas Riegl, and to some extent Wölfflin, seem to suggest that some irresistible engine is driving history, Gombrich implies that artists are made by art, instead of the other way around. As a way out of these various dilemmas, I have suggested that the history of art exemplifies fundamental patterned principles of mental growth, and that these constitute the mainspring, or basic mechanism, of historical-cultural change. That which makes history move derives, at least in part, from cognitive conditions – from a general state of knowledge which is transindividual, and which determines the very possibility of experience. These cognitive conditions limit the range of possibilities at a specific stage in history, influence the kinds of abilities and responses of which its artists are capable, and intervene in any actual achievement.

Wölfflin perceived history as proceeding in terms of eternally recurring cycles; he believed that art follows a dialectical movement between five basic sets of contrasts, or polarities. For instance, linear style always precedes painterly style in a tradition, and planar the recessive. He believed these contrasts repeat themselves rhythmically in every epoch: the general pattern is the same even though particular events will differ. Art history continually oscillates, therefore, between a classic and a baroque style. Wölfflin saw this process as entirely cyclic – as running over more or less the same loops again and again – rather than as an irreversible development or a one-way process in time.

Wölfflin considered that he had discovered a general principle which would be applicable to art in all its various phases. The fact is, however, that, although some steps and stages of Wölfflin's cycles seem to recur frequently as typical processes, it has proved impossible to systematize the whole history of art through a cyclical model: developments in the twentieth century indicate that art has a more open and unbounded character than Wölfflin's model presupposed. Modern art, in particular, cannot be defined through either set of Wölfflin's terms, although some modern styles do show features from both sets.[3] William Rubin has pointed out

how Wölfflin's fundamental dialectic between linear and painterly is transcended, for instance, by Jackson Pollock's drip technique, an extended kind of drawing with paint that actually synthesizes (rather than polarizes) the two activities.[4] Equally, a Noland target is both linear *and* painterly; and, as we have already seen, Albers's *Homage to the Square*, or Stella's *Cato Manor* are simultaneously both planar *and* recessive: the squares lie flat on the plane and also recede illusionistically in depth.

During the period in which he lived and wrote, Wölfflin had no biological concept for epistemological development upon which he could draw. There was no general interdisciplinary theory of structure, such as the one Piaget provides, at his disposal. He was thus in the unhappy position of trying to formulate something not yet really expressible in the idiom of his time. Present-day developmental theory, on the other hand, offers us a concept of development which is not only associated with the organization of living structures and life processes, *but also may be applied to systems of ideas*, which give rise to a movement over time towards greater complexity that is similar to living structures:

> This transition toward higher organization (or complexification) is not an expression of a subjective value judgement, nor connected with vitalism, a drive toward perfection or any other metaphysical supposition; it is a statement of fact describable at any length in anatomical, physiological, behavioral, psychological, etc. terms.[5]

The definition of such directively organized systems has been so stated that it can be used to characterize both biological and non-vital systems. It allows for the application of organic concepts to the structure and function of any body of organized knowledge. Within such a developmental system, however, changes are not cyclical – they are cumulative and irreversible. Change thus has a continuous direction; it implies progression through reorganization, and culminates in a phase that is qualitatively new.[6]

History is thus not merely cyclical; it does make linear jumps, so that there is both repetition and progress. Essentially, the direction of history cannot be reversed, although at times there may be lines of regression on a small scale. But these regressions do not alter the large-scale trend. (An example of such a regressive trend in our own time, for instance, is the reversion to the representational, the figurative and the descriptive in Photo-realism.)

In the end, Wölfflin was unable to say whether artistic development was internally determined, or whether outer conditions might not influence it in some way. At the close of *Principles of Art History*, he saw the question as still very much open to debate.

> Here we encounter the great problem – is the change in the forms of apprehension the result of an inward development, of a development of the apparatus of apprehension fulfilling itself to a certain extent of itself, or is it an impulse from the outside, the other interest, the other attitude to the world, which determines the change?[7]

The whole notion of stylistic evolution as the manifestation of an internal mechanism running automatically had also been put forward in a somewhat different manner by the Viennese art historian Alois Riegl. For Riegl, changes in style express a general reorientation of artistic intentions, and not the steady pursuit of one unchanging goal. Riegl considered that changes of form are not caused by extraneous forces in society but by impulses which come from the forms themselves. To designate this autonomous life in forms, he introduced the idea of artistic intention, or *Kunstwollen*. Riegl's 'will-to-form' is a creative and transcendent directive force, without aim or purpose – a sort of Bergsonian *élan vital* – that operates within artistic phenomena, seeking to realize itself.

Where Riegl differs significantly from Wölfflin is in his rejection of a dialectical movement between closed cycles in favour of an open development – but a development, it must be said, where there is neither progress nor decline. Riegl saw all styles as having equal value (earlier versions were not considered incomplete or inept versions of the more 'realistic' art that appeared later). He believed that artistic evolution follows a divine plan towards some transcendental end, and he stressed the basic spontaneity of the process, whose only inherent property is to flow, driven by a forward movement or impulse, towards the realization of the next stage.

Meyer Schapiro has described Riegl as 'the most constructive and imaginative of the historians who have tried to embrace the whole of artistic development as a single continuous process'.[8] His view of history is put to the sword by Gombrich, however, who believes that the historian must solve his problems without any recourse to a *deus ex machina* like the self-expression of a blind will which, in his view, smacks of historicism. Art history, for Gombrich, is more like the physical sciences; it is an empirical discipline and should be characterized by an interest in specific events rather than in laws or generalizations or trends. The art historian has done his work when he has described the changes that have taken place. Taking his lead from Karl Popper, Gombrich rejects theatrical and grandiose schemes of history as they were formulated by the German Romantic philosophers. He disapproves of any integrating or synthetic method which aims at reconstructing 'the whole process'. Riegl's unifying principle of the 'will-to-form' is 'pre-scientific', according to Gombrich, and is no more than a metaphysical gimmick. The *Kunstwollen* 'becomes a ghost in the machine, driving the wheels of artistic developments according to "inexorable laws"'.[9] Like Hegel, Riegl 'saw the evolution of the arts both as an autonomous dialectical process and as wheels revolving within the larger wheel of successive "world views"'.[10] Along with Popper, Gombrich staunchly resists any notion of the structural unity of a culture, or of cultures having an 'essence'; he is wary of invoking mysterious, supernatural, or cosmic agencies to explain the events of history in any way which seems to ascribe the emergence of new concepts to inscrutable agents.

'This is a very important point which attracted me to Popper's philosophy,' he has stated, 'that, in this respect, we can speak of a genuine

evolution, of a chain of problems which hang together, without thinking that there is something *inside* the style which drives automatically forward, as certain vitalistic philosophers of art have implied.'[11] Both Popper and Gombrich have argued passionately against the kind of historicism which sees history as a plot which unfolds by itself. Organic systems (of knowledge), according to Popper, should be looked on as the objective products or results of behaviour that is 'free' and not determined in any way by inexorable laws of historical destiny. The appeal to vitalistic elements or occult forces is anti-scientific, speculative and metaphysical; what is more, the thesis that the movement of history is determined by an immanent scheme generates the notion that future events are predictable once we discover these laws. This would imply that we would not have the power to alter things in the light of criticism and experience.[12]

The result of this wholesale rejection of determinist philosophies and of their implied doctrine of historical inevitability, is that Gombrich goes to the other extreme in his own writing; he throws the baby out with the bath water. Finding the Hegelian approach incompatible with any truly scientific attitude, he ends up rejecting everything but precise, small-scale theories. Restraint is the order of the day in all speculations concerning the ultimate causes of historical change. When confronted with the necessity of assigning causes to events, Gombrich chooses the functional approach (how it happened) rather than the causal approach (why it happened).

Where Gombrich would maintain that we can analyse stylistic evolution simply by doing empirical history and by being a historian, it has been my intention to show, via Piaget's genetic epistemology, that history alone is far from explaining everything, and that, on the contrary, it raises a certain number of questions concerning the very mechanism of its development. The historian, using purely historical means, will never discover the proper nature of the historical.

Thus, if Wölfflin and Riegl both inclined to the idea that the development of art was internally determined – that, on the whole, outer conditions could retard or facilitate the process but were not among its causes – Gombrich sees change as circumstantially imposed on art from without. History receives its impetus entirely from 'extra-artistic' factors; whatever happens to art is propelled and guided by events in the environment. Gombrich believes, along with Arnold Hauser, that the development of artistic forms is not autonomous but is connected with changing attitudes, interests and conditions in the environment. He agrees with Hauser that social factors determine the progress of art; and Hauser agrees with Gombrich that 'the stimulus to a change of style always comes from without, and is logically contingent'.[13] (Hauser feels, for instance, that Wölfflin's *Principles of Art History* lacks any sociological sense.)

I wish to claim that what Wölfflin could only formulate in crude terms as 'the apparatus of apprehension fulfilling itself', and Riegl as 'the will-to-form', becomes more explicable once we have taken into account the cognitive determinants of artistic development. There is no need to postu-

late either a dialectical process impelled by polar oppositions or the unfolding of some Hegelian World Spirit to explain the history of art, once we introduce the idea of a directed evolution which is based on the development of cognitive structures. Such an evolution would then be neither mysterious or supernatural; it is 'pre-determined' in so far as it aims at the realization of certain thought forms in the mind, but it is independent of any final cause or goal. Even if we cannot discover any teleology in the evolution of art, we can nevertheless discern a direction – towards an increase of (internal) means for coordinating knowledge. It should be stated once again, however, that evolution which has a direction from simple to more complex function – that is mediated by more and more complex structures – in no way presupposes a steady improvement in aesthetic quality. I am concerned here not with value judgments but with trying to understand what sorts of factors generate this complexity.

It has been my submission all along that internal laws of cognitive growth supplement the mechanism of artistic evolution with non-random influences and to a large extent govern its progress. Although the history of art may be the outward expression of internal changes in the cognitive structures of intelligence, it is also true that the evolution of these structures occurs in response to external pressures and demands. Stages are not purely a question of an automatic maturational process unfolding on its own; their emergence depends upon interaction with the social environment and upon experience in general, and some environments provide the kind of stimulation which results in more developed perceptual and representational strategies.

The inadequacy and one-sidedness of earlier theories may be resolved, I believe, by a synthesis of both considerations – that is to say, by not opting exclusively for either an internalist or an externalist explanation, each of which contradicts and necessarily excludes the other. What we need to understand is the process of their mutual interdependence. There is an *internal* development, which has to do with the emergence of cognitive structures according to a 'prefigured' pattern of development; the development of these structures, however, depends on *external* factors – on cultural and social conditions – to actualize the possibility of their being formed. By translating the problem of cultural and artistic change into the terms of developmental psychology, as I have tried to do, a model of artistic development emerges that can embody the interdependence of inner and outer factors in a relational totality. It embraces their complementary roles, without giving primacy to either. Within the terms of Piaget's interactionist thesis, to ask whether internal or external factors are more important in artistic development is like asking which contributes more to the area of a field – its length or breadth. The development of art has both internal and external dimensions and one must understand both to understand either.

The concept of development, in the sense in which we have been using it here, involves two essential components: the notion of a system which

possesses a definite structure, and that of a sequential set of changes within that structure in its mode of operation. By now, we must have begun to see that history is not merely the sum of events placed end to end; a knowledge of the social sources of art cannot, of itself, explain why a particular notion such as perspective could only have been attained by a series of successive steps, and could therefore never have appeared before its time or apart from specific (cognitive) conditions. The phenomena of art history only become fully intelligible when they are related to something both biological and logical that can help to explain why, in the development of representation, one stage follows another, or why these stages show a 'sequential' character (each being necessary to the following one in a constant order).

Developmental laws are not teleological in the sense of having some specific end in view, but they dominate growth in such a way that earlier stages are preconditions for the later ones which emerge from them. (In Piagetian theory, to arrive at later stages one must pass through earlier stages.) Wölfflin's famous dictum that 'not everything is possible in every era' strikes at the heart of the matter, since it is precisely at this point that I have taken up the problem by asking 'why not?' In order to define an epoch, it is not enough to know what has been done in it; it is also necessary to know what was not done, what was, in fact, impossible in it.

By way of an answer, I have suggested that a particular stage of cognitive development could set an upper limit to what can be learned at a given period in history. Why else were artists in the Renaissance suddenly able to master the basic elements of Euclidean spatial representation in a way that had never been done before, and to succeed in constructing a perspectival system which overcame the spatial inconsistencies of the art which preceded it? Why should Braque and Picasso, who had hardly heard of Einstein and certainly had not read him, have nevertheless arrived, quite independently, at a similar conceptualization of space and time in their Cubist works? What else but a new stage of cognitive development could account for these strange convolutions of intellectual initiatives which, like an eruption, suddenly break the 'traditional' crust of existing knowledge?

I have tried to show how major achievements in art are related to the state of its knowledge at a particular time; and how this knowledge is itself related to an increasing ability to coordinate elements of the environment into coherent systems. Art history viewed as an organic development is far more than a mere succession of stylistic phenomena. It is a matter of a progressive structuration, or organization, manifesting an increasing integration through stages of development.

Art as Mimetic Conjecture

One way in which art differs from science is that science has a final commitment to objective truth. Generally speaking, art has no such commitment: it does not view the universe as an external object of study, nor does it only seek truths about the physical world. Works of art cannot be said to contradict each other, in the way that scientific theories do, nor can styles be 'falsified'. According to Karl Popper, scientific theories can never actually be proven true; they can only be proven false. (Freudianism and Marxism, on this view, are examples of 'pseudo-scientific' theories, because one cannot construct tests that could refute them.) The growth of scientific knowledge, according to Popper, proceeds from old problems by means of conjectures and refutations, or through the corrections and modifications of previous knowledge.[1] The function of observation and experiment is to test our conjectures and hypotheses and to eliminate those which do not stand up to tests: this is 'the logic of scientific discovery'. Criticism is governed by the regulative idea of truth, or getting nearer to the truth, and it is the world (which is independent of our knowledge) that determines what is true.

Artistic development, according to Gombrich, is analogous to scientific discovery in so far as it also involves an active process of building hypotheses and testing them out. This is the concept of representation developed in *Art and Illusion*, and it derives largely from Popper's model of how science progresses: the formula of 'conjectures and refutations' is metamorphosed by Gombrich into one of 'schema and correction'. If science develops by means of conjectures and refutations, representation develops through schema and correction – or 'making and matching' – whereby it, too, achieves a greater approximation to the truth.

Gombrich limits his effort to impose a scientific model of progress on art to specific periods in which, he claims, art actually had a scientific basis, that is, those periods when it strove for a high degree of anatomical likeness and accuracy of representation (for example, Italian painting from the beginning of the fourteenth to the middle of the sixteenth century). In fact, a great deal of Renaissance science actually evolved within the context of art; in 1500, Michelangelo and Leonardo were both dissecting corpses in a scientific study of anatomy.

Elsewhere, Gombrich has asserted that Greek and Renaissance art differ from other evolutions precisely because the sciences of anatomy, projective

geometry, and optics were called in to hasten the experimentation towards recognizable images.[2] Devices like perspective, and the study of light and shade, developed in a scientific manner precisely *because* they had a 'scientific ingredient', and also because existing solutions to the problem of representing reality were systematically criticized and tested for their validity, thus fulfilling Popper's criterion of testability.

Described in Popperian terms, the history of art begins tentatively and schematically; inadequate solutions to the problem of representing reality are subsequently modified and corrected through a critical feedback process of adjustment and error-elimination. Behind Gombrich's theory lurks the idea of a progressive 'fit', or match, between the representation and its real counterpart in nature: we are not simply describing the world, we are getting our representations into shape. For Gombrich, art proceeds by mimetic conjecture. The conjecture is then exposed to criticism to find out whether or not it is like the real world.

On this view, representational art (if not modern art) is said to have progressed precisely because it generated results, and asserted a world, in principle testable through a comparison with nature. 'With the descriptive function of human language,' Popper writes, 'the regulative idea of *truth* emerges, that is, of a description which fits the facts.'[3]

Within this reconstructed Popperian formula, however, art can only aim at increasing the verisimilitude of its representations. As a model for the whole history of art, or for the criteria of its progress, it falls short of explaining how constructs could have emerged which do not conform to the test of perceptual experience and are in fact not testable.

It seems to me that if art can be said to progress it must be by some other process than the method of error-elimination which Gombrich suggests. 'Schema and correction' may be a way to describe the testing of hypotheses, but it does not account for their *discovery*. It does not explain, for example, how new knowledge becomes possible, or the integrative direction that can be seen in it afterwards. This limitation only becomes problematic, however, when art no longer fulfils the demands of a realist aesthetic: the empiricist framework simply ceases to function in the face of developments that demand the absolute independence of art from the world of perceived reality. For against what standards can non-representational (or non-morphological) art be tested for its truth or falsehood? What could the distinction between 'art' and 'pseudo-art' mean, and how can we ever demarcate between them?

The fact is that both Popper and Gombrich believe that there are no 'standards' in the world of contemporary art, precisely because it makes no attempt to match the perceived world. And, since such art lies outside the realm of testability, the tendency is to dismiss it as nonsense. There is no way, within Gombrich's formula, to account for non-representational art, since he deals only with the kind of thinking that is generated in response to external demands. So much of modern art, however, like modern thought generally, obliges us to admit a truth which does not resemble things –

which is without any external model – and may even defy the data of sense experience. This fact becomes the starting point for a critique of *Art and Illusion*, since the intrusion of propositional logic into art and the move away from representation defy the conventions of traditional stylistic analysis.

The notion of 'testing' is obviously without application to the post-object art we have now, an art which often rejects visual norms altogether and does not depend on the creation of objects. The fact remains, however, that Gombrich has raised important epistemological questions in *Art and Illusion*, a number of which are relevant to the question of progress in art. Since my own answers to these questions turn out to be not the same as his, in some ways my text has taken on the form of a continuous discussion with him.

Progress in science is generally linked with an increase in the truth-content of its theories. In the same way, the notion of progress in art has been bound up with the idea of an increase in visual truth, or verisimilitude. The concept of 'progress' has been considered legitimate only within the limited context of finding technical solutions to the problem of represent-ing nature. On this view, later styles are considered as improvements on earlier ones, and each solution is measured by its distance from some fixed, immutable ideal in terms of which all styles are judged. Vasari actually identified painting with the imitation of nature, and with progress in the skilful or superior workmanship which he called *disegno*.[4] Accepting this model of artistic progress, it seems to me, places representational art within a closed system; it does nothing towards explaining the way in which art has progressed since then. All modernist, non–representational and post-object art is doomed by this formulation to remain a tantalizing loose end, a conspicuous aberration which can only be explained by *ad hoc* causes and a separate interpretative framework; or, as in Gombrich's case, the art it-self must be categorically refuted. As an epistemological model for the growth of artistic knowledge, the doctrine of artistic technique, which implies that art is some kind of craft, simply cannot take us beyond the nineteenth century.

Early historians all thought in terms which took this teleology for granted. Progress in this sense was a sort of colour-wash under almost the whole of art-historical analysis. 'The arts are approaching the stage of complete perfection in which they exactly reproduce the truth of nature,' wrote Vasari. Artistic 'progress' hinged for so long upon the mastery of technical means in pursuit of a given end (verisimilitude) that it was virtually unthinkable to consider the history of representation in any sense other than as the sum of formal solutions to a predetermined pictorial problem.[5]

Like the discovery of 'truth' in science, the notion of 'verisimilitude' in art presupposes a goal towards which the historical process is moving, in which is meant to reside its meaning and purpose. Whatever happens is thought of as determined by some final stage to be reached, as though throughout history artists had been working at the same problem and solving it better and better.

One historian who, as recently as 1900, still defined the progress of art in this way – in terms of the struggle to master the representation of nature – is the German Emanuel Loewy (who was, in fact, a teacher of Gombrich's). In his excellent book, *The Rendering of Nature in Early Greek Art*, Loewy describes the development of art from the earliest schematic forms which he calls 'memory-pictures'. (Gombrich's 'schema' is a later variant, if you will, of Loewy's 'memory-picture'.) These simple forms, Loewy claims, were slowly transformed by the deliberate observation of nature. Loewy assumes that early artists worked entirely from memory and did not test their work against visual evidence. The 'testing' principle is hardly conclusive, however, if the assertion is correct that representational skills are a function of the intellectual complexity of the relations in question, *and not of the degree of familiarity with the objects to be represented*. After all, a child, as Gombrich discovered, will draw according to his level of comprehension *even if the model remains in front of him*.

Loewy showed some anxiety about couching the criteria of artistic development exclusively in observational terms, perhaps because it did seem to suggest that there were ontological limits to the direction in which painting could go, as if art were an enterprise which constantly drew nearer to some goal set by nature in advance. Perhaps he recognized that the attainment of the goal of history would also mean the end of history. He could not, of course, have foreseen the emergence of an art which is non-representational, but he was prompted to write, all the same, that 'the goal of this development can never actually be reached since, if it were, art itself would be brought to a finish'.[6] That is, if artists were to continue along the same lines, they would eventually and almost inevitably come to a dead end, to some terminus where they could do nothing but circle around without further progress.

Loewy's and Gombrich's conception of art remains linked to the Renaissance ideal: that the arts were learned by reason and method and mastered by practice. Such a theory was well enough until the twentieth century, when the whole notion of the 'work of art' was itself called into question, along with the concept of the artist as a special kind of craftsman. The criteria of 'work', craft and originality were all undermined by Duchamp, for example, whose ready-mades gave aesthetic value to purely functional objects (a urinal, a bottle-rack) by a simple mental choice rather than through any exercise of manual labour or skill. The old canons of style and quality were equally challenged by Moholy-Nagy, who was probably the first artist to execute a series of paintings by telephoning instructions to a factory.

The way in which Duchamp's ready-mades subverted the notion of work (in the sense of manifest effort, or skill) has been summed up by Richard Wollheim: 'They force us to reconsider what it is to *make* a work of art, or, to put it linguistically, what is the meaning of the word "work" in the phrase "work of art"?'[7] The implication is that if art has something to do with making things, these things are not material things made by skill in

the carrying out of a preconceived plan; they are things of another kind, and made in some other way.

That the art-object is only a by-product of whatever happens in an art-work is an attitude increasingly in the ascendant on the contemporary scene; in 1970, Robert Morris wrote that 'the notion that work is an irreversible process ending in a static icon-object no longer has much relevance'. What matters is 'the detachment of art's energy from the craft of tedious art production'.[8] The new role of the artist demands that he construct perceptual fields which offer a disorienting experience to the perceiver.[9] Art itself (and not the world) has become the focus of the artist's investigations, a situation which often entails linguistic and philosophical enquiry rather than the creation of art objects.

What I have been trying to point to is this. We have seen how the whole notion of art as a goal-directed process evolving towards pictorial 'truth' comes to a sticky end with the onset of modernism. In general, modern art is devoid of that special kind of purposiveness which requires of imagery that it make sense in terms of the external world. Since Cubism, we can no longer speak of an end-in-view for painting, or of a commitment to the finality of any form. Along with the descriptive function, the idea of truth – that is, 'of a description which fits the facts' – disappears from art, together with the disappearance of the goal of verisimilitude. And, since there are no longer any objective standards (no criteria of verisimilitude) against which to judge the results of artistic activity, *it is also generally assumed that we have been deprived of any norms for progress.*

As Gombrich himself put it, in the course of developments which began towards the end of the nineteenth century, 'the whole comfortable idea of the imitation of nature disintegrated, leaving artists and critics perplexed'.[10] Obviously it is more difficult for artists and critics to agree among themselves about what is authentic and what is sham, once the notion of 'representation' – in the sense of a thing which refers to something other than itself – drops away from art (along with the view that Dewey once called the 'spectator theory' of man).

In the light of earlier theories, representational art appears as an interpolated closed system in which the terminal point is implicit from the beginning and all that needs to be discovered is the solution, or the rest of the way to get there. The artist who is operating from within such a closed system is in the position of a spectator searching for something which he must treat as being in some way already 'there'. By this account, the existence of art hinges, as I have tried to show, on imagining that there is one objective and true account of nature and that the measure of artistic achievement is the extent to which it brings us closer to that goal. (I have argued that essentially this is what is implied by the main thesis of *Art and Illusion*).

The experimental artist, on the other hand, must add to some structure that is not yet finished and that he himself is not going to complete. This is more in keeping with the open-ended, paradigm-type situation described by Thomas Kuhn in *The Structure of Scientific Revolutions*. Here, the

terminal point has continually to be discovered or constructed: *it is a matter of finding something which is not yet known.*

A paradigm is a unifying ground of presuppositions that influences and makes possible certain ideas and practices, and provides model problems and solutions to the scientific community. (This describes a scientific tradition, but it is also true for stylistic traditions within the artistic community.) But the paradigm is even more, since, according to Kuhn, it is also an organizing principle which can govern perception itself or a new way of seeing.[11] (There is an unconscious element here which resembles Foucault's *episteme.*) In any epoch, man sees the world in terms of a particular paradigm, which serves as an unconscious conceptual framework by which many different facets of the universe can be and are meaningfully related to each other.

Kuhn has defined scientific activity as fundamentally a matter of creating frameworks (paradigms) and of fitting systems together, rather than of simply discovering the 'truth' about nature. Popper's view (and Gombrich's), on the other hand, is that truth is approached by successive approximations; it is the direction in which science is moving, but it is not something which is ever finally achieved. The aim remains, however: to find theories which, in the light of critical discussion, get nearer to the truth.[12]

Kuhn's apparent readiness to relinquish the idea that changes of paradigm *necessarily* carry scientists closer to the 'truth' has appalled Popperians. Kuhn claims that the 'match' between the ontology of a theory and its 'real' counterpart in nature may be illusive in principle.[13] He has even implied that science may not in fact evolve towards *anything*, an assumption which Popperians look upon as leading straight to the breakdown of rational science. (Since the reader may pursue this rather Byzantine quarrel between Kuhn and Popper in *Criticism and the Growth of Knowledge,* I shall not elaborate on it further here.)

These issues, although drawn from current debates in philosophy of science, bear directly on the question of progress in art. The philosophical nature of the Kuhnian paradigm – more specifically, his view of science as a non-goal-oriented process – would seem to allow of effective comparisons with the heuristic nature of much contemporary art. Indeed, since being an artist now seems to mean questioning the nature of art, the ramifications of Kuhn's fundamental question – as to what 'evolution', 'development' and 'progress' could mean *in the absence of a specified goal –* need to be answered as much for art as they do for science. We can speak quite easily of linear progress within a shared paradigm tradition (in either science or art), but how can we say that progress is made when one paradigm replaces another? Are standards changed in the Popperian manner by a critical discussion of alternatives, or are there processes which, as Kuhn suggests, defy a rational analysis?[14]

The whole question of truth conceals, in fact, a highly dramatic problem. Is the nature of all truth transitory and relative only to the frame of certain

periods, or is there a truth independent of all observers, complete in itself and invariable?

We have seen that, at least for Piaget, the 'laws of the universe' are at best the laws of our interaction with it. Knowledge is not a simple approximation of 'truth' or 'reality'; it is an interaction between knower and known, and depends on many factors of a biological, cultural and linguistic nature. In the child's efforts to produce a proper 'fit' between his cognitive schemata and the external world, he uses a system of reference which is the norm of existing scientific thought. 'In each explanation given by a child,' Piaget writes, 'it would be possible to determine the part played by the activity of the subject and the part played by the pressure of objects, the latter being, by definition, objects as we now conceive them to be.'[15] Since 'objects as we now conceive them to be' refers to the current scientific norm, and this scientific norm may itself be regarded in turn as a stage among other stages, the question as to the true nature of external reality is thus left open.[16] Just as the individual's perceptual field can be regarded as a historical phenomenon which changes through time, the collective perceptual field also changes through time.

We now know that scientific progress requires more than merely 'adding to' existing knowledge and the systematic building up of achievement. We also know, since the shift into Modernism, that progress in art is not made, as was once thought, by the accumulation of knowledge within existing categories: it is made by leaps into new categories or systems. Art is not a descriptive statement about the way the world is, it is a recommendation that the world ought to be looked at in a given way.[17]

This is not to say, however, that thinking does not proceed through a succession of steps, or stages, or that there is not some connection of necessity from step to step. Here Kuhn's distinction between 'normal' and 'revolutionary' science is a useful parallel. Normal science consists of systematic attempts to solve problems which have been raised by the paradigm, but does not bring into question its basic assumptions. Those committed to a particular paradigm (e.g. Ptolemaic astronomy or Einsteinian relativity in science; Renaissance perspective or Cubism in art) take their cognitive and methodological framework for granted and concentrate on resolving issues within that framework. This sort of activity leads to the systematic accumulation of relatively precise knowledge.

Now, assuming that a long stylistic tradition such as the Renaissance, which went on for several centuries, is 'normal' art, then Gombrich's Popperian model perfectly well describes the kind of linear progress made *within that tradition*. In this sense, Leonardo, Piero and Michelangelo were an 'improvement', or 'progress', over Giotto, in that they solved the problem of three-dimensionality better.

However, we are still left with the problem of 'revolutionary' art. We must still account for radical innovation – for the overthrow of an entire paradigm. Why, for instance, did artists abandon the illusionistic paradigm which had conceived of painting as a 'window-on-reality' in favour of the

flat, non-illusionistic space of modern abstract art? Put in another way, if changes within a tradition may be compared with the sequence of moves within a game structure, what causes the game itself to be changed?

I think that we can answer this by saying that, although *learning* takes place within a paradigm, cognitive development itself is a mechanism of change. Moreover, as Marx Wartofsky has pointed out, a pattern of *cognitive* growth need not necessarily be interpreted as a pattern of *epistemological* growth, so that one need not ascribe greater approximation to truth in later stages. The order of stages of growth, rather than being determined by a definition of truth and a truth-criterion, could be determined by a temporal or maturational sequence.[18]

Even though the kind of experimental thinking we find in art is set (like other forms of thinking) to solve problems in a step sequence, it is never satisfied with this; it must continually achieve new openings and new possibilities. A distinction must be made between a development which is fixed in advance by the end state that it must reach – as with Loewy's and Gombrich's model of progress – and a sequence of events that is open-ended to the future because its specific outcome is not foreseen. Cognitive psychologists have stressed the anticipatory nature of cognitive activity and the constant tendency of the mind to go beyond the information given. Microphysicists, for instance, continually seek new modes of conceptual organization from which the finding of new entities will follow.

That the earlier models will not hold good has only become apparent in our own time: the finite and clearly definable goal of progress as postulated by the early historians is no longer tenable, once nature does not serve as a model and as a constant reference point. It breaks down at the first appearance of abstract forms that have been dissociated from any particular content to the extent of becoming entirely free of representational or figurative elements. Teleological models, since they posit a goal outside art (verisimilitude, or truth-correspondence with reality) in order to explain its progress, are unable to explain how new forms emerge which make no attempt to match the perceived world.

The parallel with science was, and still is, useful, but only if we can find a model which can grasp the idea of abstraction, and which is capable of explaining how non-representational, and even non-morphological, styles could have come about. Kuhn's open-ended paradigm situation would seem, on the face of things, to overcome certain weaknesses in the Gombrich–Popper formulation, and gains special force for that reason. It seems clear, however, that if the historian is to save his hypothesis of progress, it can only be by treating the history of art as a developmental learning process into which the demands and conditions of successive periods have put their own specific content.

Revolutionary Theories of Knowledge

By Gombrich's formulation, then, 'schema and correction' is what determines artistic change. The artist starts with a schema, a first loose category which is gradually adjusted and corrected to fit the form it is intended to reproduce. The rhythms of this activity Gombrich calls 'making and matching'.[1] In archaic and medieval art, he claims, the schema was itself the image, and most civilizations never made the change from 'making to matching'. The problem, then, as Gombrich sees it, is to explain why at a certain moment artists should have felt their schema was in need of correction. What explains the sudden departure from primitive schemata that began in Greece and spread to other parts of the world? How did the Greeks manage to achieve, within less than a two-hundred-year period, ways of rendering the human figure with techniques of foreshortening and modelling which the Egyptians, Mesopotamians and Minoans had been unable to achieve?

Gombrich's answer is that 'form follows function'. The formal, technical revolution which occurred in Greece towards the middle of the sixth century was the result of a social change in the function of art. It reflected an incipient need to visualize episodes from Homeric poetry. Thus, it was a demand to fill in the details of stories that led artists to 'cast around for an existing schema which would lend itself' to the depiction of narrative scenes.[2]

For Gombrich, artistic schemata arise in the first place through a series of random guesses, and only those guesses that are able to withstand the constant check against experience are likely to survive. The rhythm of 'schema and correction' represents 'an arboriform stratification of guesses about the world',[3] in the course of which errors are gradually eliminated and successful trials retained.

Like Popper, Gombrich sees historical change in Darwinian terms – as a trial-and-error process sustained by natural selection. Artistic evolution is presented as if it required nothing but a theory of natural selection – in which better adapted forms tend to crowd out and supplant the less fit – to explain its action as an integrated system. 'The fitting of form to function follows a process of trial and error,' he writes, 'of mutation and the survival of the fittest.'[4] The struggle among competing alternatives is resolved through criticism, which eliminates those guesses which are unfit.

If 'fitness' is what determines the evolution of artistic forms – rather than any tendency towards the production of new or more complicated forms – then what permits the mind eventually to transcend perceptual reality, and to construct hypothetical systems which suggest other possibilities (what Piaget calls 'full combinatorial ensembles')? How, according to such a model, can we account for the emergence or generation of new properties in artistic development, the features of which do not derive from the features of the external world? Piaget writes:

> For me the real problem is how to explain novelties. I think that novelties, i.e. creations, constantly intervene in development. New structures, not preformed either in the external world or in genetic structure, are constantly appearing. My problem is how to explain the novelties.[5]

In discussing the emergence of new ideas in science, Kuhn identifies radical innovation with a sudden shift in focus – a 'Gestalt-switch', or displacement of the conceptual network through which scientists view the world. This shift causes scientists to see things in a new way. The difficulty is, however, that Kuhn never really explains the source of the Gestalt-switch which signals a change of paradigm. He does not really state where paradigms come from nor how they are formed. What determines which body of scientific beliefs is admissible at a certain period? How do scientists make the choice between competing paradigms?

Kuhn claims that, in the transfer of allegiance from one historical paradigm to another, 'neither truth nor error is at issue,' only a 'conversion experience that cannot be forced'.[6] The notion of a conversion experience belies that there is any epistemological rationality in the choice (no regulative idea of truth, or truth-criterion) and, indeed, Kuhn does state that 'an apparently arbitrary element, compounded of personal and historic accident, is always a formative ingredient of the beliefs espoused by a given scientific community at any given time'.[7]

But if there is no external criterion (truth) which is common to two successive paradigms, and if science (to say nothing of art) is to be viewed merely as a series of discontinuous forms replacing one another, the notion of evolutionary progress loses its meaning. To overcome this dilemma, we must admit that there is something which underlies change (i.e. fundamental epistemological structures in the process of development). Otherwise history will lack both integration and continuity.

Kuhn describes changes of paradigm as relatively unstructured events that come about in sudden and unpredictable ways – like 'lightning flashes' of intuition. He does concede, however, that even if such changes have the appearance of being sudden, they are actually the result of an extended process of conceptual assimilation, and not isolated events: it is impossible to attribute a 'discovery' unequivocally to an individual or a moment in time. Once he even suggests that transformations of paradigm follow a developmental pattern, but he never actually elaborates the idea. (We, on the other hand, have been taking development to mean, whether in science

or in art, any change which has a continuous direction and which culminates in a phase that is qualitatively new – since the hierarchical organization of cognitive systems favours the emergence of new properties at each level.)

Whenever there is significant (revolutionary) advance in science, it is through the discontinuous shattering and displacement of a total paradigm (e.g. the replacement of the Ptolemaic by the Copernican system) under a complex of pressures that neither Kuhn nor anyone else has yet explained. An increasing number of anomalies strain the credibility of the paradigm and eventually induce a paradigm shift. This shift cannot be accounted for, in my view, without considering the internal cognitive components which direct the growth of knowledge and govern the process of concept-formation. For, without them, the historical continuity of scientific development is not assured. The paradigm then appears to have a capricious and irrational source for its rules, as if it were possessed of a capacity of its own for acting, rather than being the subjective ground upon which our representations are brought into inner connection. Artistic styles and scientific paradigms both constitute models of cognitive interaction between a group of individuals and the environment. As we have seen, modifications and additions to the system continue to occur by virtue of both maturation and experience; these eventually unbalance whatever stability or 'equilibrium' has been achieved through integrated structures, and lead to changes from one stage to the next.

If changes in scientific (or artistic) thought do constitute a progressive development, how should the transition between paradigms (or styles) best be conceptualized? Should it be construed as abrupt or gradual in nature?

On this question, even Kuhn ends up in the low water of Darwinism. He uses the shift of theoretical Gestalt to show that science is not so much additive (an adding to knowledge) as it is evolutionary, advancing through relatively discontinuous mutational 'jumps'. What he fails to consider is the way in which scientific evolution creates successive levels of integration, each characterized by its own laws, or how these levels are coordinated among one another by the continual restructuring of previous acquisitions. Stages, as we have seen, represent a description of cognitive behaviours qualitatively different from one another. By emphasizing the abrupt character of the paradigm shift, Kuhn undervalues the developmental aspect of the process, whereby an accepted system of concepts is reconstructed in such a way that new insights are coordinated with former intellectual gains through a system of integrated structures.

The two-way Gestalt figure of the duck-rabbit is a misleading metaphor for the growth of scientific knowledge for just this reason, because in a simple figure-ground reversal, *nothing is reconstructed*. What we have is a perfectly ordinary picture of a simple, concrete object which, unlike a paradigm, cannot be extended or developed.[8] There is a sudden reorganization of the cognitive field, but it has no development. We have already seen that whenever mental development is presented in Gestalt terms, it

appears as a series of spontaneous insights that emerge unpredictably. In his model of the paradigm shift, Kuhn does not successfully unravel the sudden insight v. the slow-growth models of scientific development, and for this reason his account falls short of offering an entirely satisfying explanation of why and how change occurs, or how new paradigms emerge. His paradigm lacks one crucial wheel – the significant force which contributes to the forging of new concepts and new forms, whether in art or in science.

Popper has also tried to find answers to the problem of emergence, and to the emergence of the genuinely new. It is his considered opinion, however, that man's 'third-world' creations – and by these he means science and art, language and culture – do not necessarily progress, although they are of their nature open to change.[9] According to Popper, there are neither laws of succession nor laws of evolution; there is only the historical fact of change. The idea of a law which determines the direction and character of evolution is 'a typical nineteenth-century mistake, arising out of the general tendency to ascribe to "Natural Law" the functions traditionally ascribed to God'.[10] In Piaget's cognitive stage theory, however, the impetus to cognitive growth comes from both biological mechanisms *and* environmental input. New constructs evolve in a continuous hierarchical series as individuals interact with their environment.

Gombrich and Popper both believe that the process of variation-and-selection positively accounts for the diversity and complexity of forms, when in fact it only accounts for the non-survival and for the elimination of forms. Beyond a description of the random trial-and-error switching from a false hypothesis to a correct one, Gombrich, for instance, does not identify the progressive approximations of his 'schema and correction' as forming a cognitive sequence, and therefore a development. This reduces learning to a succession of empirical acquisitions which simply get added to one another. Moreover, from the empiricist point of view, although a 'discovery' is new for the person who makes it, what is discovered was already in existence in external reality: *there is therefore no construction of new realities.*

The model of 'schema and correction' can *only* be made to work, in my view, if it presupposes a cognitive organization or system through which the associative elements are linked, and only if it is seen as an 'oriented' evolution, in which cognitive structures mediate between the artist's activities and external data. These structures are present in all attempts to conceptualize reality and create an indissoluble relation between subject and object. It is precisely this cognitive dimension, however, which is found to be lacking, since what Gombrich does is to reduce it to physiology, on the one hand, and to sociology on the other. Whereas for Piaget a schema is a way of seeing, for Gombrich a schema is merely a technique for expressing what is already seen. It is a pictorial device. It cannot account for the capability of giving certain responses or for the emergence of new levels of competence and coordination.

The fact that 'schema and correction' by Gombrich's formulation represents a trial-and-error groping which is fortuitous in relation to the object shows that he has not taken into account a significant change in the psychological interpretation of the learning process, which is that *learning is dominated by developmental laws and not by trial-and-error.* Piaget states that we can interpret the process of 'trial-and-error' groping in two ways:

> Either one asserts that groping activity is directed, from the outset, by a comprehension related to the external situation and then groping is never pure . . . or else one states that there exists a pure groping, that is to say, taking place by chance and with selection, after the event, of favourable steps.[11]

Where Gombrich would support the second interpretation, Piaget, of course, supports the first. Moreover, since the development of thought follows particular sequences, or stages of progressive structuration, in Piaget's view *it is development that directs learning rather than the other way around.*[12]

In the passage from one stage to the next, knowledge is a continuous construction; it is not a simple additive or incremental process but occurs in different cognitive modes. This means that artistic development cannot be reduced to a succession of empirical acquisitions in the manner suggested by Gombrich, since it always entails an internal reorganization of structures and the formation of new structures which did not exist before. Even when trial-and-error occurs, it cannot be explained solely in mechanical terms since the artist anticipates his failures and successes; as Piaget has shown, there is an assimilatory activity which directs the search and gives a meaning to fortuitous events. The role of chance in trial-and-error is therefore greatly reduced by the fact that the artist brings his particular perceptual apparatus and coping strategy to bear on any problem. (Only in pre-operational thought can it be said that trial-and-error combinations are made without being organized in a comprehensive manner.)

Evolution is thus more creative than chance mutations or the variation-and-selection hypothesis derived from Darwin would suggest. It is co-determined by internal cognitive factors towards more complex forms of organization. The root notion of 'schema and correction' is valid only when buttressed by a theory of cognitive development that can show how artistic 'schemata' derive from one another through successive differentiations and integrations, and only if it is made clear that the process of formation which characterizes such schemata has a necessary order of emergence. My basic argument with Gombrich has been predicated on the assumption that, unless we take developmental laws into account, as well as the mechanisms that define the learning process, we cannot explain why representation should have had a history, or why art itself has had a history. Evolutionary theory (which claims that random factors generate theories or styles, and that these are then selected and retained for their usefulness) must be combined with the notion of 'sequential' laws of cognitive development

(which govern the process of concept-formation and assure the historical continuity of mental development). Only then can we establish that what appears as a kind of unprompted phenomenon in terms of Gestalt theory is actually a long process of conceptual evolution.

The most interesting and critical issue at stake with respect to changes in both science and art, as I see it, involves the process by which any theoretical 'constellation' may be said to develop or emerge from the preceding one, and by which earlier stages are preconditions for later ones. By emphasizing the historical continuity of mental development, Piaget has been able to show that these apparently sudden reorganizations are in fact the successive crystallizations of long-range cognitive activity, and that cognitive growth is a continuous process, although it appears to proceed in discontinuous ways with spurts and plateaux of achievement.

The Transformation of Reality

The history of art begins with the handing down of tradition. Traditions give us something upon which we can operate: something that, in the Popperian sense, we can criticize and change. In stating that we cannot copy straight from nature but must first 'learn the trick' by looking at other pictures,[1] Gombrich makes pictorial representation a special case of Popper's view that propositions in science can only be derived from other propositions; they cannot be derived from facts.

The difficulty in this, however, is that it presupposes an infinite regress of artists who have all learned to copy nature by copying the copies. And if this is so, a nagging question remains: how did the first copy come into existence? This dilemma is not just an argumentative trick; in its present formulation, the notion of 'schema and correction' reveals a more profound inadequacy that arises from the problematic gap it sets up between mind and the world. It gives rise to poisonous philosophical difficulties, not the least of which is whether or not traditional methods of illusionist art can be said to reproduce the world as it 'looks'. What do we mean when we speak of art as a 'reflection of reality'? Is what we see in the picture the look of the world, or is it merely the reflection of our particular way of looking at the world?

These questions are not idle; they become even more dramatic in the light of Piaget's statement that 'in order to make a copy, we have to know the model that we are copying, but according to this theory of knowledge the only way to know the model is by copying it, until we are caught in a circle unable ever to know whether our copy of the model is like the model or not'.[2] Thus, the copy theory is stopped at the start by *the inability to specify what is copied*. What, for instance, is the meaning of the word 'world' when we say that different artistic traditions describe the world differently? Is there a description of the world which can be formulated independently of any observer whatsoever? Nelson Goodman has argued on this point that 'the world is as many ways as it can be truly described, seen, pictured, etc. and that there is no such thing as *the* way the world is'.[3] All we have are diverse cognitions of the environing universe. This assertion, if true, brings a number of philosophical problems in its wake that cannot be dodged without cutting Gombrich's theory off from the roots of its meaning.

The first is the notion of a 'real world' objectively given, whose truth becomes 'manifest by inspection'. Gombrich's reflections are founded, massively and concretely, in a set of dimensions which regards perception as the source of our knowledge. Intrinsic to the very concept of 'making and matching' are the assumptions that (1) there is an independent world around us of which our senses give true information, and that (2) our knowledge merely has to take in what is out there. Corresponding to this one objective world is a single absolute observer who (ideally) is able to unite all different standpoints and merge all perspectives into a single objective whole. The expectation is that if all perceptual reports were in, there would be an optimal way of selecting among them so as to have one ideally recognized system of representation. (We have already seen that, in Gombrich's view, perspective is such a system.)

To be fair, Gombrich adheres to this view only part of the time. For, as one commentator on *Art and Illusion*, Richard Wollheim, has pointed out, Gombrich also advocates the thesis that 'whenever we see, there is nothing at all of which it can properly be said that it is what we really see, since what we see is always partly determined by the concepts we bring to the perception. There is not one thing that we always see.'[4] Wollheim comments, therefore, that 'if there is no one kind of thing that we really see whenever we see, then the art that sets out to depict what we really see will not have any consistent look; there is no pictorial manner in which we can say *a priori* that a naturalistic painter should work'.[5]

This seems to me to be the weakness in Gombrich's theory, where his attempt fails. His arguments are caught up in ways of thinking that rest, at least in part, on Cartesian foundations, inviting us to set up the neat division of a spectator on one side and a spectacle on the other. This duality greatly distorts the existing situation. (Here Gombrich's theory is incapacitated by its terms of reference, which are reductivist theories of perception and therefore do not associate changes in ways of seeing with changes in cognitive development.)

The acquisition of knowledge, far from setting subject and object sharply apart, presupposes an interaction between the knowing subject and the object known. The empirical tradition to which Gombrich belongs, on the other hand, assumes a complete separation between mind and reality. Gombrich does not sufficiently allow for this interaction; he lays all the weight on subject and object respectively. What Piaget's work brings to light is that 'there exists between these two terms a complexus of relations, of changes and reactions which implies complete physico-chemical continuity'.[6] (What this means is that knowledge is neither solely in the subject, nor in a supposedly independent object, but is constructed by the subject as an indissociable subject-object relation.)

Piaget argues that the mind never copies reality but instead organizes it and transforms it, according to its own structures. The artist's reaction to what he sees is not merely a response to an outside stimulus: it is never a simple copy of what exists in the outside world, but is always the response

of an underlying structure within the individual. A stimulus does not impose any meaning in itself; meaning must be 'read' by assimilating it to known patterns.

Gombrich tends to reduce this transformational aspect of perception to an associative mechanism. 'Schema and correction' merely specifies, after all, an act of identification between the properties of a stimulus input and the specifications of a schematic category. For Gombrich, it is a matter of 'selecting the nearest equivalence'.

He concedes that we can never wholly eliminate the 'subjective element' in perception, and that, in painting, there are limits to objectivity. Like Malraux, Gombrich claims that perception already stylizes: art is always an interpretation, never a pure recording of visual facts. Indeed, it is the pivotal concern of *Art and Illusion* to drive home 'the grip of conventions and the power of traditions' on the way that an artist perceives. For Gombrich, however, this activity of the mind is troublesome – something that needs to be checked and, if possible, overcome. The assumption hidden within the root notion of 'schema and correction' is still that we let our gaze roam over the world as something that is external to this gaze. In other words, the world as we experience it is the *cause* of what we perceive, and not the product of our perceptions.

I am arguing that such a view is tainted with phenomenalism, since it thinks of nature as in the last resort appearance and of mind as that to which it appears. It presumes an existence for the known object which is independent of the act of knowing, an assumption which produces a disjunction between the inner and outer aspects of experience, between mind and the world. It presumes that (ideally) we can distinguish the world as it is in itself, independent of our perceptions, from the world as we perceive it.

'If we examine the intellectual development of the individual,' Piaget has written, 'or of the whole of humanity, we shall find that the human spirit goes through a certain number of stages, each different from the other, but such that during each, the mind believes itself to be apprehending an external reality that is independent of the thinking subject.'[7] The 'primitive' painter, for example, depicts the world from his point of view, according to beliefs which are peculiar to him; but he believes that he paints it *as it is*. We measure what presents itself to us as reality by our idea of reality. The mind is inextricably tangled with external reality, forever injecting its own characteristics into the world of matter, to the point where it is no longer possible to separate the two. This is why, from the point of view of genetic psychology, our awareness of the world can only be seen as the functioning of schemata of perception, reality itself being unknowable.

Despite his commitment to the psychological relativity of seeing and to the variability of perception, Gombrich repudiates the view that the demand for fidelity to nature must always be meaningless. He asserts that 'the undeniable subjectivity of vision does not preclude objective standards of representational accuracy'.[8] He is trapped somewhere between the mind's dynamism and its individual construction of the world, and his desire for

absolute certitude – the need to be free of the limits of subjectivity in order to see what is as it is. He has rejected 'naïve realism' – the belief in a pure observational language free of all interpretation – but he still holds to an epistemological realism, in the sense of believing that the function of intelligence is to catch hold of a ready-made reality which the act of cognition itself does not substantially transform. He does not, ultimately, reject the objectively pre-given world and the general spectator for whom this objective world would lie open as a landscape.

Thus, although Gombrich initiates a crucial shift of emphasis from the external stimulus, or object, to the subjectivity of the artist's vision, he still fails to transcend the subject-object dichotomy which divides reality into inner and outer, into subject and object. He continues to insist on the traditional empiricist separation of mind and reality.

If Piaget's research is correct, however, and knowledge does not arise through the senses, then the construction of reality, and what we perceive, cannot be the product of pressure exerted then and there by the physical environment, but is built up by intelligence and is the fruit of a genuine collaboration between mind and the world around it.[9]

A stimulus, therefore, is not something that is constituted ready-made outside the artist, but is a function of his interaction with the environment and of his particular interpretative structure. Thus, the central question in *Art and Illusion* (to which, in my view, Gombrich offers only a partial solution), 'are painters successful in the imitation of reality because they "see more", or do they see more because they have acquired the skill of imitation?'[10] can only be answered by saying that what the artist responds to, and whether or not there is anything at all for him to respond to, depends on the cognitive schemata to which the stimulus is assimilated. Assimilation means that reality is incorporated into the organism's physiological or mental structures, and this incorporation implies a transformation of reality as well as of the organism. *Experience is not sufficient for creating knowledge of the real world if the relevant structures are not available to incorporate the results of that experience.* What we see depends on what we have learned. The acquisition of knowledge always involves the transformation of reality and is the result of continuously changing interactions with the environment.

On these grounds, it does become meaningful to assert that an artist at a certain stage in history may not have been influenced by certain classes of stimuli but that others could be and were influenced by them later, *when cognitive-structural development permitted meaningful assimilation.* What we have within the history of art is a slow process of development in which spectacular leaps occur from time to time, and in which the interaction between the artist and what he observes is continuously changing. Within the terms of such a conception, it is possible to envisage artistic development as a gradual, step-by-step process of structural accrual and change, with each structural form necessarily building on its predecessors yet – by virtue of new increments of 'assimilation-accommodation' activity – going a little beyond it.[11]

If our knowledge of objects is never direct but is always relative to the actualization of schemata which give stimuli their meanings, then the influence of the environment can never be pure. Cognition can never be the mirror-image of an external world radically divorced from the human mind, since the degree of schematization governs which attributes are actually accessible to the perceiver. Every external stimulus presupposes an internal reaction, a schema of assimilation and the intervention of coordinating activities peculiar to the subject. In the words of Piaget:

> The object only exists, with regard to knowledge, in its relations with the subject and, if the mind always advances more toward the conquest of things, this is because it organizes experience more and more actively, instead of mimicking, from without, a ready-made reality. The object is not a 'known quantity' but the result of a construction.[12]

Gombrich's theory rests on a psychological relativism which is still far removed from such an idea of construction. He fails to stress sufficiently the sense in which the artist's thought is primarily *active* rather than merely being *reactive*. He stresses the role of subjectivity in perception without ever arriving at the concept of an epistemological subject whose power of radically assimilating physical reality allows him to construct it into an object of knowledge. It is not enough to assert that there are no facts (visual or otherwise) free of interpretation: it is equally the case that *there is no interpretation which is not subject to certain dominant mental tendencies* – i.e. without a specific mental structure which makes that particular response or interpretation possible.

The assumption is that all artists begin from the same visual data but that they *interpret* what they see differently, according to different cultural contexts and backgrounds; although Gombrich emphasizes the relative differences in the conceptual spectacles through which we view the world, he does insist upon a common visual world.

Once our spectators find that their views of the landscape do not agree, however, do we then say that one view of the landscape is false? Are both views illusory? Such a conclusion would involve a belief in the existence of a third landscape, an authentic one, not subject to the same conditions as the other two. This would have to be Gombrich's common visual world. But there is no reality which remains the same from whatever point of view it is observed, no Archimedean point that is a place which permits us to seize reality as it is, and since we can only see with spectacles it becomes senseless to speculate what seeing without spectacles would be like. Here we enter Whorfian territory, and the relations between language, perception and thought. When an Eskimo distinguishes three different kinds of snow, for instance, where we only 'see' one, is he seeing the same snow? Because a man describes something differently, does he perceive it differently?

It seems to me that these arguments trade on confusion at just this point. (One problem is in the use of words like 'see' and 'reality'. As the philosopher J. L. Austin has pointed out, these are philosophically very slippery words.

They do not have one single, specifiable, always-the-same meaning, and are therefore conspicuous snakes in the linguistic grass.[13] To assert that all artists *see* the same things but *interpret* them differently according to different artistic and cultural traditions is to maintain a problematic distinction between 'givenness' and interpretation. In Gombrich's case, it is to ignore what is 'given' as already the product of an indissociable interaction between subject and object, and the fact that we must start from this relation (by studying their reciprocal modifications of each other) *in order to attain reality*.[14]

Thus, while stressing the conventional element in many modes of representation, Gombrich holds firmly to the idea that we must interpret them in terms of a neutral visual world, without being at all uneasy about the implicit dichotomy that is thus set up between the world as perceived and shaped by our concepts on the one hand, and some other more neutral (or more objectively 'real') world on the other, against which the artist must continually test his representations. But the fact is we do not see the same thing and then interpret it differently; *we just see something different*. What is seen cannot be distinguished from the interpretation a subject brings with him because of his knowledge, understanding and culture. Perception involves a means of perception, and the properties of what is perceived are, inevitably, always a function of that means. Kant was right when he said that to change one's concepts is to change what one experiences, and to change one's phenomenal world. The idea of a percept (or common visual world) which remains identical through changes of interpretation depends on maintaining the given/interpretation distinction, and it splits the organism up into a passive receiver of stimuli on the one hand, and an active interpreter of what has been imprinted there on the other. Once we do away with this distinction, the suggestion that our concepts shape neutral material no longer makes sense, since *there is nothing to serve as this material*:

> As soon as we start thinking of 'the world' as atoms and the void, or sense data and awareness of them, or stimuli of a certain sort brought to bear upon organs of a certain sort, we have changed the name of the game, for we are now well within some particular theory about how the world is.[15]

Retinal imprints are never the sole basis for what one perceives: all seeing is 'epistemic' and contains a way of representing the world. The organization of what one sees is mediated at all times by a cognitive network that actually determines what it is that we perceive. Any shift in this cognitive network causes us to see the world differently. Conceptualizations are not only embedded in, *they actually transform perceptual reality*. What we ascribe to reality is what appears to us to be the case *because of our point of view*. Thus, any theory of artistic style must describe how style is both a call for, and a consequence of, our way of seeing.

The significance of Piaget's work for art historians lies in his discovery that the manner in which the human mind represents reality and organizes its experience of the world passes through phases of development both individually, and collectively in terms of world-pictures; and that cognitive laws direct this development. The philosopher of science Paul Feyerabend endorses Piaget's approach concerning the variability of perception, when he suggests that even the adult stage of perception may be mobile and subject to fundamental changes. 'Is it an incontrovertible fact', he asks, 'that an adult is stuck with a stable perceptual world and an accompanying stable conceptual system which he can modify in many ways but whose general outlines have forever become immobilized?'[16] Just as the individual's perceptual field can be regarded as an historical phenomenon, changes in the perceptual field which occur at the collective level (in terms of world-views) are dependent upon the historical character of beliefs, values and ideas that are propelled alternatively by social and unconscious psychological conditions. Slow changes may occur beneath the threshold of ordinary perception, and only very long time-frames, beyond the human life span, are large enough to experience these changes. Nothing is eternally fixed in nature – not even, as Hipparchus discovered, the planetary system of fixed stars.

The problem, as I have tried to present it here, is to account for the system of concepts, constituted by the mind in the course of its interaction with the environment, which causes artists in a particular period to see and to represent the world in a particular way; and, further, to elaborate the cognitive principles which have led to the construction of such systems in the first place. It seems to me that genetic epistemology can provide art history with a useful model (much as linguistics did for anthropology) through which to grasp the structural principles that underlie changes in its historical development. The value of such a model is that it tells us much more than a mere description of historical facts ever does. Piaget's model has a functional and operational validity in explaining – rather than merely describing – how change occurs. My confidence in it as a methodology derives precisely from its ability to make coherent sense of many problems which have not been satisfactorily resolved by older views of historical change, and to overcome the weaknesses and contradictions of other theories. It allows us, in fact, to grasp a form of order in artistic development that has eluded other theories.

I have used Piaget's concepts as analogues of my own hypothesis, which is that changes in the course of artistic development are not random but have a direction given them by specific organizing mechanisms which determine problem-solving, or concept-learning, capacities. I have tried to show how our way of representing the world is regulated by cognitive processes of different degrees of development, and how levels of cognitive organization intervene in the formation of artistic styles, making possible the acquisition of knowledge on the one hand, and determining and limiting its scope on the other. Everything I have had to say about art in this

book presupposes its permanent affinity with the structures of the mind. I have therefore claimed that stylistic change reflects varying modes of cognitive-logical capacity, suggesting that the history of art may be seen as an evolution in certain kinds of thought processes. By providing a framework for seeing the history of art as one continuous and integrated history, I have hoped to show that we have recently entered on a new phase or modulation without losing the fundamental homogeneity of the past. Hopefully, all this may help to dispel belief in the negative character of modern art, and in the charges of nihilism, inadequacy and decadence put forward by its detractors. Accusations that this is an age of 'cultural liquidation' because the figurative arts are in recession, the fear that art has run its course and is coming shortly to an end, have no grounds within my theory. On the contrary, I should like to dismiss out of hand the 'endgame' theory of art since, as I see it, we are just at the beginning of a new style of thinking that can generate, like an endless algebraic fraction whose denomination splinters itself an infinite number of times, an indefinite array of logical systems.

To conclude, I should like to make a final remark about my use of a developmental model for the history of art. A model is never the thing concerned; it only represents certain aspects of it in a more or less adequate way. I believe this book is valid in so far as it represents particular aspects of the history of art; it offers a model which is not intended, however, as an absolute or ultimate expression of all that the history of art is about. There are any number of ways in which art can be analysed, and whatever analytic system one adopts is likely to limit the results and pre-define the scope of the analysis. No inquiry is ever exhaustive; it only asks certain questions of reality and chooses the facts in the light of these questions. At no time would I wish to deny that there are other important aspects to the history of art which I have disregarded in my use of this particular kind of structural model.

Aside from the fact that the thesis suggested here may be true or false, I am aware that it will of necessity clash with general currents of thought which tend to take an opposite position to mine – namely, that there is no 'progress' in art. Many people feel that the art of each civilization should be judged by its own standards, and not by some theory which has been imposed on history by the historian and does not necessarily derive from it. Nevertheless, I feel that certain aspects of art may be best suited to treatment by constructs of the kind I have chosen, despite the fact that such constructs inevitably carry the stamp of mental habits belonging to my own period of intellectual history.

I have in this book a vision of art as it may be – to share with those who may want to look at it. I cannot plant this vision in anybody's mind, since everyone makes his own model of reality; but I can hope that the light I throw on experience may help some people to see things differently and to make a new vision of their own.

Notes

Editions to which reference is made are given in the bibliography.

CHAPTER ONE

[1] Solzhenitsyn, *The First Circle*, p. 328.

[2] Proust, *The Guermantes Way*, pp. 22–3.

[3] Kuhn, *The Structure of Scientific Revolutions*, p. 162.

[4] See Popper, *The Poverty of Historicism*, and Berlin, 'Historical Inevitability', in *Four Essays on Liberty*, pp. 41–117.

[5] Ortega y Gasset, 'The Dehumanization of Art', in *Velasquez, Goya, The Dehumanization of Art and Other Essays*, pp. 65–83.

CHAPTER TWO

[1] Ivins, *Art and Geometry*, p. 31.

CHAPTER THREE

[1] Piaget, *Genetic Epistemology*, p. 48.

[2] ibid., p. 17.

[3] ibid., p. 15.

[4] Before such processes are fully developed, however, information received through the senses tends to be accepted uncritically: no distinction is made between how things look and how they really are. (This same phenomenon, or principle of mental growth, has also occurred in history with respect to the early beliefs of man. These were that the sun revolved around the earth and that the earth was flat – both were ideas that *appeared* to be true.) See Evans, *Jean Piaget: The Man and His Ideas*, p. xxxiii.

[5] Flavell, *The Developmental Psychology of Jean Piaget*, p. 82. (In his later writings, Piaget describes mental structures of development in terms of mathematical groups and lattices, algebraic logic and set theory, none of which I am qualified to explain. I shall therefore confine myself to his verbal-descriptive models, since they are more understandable and accessible to a non-specialized reader.)

[6] Lazlo, *Introduction to Systems Philosophy*, p. 134.

[7] Piaget, op. cit., p. 13.

[8] Arnheim, *Art and Visual Perception*, p. 201.

[9] Arnheim, *Visual Thinking*, p. 13.

[10] Arnheim, *Art and Visual Perception*, pp. 36–7.

[11] Piaget, *The Mechanisms of Perception*, p. 307.

[12] Arnheim, *Visual Thinking*, p. 255.

[13] Arnheim, *Art and Visual Perception*, p. 50.

[14] Barbara Rose, 'The Politics of Art: Part III', in *Artforum*, (Vol. VII. No. 9), May 1969, p. 48.

[15] Flavell, op. cit., p. 232.

CHAPTER FOUR

[1] Gombrich, *Art and Illusion*, pp. 247–50.

[2] ibid., p. 248.

[3] Lazlo, *Introduction to Systems Philosophy*, p. 42.

[4] In a personal communication to the author.

[5] Piaget, *Biology and Knowledge*, pp. 359–60.

[6] Bury, *The Idea of Progress*, p. 107.

[7] Gombrich, op. cit., p. 18.

[8] Gombrich, op. cit., p. 247. This assumption is anchored in the assertion of Gestalt psychology that perceptual patterns show an innate tendency towards greater simplicity.

[9] Piaget, *Structuralism*, p. 116.

[10] Piaget, *Insights and Illusions of Philosophy*, p. 48.

[11] Panofsky, *Renaissance and Renascences in Western Art*, p. 122–3.

[12] For a convincing discussion of the Greeks' failure to achieve a perspective system and a logically unified spatial representation, see Ivins, *Art and Geometry*, especially pp. 43 and 57.

[13] Piaget, Inhelder and Szeminska, *The Child's Conception of Geometry*, p. 70. Piaget finds it

necessary to break down a seemingly simple and unitary acquisition like, say, our apprehension of Euclidean space (seeing the world of objects within the framework of a 'grid' of horizontals and verticals) into two acquisitions: a perceptual one in infancy and a representational one which does not get constituted until well into middle childhood. See also Flavell, *The Developmental Psychology of Jean Piaget*, p. 70.

14 Schapiro, 'Style'. In Philipson (ed.), *Aesthetics Today*, p. 98.

15 Piaget, *Psychology and Epistemology*, pp. 61–2.

16 Lévi-Strauss, *The Savage Mind*, p. 268. This view contraverts the earlier position of Lévy-Bruhl, who considered that non-Western minds think in modes qualitatively different from our own (Lévy-Bruhl, *How Natives Think*).

17 Burnham, *The Structure of Art*, pp. 3 and 27.

18 In personal communications to the author. 'In my view,' Lévi-Strauss adds, 'the "static" level is, as it were, sandwiched between two "dynamic" levels: below the individual and the genetic; above the collective and the historical.'

19 Flavell, op. cit., p. 43.

20 Piaget, *Structuralism*, p. 114.

CHAPTER FIVE

1 Werner, 'The Concept of Development from a Comparative and Organismic Point of View', in Harris (ed.), *The Concept of Development*, pp. 126–7.

2 Piaget, *The Child's Conception of Physical Causality*, p. 242. Among 'subjective adherences', Piaget names magical beliefs, animism (which makes the child endow things with consciousness and life) and artificialism (which takes man as the departure for everything). See pp. 244–5.

3 Piaget, *Insights and Illusions of Philosophy*, p. 115.

4 Flavell, op. cit., pp. 69–70. Piaget's interactionist model comes very close to General Systems Theory, as conceived by Ludwig von Bertalanffy, where a system is any set of related elements and an open system – which best characterizes the nature of artistic development – is simply one that constantly interacts with the environment. As a theory it includes principles which apply to the widest possible range of systems. See Bertalanffy, *General System Theory*, and Ervin Laszlo (ed.), *The Relevance of General Systems Theory*.

5 'Organization', writes Piaget, 'is inseparable from adaptation: they are two complementary processes of a single mechanism, the first being the internal aspect of the cycle of which adaptation constitutes the external aspect. . . . These two aspects of thought are indissociable. . . . It is by adapting to things that thought organizes itself and it is by organizing itself that it structures things.' Piaget, *The Origins of Intelligence in Children*, pp. 7–8.

6 Piaget, *The Place of the Sciences of Man in the System of Sciences*, p. 13.

7 Tanner and Inhelder, *Discussions on Child Development*, p. 123. Although Lévi-Strauss does not admit the existence of structurally different modes of thought and does not support the theory of stages in collective mental development, his description of primitive thought in *The Savage Mind* resembles Piaget's description of concrete-operational thought to a degree which suggests that the difference between them may be less profound than would seem to be the case. In contrast to the modern scientist or engineer who works by means of abstract concepts, the *bricoleur* – Lévi-Strauss's word for the primitive or mythical thinker – is limited to 'concrete' events and to concrete perceptions. Mythical thought remains entangled in imagery; it is not given to abstraction: 'It is impossible to separate percepts from the concrete situations in which they appeared,' he writes, 'while recourse to concepts would require that thought could, at least provisionally, put its projects (to use Husserl's expression) "in brackets".' Lévi-Strauss, *The Savage Mind*, p. 18. The *bricoleur* works by means of iconic signs, dealing only with perceived relations and directly given data; he is, in Piagetian terms, a concrete-operational thinker. He is confined to rearranging elements at his disposal – 'whatever is to hand' – unlike the scientist who tries, by means of formal deductions and hypotheses, to go beyond these constraints.

8 Green, Ford and Flamer, *Measurement and Piaget*, p. 193.

CHAPTER SIX

1 Ortega y Gasset, 'On Point of View in the Arts', in Philipson (ed.), *Aesthetics Today*, p. 73.

2 Willetts, *Foundations of Chinese Art*, p. 330.

3 Meyer Schapiro, 'On Some Problems in the Semiotics of Visual Art: Field and Vehicle in Image-Signs', in *Semiotica* (I), 1969, p. 497.

4 Merleau-Ponty, *Phenomenology of Perception*, pp. 265–7.

5 I am indebted for this observation to David Castillejo, *The Formation of Modern Objectivity*, unpublished manuscript, p. 76.

6 Piaget, *The Child's Conception of Space*, p. 18.

7 Lloyd, *Perception and Cognition*, pp. 61–6 and

84–8. This book contains an excellent bibliography of studies in this area. See also, for a discussion of the same experiments, Jan B. Deregowski, 'Pictorial Perception and Culture', in *Scientific American* (Vol. 227, No. 5), November 1972, p. 83.

[8] Merleau-Ponty, op. cit., p. 261.

[9] Piaget, *The Child's Conception of Geometry*, p. 69.

[10] Piaget, *The Child's Conception of Space*, p. 459.

[11] Laurendeau and Pinard, *The Development of the Concept of Space in the Child*, p. 170.

[12] Piaget, *The Child's Conception of Space*, pp. 466–7.

[13] ibid., p. 454.

CHAPTER SEVEN

[1] Flavell, *The Developmental Psychology of Jean Piaget*, p. 328.

[2] Gombrich, 'Visual Discovery through Art', in Hogg, *Psychology and the Visual Arts*, p. 222.

[3] Goodman, *Languages of Art*, p. 14.

[4] W. Hudson, 'Pictorial depth perception in sub-cultural groups in Africa', in *J. Soc. Psychol.*, 52, 1960, pp. 183–208.

[5] J. B. Deregowski and R. Serpell, 'Performance on a sorting task with various modes of representation: a cross-cultural experiment', in *Human Development Research Unit Reports* (No. 18), University of Zambia, 1971. Reference in Lloyd, *Perception and Cognition*, p. 107.

[6] Segall, Campbell and Herskovits, *The Influence of Culture on Visual Perception*, pp. 59–60.

[7] Von Senden, *Space and Sight*, pp. 156–204.

[8] Wartofsky makes this same point in his paper, 'Pictures, Representation and the Understanding', in Schaffler and Rudner (eds.), *Logic and Art: Essays in Honor of Nelson Goodman*, p. 162.

[9] Bartlett, *Thinking*, p. 143.

[10] Reichenbach, *The Philosophy of Space and Time*, pp. 38–48.

[11] Toulmin, *Human Understanding* (Vol. I), p. 436.

[12] Piaget, *The Child's Conception of Space*, p. 450.

[13] ibid., p. 448.

[14] Gombrich, *Art and Illusion*, p. 20.

[15] ibid., p. 217.

[16] All references are to Francastel, *Peinture et Société*, Part One. I must acknowledge two further debts here; to Jane Bell Davis, who kindly let me read her excellent thesis on Francastel, and to Christo-

pher Johnston, who showed me his partial translation of *Peinture et Société*, both of which helped to clarify my knowledge of Francastel's views.

[17] Piaget, *The Child's Conception of Space*, p. 448.

[18] ibid., p. 449.

[19] Kline, *Mathematics in Western Culture*, p. 479.

[20] Jammer, *Concepts of Space*, p. 153.

[21] Duchamp, taped interview with Harriet and Carroll Janis, 1953. © Estate of Harriet and Carroll Janis.

[22] Whorf, *Language, Thought and Reality*, p. 153.

[23] Piaget, *The Child's Conception of Space*, p. 294.

[24] ibid., p. 295.

CHAPTER EIGHT

[1] Gombrich, *In Search of Cultural History*, p. 36.

[2] Gombrich, *Art and Illusion*, p. 17.

[3] Foucault, *The Order of Things*, p. xi.

[4] Piaget, *Structuralism*, pp. 131ff.

[5] Gleizes and Metzinger, *Du Cubisme*, 1911. Quoted in Kozloff, *Cubism/Futurism*, pp. 8–9.

[6] Apollinaire, *Les peintres cubistes*. Quoted in Linda D. Henderson, 'A New Facet of Cubism: "The Fourth Dimension" and "Non-Euclidean Geometry" Reinterpreted', in *The Art Quarterly* (Vol. 34, No. 4), 1971, pp. 410–33. The article contains an interesting discussion of the influence of non-Euclidean geometry on Cubism.

[7] Braque, interview with Jacques Lassaigne, 1961. Quoted in catalogue for exhibition, 'Les Cubistes', Galerie des Beaux-Arts, Bordeaux, 1973.

[8] Greenberg, 'The Crisis of the Easel Picture', in *Art and Culture*, p. 155.

[9] Jung, *Synchronicity: An Acausal Connecting Principle*, in *Collected Works*, p. 511.

[10] Kenner, *The Pound Era*, p. 165.

[11] Quoted in Prof. Will Grohmann, catalogue for exhibition, *The Painters of the Bauhaus 1919–33*, Marlborough Fine Art Ltd., London, March–April 1962, p. 37.

[12] Quoted in Rickey, *Constructivism: Origins and Evolution*, p. 22.

[13] Kasimir Malevich, quoted in catalogue for exhibition, *Conceptual Art and Conceptual Aspects*, New York Cultural Center, 1970, p. 56.

[14] Kubler, *The Shape of Time*, pp. 39–53.

Notes

[15] Kasimir Malevich, quoted in catalogue for exhibition, *Conceptual Art and Conceptual Aspects*, New York Cultural Center, 1970, p. 56.

[16] Don Judd, quoted in ibid., p. 59.

[17] Carl Andre, in Andrea Gould, 'Dialogues with Carl Andre', *Arts*, May 1944, p. 27.

[18] Sol LeWitt, 'Paragraphs on Conceptual Art', in *Artforum* (Vol. V, No. 10), June 1967, p. 26.

[19] Inhelder and Piaget, *The Growth of Logical Thinking*, p. 332.

CHAPTER NINE

[1] Wölfflin, *Principles of Art History*, p. 226.

[2] Gombrich, *Meditations on a Hobby Horse*, p. 34.

[3] Schapiro, 'Style', in Philipson (ed.), *Aesthetics Today*, p. 95.

[4] William Rubin, 'Jackson Pollock and the Modern Tradition', in *Artforum* (Vol. 5, No. 6), February 1967, p. 21.

[5] Bertalanffy, 'Chance or Law', in Koestler (ed.), *Beyond Reductionism*, pp. 66–7.

[6] See the group of essays in Harris (ed.), *The Concept of Development*.

[7] Wölfflin, op. cit., p. 229–30.

[8] Schapiro, op. cit., p. 100.

[9] Gombrich, *Art and Illusion*, p. 16.

[10] Gombrich, *In Search of Cultural History*, p. 27.

[11] Gombrich, 'Sir Karl Popper', interview in *The Listener*, pp. 227–8.

[12] Gombrich and Popper both oppose historicist philosophies (like Hegelianism and Marxism) because they believe that to talk in terms of collectives (whether it be 'mankind', 'races' or 'ages') depreciates the individual and weakens one's resistance to totalitarian habits of mind. See pp. 16–17 in *Art and Illusion*, and Popper's book *The Poverty of Historicism*, which was written under the strong emotional influence of the reaction against Hegel, who was treated, together with Plato, as the spiritual ancestor of Nazism.

[13] Hauser, *The Philosophy of Art History*, p. 26.

CHAPTER TEN

[1] Popper, 'Evolution and the Tree of Knowledge', in *Objective Knowledge*, p. 258.

[2] Gombrich, 'Visual Discovery through Art', in Hogg (ed.), *Psychology and the Visual Arts*, p. 227.

[3] Popper, 'Epistemology without a Knowing Subject', in *Objective Knowledge*, p. 120.

[4] Vasari, *Lives of the Artists*, p. 90.

[5] The historian Arnold Hauser has pointed out quite rightly that if there are problems in art, they don't exist in some teleological, pre-ordained manner as a precondition of progress; problems come into being along with their solution. Strictly speaking, Hauser argues, there are no unsolved problems: before Monet, there was no problem of light in the same sense as there was after the *Gare Saint-Lazare*. The appropriateness of treating a work of art as just a 'solution of a problem' may be doubted, if only because the supposed problem as a rule gets its meaning from the works it is intended to explain. See Hauser, *The Philosophy of Art History*, p. 163.

[6] Loewy, *The Rendering of Nature in Early Greek Art*, p. 33.

[7] Wollheim, 'Minimal Art', in Battcock (ed.), *Minimal Art: A Critical Anthology*, p. 395.

[8] Robert Morris, statement in catalogue for exhibition, *Conceptual Art and Conceptual Aspects*, The New York Cultural Center, 1970.

[9] Peckham, *Man's Rage for Chaos*, p. 123.

[10] Gombrich, *Art and Illusion*, p. 162.

[11] Margaret Masterman observes that Kuhn uses at least twenty-one multiple definitions of a paradigm. See Masterman, 'The Nature of a Paradigm', in Lakatos and Musgrave (eds.), *Criticism and the Growth of Knowledge*, pp. 61–6.

[12] Popper, 'Normal Science and Its Dangers', in ibid., p. 57.

[13] Kuhn, *The Structure of Scientific Revolutions*, p. 205.

[14] This question is posed by Paul Feyerabend to both Popper and Kuhn in Lakatos and Musgrave, op. cit., p. 216.

[15] Piaget, *The Child's Conception of Physical Causality*, p. 238.

[16] ibid., p. 238.

[17] Peckham, op. cit., pp. 124–298.

[18] Wartofsky, 'From Praxis to Logos', in Mischel, *Cognitive Development and Epistemology*, p. 135.

CHAPTER ELEVEN

[1] Gombrich, *Art and Illusion*, pp. 55–64.

[2] ibid., p. 110.

[3] ibid., p. 77.

[4] Gombrich, 'Visual Discovery Through Art', in Hogg (ed.), *Psychology and the Visual Arts*, p. 225.

5 Quoted in Green, Ford and Flamer, *Piaget and Measurement*, p. 192.

6 Kuhn, *The Structure of Scientific Revolutions*, p. 151.

7 ibid., p. 4.

8 Masterman, 'The Nature of a Paradigm', in Lakatos and Musgrave (eds.), *Criticism and the Growth of Knowledge*, p. 76.

9 Magee, *Popper*, p. 62.

10 Popper, *Conjectures and Refutations*, p. 340.

11 Piaget, *The Origins of Intelligence in Children*, p. 397.

12 Piaget, *The Psychology of Intelligence*, pp. 93–9.

CHAPTER TWELVE

1 Gombrich, *Art and Illusion*, p. 73. Wölfflin also stated that the effect of one picture upon another is a more important factor in style than the observation of nature. Wölfflin, *Principles of Art History*, p. 230.

2 Piaget, *Genetic Epistemology*, p. 15.

3 Goodman, 'The Way the World Is', *Review of Metaphysics* (Vol. 14), 1960, pp. 48–56. Quoted in Goodman, *Languages of Art*, p. 6.

4 Wollheim, 'Reflections on Art and Illusion', in Wollheim, *On Art and the Mind*, p. 268.

5 ibid., p. 269.

6 Piaget, *The Child's Conception of Physical Causality*, p. 283.

7 ibid., p. 237.

8 Gombrich, in the new preface to the second edition (1962) of *Art and Illusion*, p. xi.

9 Piaget, *The Child's Conception of Physical Causality*, p. 256.

10 Gombrich, op. cit., p. 9.

11 Flavell, *The Developmental Psychology of Jean Piaget*, p. 407.

12 Piaget, *The Origins of Intelligence in Children*, p. 375.

13 Austin, *Sense and Sensibilia*, p. 15.

14 According to Piaget, the history of science (and I wish to extend this to include the history of art), as much as the study of individual development, shows that this interaction, while remaining indissociable, passes from an undifferentiated phase to one of coordination. See Piaget, *Insights and Illusions of Philosophy*, p. 115.

15 Richard Rorty, 'The World Well Lost', in *J. of Phil.* (LXIX, 19), 26 October 1972, p. 663. According to Rorty, if a stimulus is thought of as somehow 'neutral' in respect to different conceptual schemes, it can be so only by becoming 'a wheel that can be turned though nothing else moves with it'. Ibid., p. 651.

16 Paul Feyerabend, 'Consolations for the Specialist', in Lakatos and Musgrave (eds.), *Criticism and the Growth of Knowledge*, p. 224.

Bibliography

Editions other than those to which reference is made in the notes are given in brackets.

ADLER, IRVING. *The New Mathematics*. New York 1959.

ALBERTI, LEON BATTISTA. *On Painting*. New Haven and London 1971.

ARNHEIM, RUDOLF. *Towards a Psychology of Art*. London and Berkeley 1966.

—— *Art and Visual Perception*. London 1969.

—— *Visual Thinking*. Berkeley and London 1971.

AUSTIN, J. L. *Sense and Sensibilia*. Oxford and New York 1962.

BARTLETT, SIR FREDERIC. *Thinking*. London 1964. (New York 1958.)

BATTCOCK, GREGORY (ed). *Minimal Art: A Critical Anthology*. New York 1968.

—— *Idea Art: A Critical Anthology*. New York 1973.

BAXENDALL, MICHAEL. *Painting and Experience in Fifteenth Century Italy*. Oxford and New York 1972.

BEARD, RUTH M. *An Outline of Piaget's Developmental Psychology*. London 1971.

BERLIN, ISAIAH. *Four Essays on Liberty*. Oxford and New York 1969.

BERTALANFFY, LUDWIG VON. *Robots, Men and Minds*. New York 1967.

—— *General System Theory*. New York 1968. (Harmondsworth 1973.)

BRUNER, J. S., J. J. GOODNOW and G. A. AUSTIN. *A Study of Thinking*. New York 1967.

BUNIM, MIRIAM. *Space in Medieval Painting and the Forerunners of Perspective*. New York 1940.

BURNHAM, JACK. *The Structure of Art*. New York 1970.

BURY, J. B. *The Idea of Progress*. New York and London 1955.

CAMPBELL, NORMAN. *What is Science?* New York 1952.

CANTRIL, HADLEY. *The Why of Man's Experience*. New York 1950.

CARR, E. H. *What is History?* Harmondsworth 1972.

CASSIRER, ERNST. *The Problem of Knowledge*. New Haven and London 1969.

CAZANEUVE, JEAN. *Lucien Lévy-Bruhl*. New York and London 1973.

CHURCH, JOSEPH. *Language and the Discovery of Reality*. New York 1961.

COLLINGWOOD, R. G. *The Idea of Nature*. Oxford and New York 1964.

—— *Essays in the Philosophy of History*. New York and London 1966.

DANTO, ARTHUR and SIDNEY MORGENBESSER (eds.). *Philosophy of Science*. Cleveland 1970.

DILTHEY, WILHELM. *Pattern and Meaning in History*. New York 1962. (London 1961.)

ELKIND, DAVID and JOHN H. FLAVELL. *Studies in Cognitive Development*. New York and London 1969.

—— *Children and Adolescents: Interpretative Essays on Jean Piaget*. New York and London 1970.

EVANS, RICHARD I. *Jean Piaget, The Man and His Ideas*. New York 1973.

FINCH, MARGARET. *Style in Art History*. Metuchen, N. J. 1974.

FLAVELL, JOHN H. *The Developmental Psychology of Jean Piaget*. New York and London 1963.

FOUCAULT, MICHEL. *The Order of Things*. London 1970.

FRY, EDWARD. *Cubism*. New York and London 1966.

FRANCASTEL, PIERRE. *Peinture et Société: Naissance et déstruction d'un espace plastique de la Renaissance au Cubisme*. Audin 1951.

FURTH, HANS G. *Piaget and Knowledge*. New Jersey and London 1969.

GARDNER, HOWARD. *The Quest for Mind: Piaget, Lévi-Strauss and the Structuralist Movement*. New York 1973.

GELDZAHLER, HENRY. *New York Painting and Sculpture: 1940–1970*. New York and London 1969.

GIBSON, JAMES J. *The Senses Considered as Perceptual Systems*. New York 1966.

GOLDMANN, LUCIEN. *The Human Sciences & Philosophy*. London 1973.

GOMBRICH, E. H. *Art and Illusion*. London 1962. (New York 1960.)

—— *Meditations on a Hobby Horse*. London 1963.

—— *Norm and Form*. London 1966.

—— *In Search of Cultural History*. Oxford and New York 1969.

GOMBRICH, E. H., JULIAN HOCHBERG and MAX BLACK. *Art, Perception and Reality*. Baltimore and London 1972.

GOODMAN, NELSON. *Languages of Art*. London 1969. (Indianapolis 1968.)

GREEN, DONALD ROSS, MARGUERITE P. FORD and GEORGE B. FLAMER (eds.). *Measurement and Piaget*. New York 1971.

GREENBERG, CLEMENT. *Art and Culture*. London 1973.

GREGORY, R. L. and E. H. GOMBRÏCH (eds.). *Illusion in Nature and Art*. London 1973.

HANSON, NORWOOD RUSSELL. *Patterns of Discovery*. Cambridge 1961.

HARRIS, DALE B. *The Concept of Development*. Minneapolis and London 1967.

HAUSER, ARNOLD. *The Philosophy of Art History*. London and New York 1959.

HAYES, E. NELSON and TANYA HAYES. *Claude Lévi-Strauss: The Anthropologist as Hero*. Cambridge, Mass. and London 1970.

HEISENBERG, WERNER. *Physics and Philosophy*. New York 1962. (London 1959.)

HELMORE, G. A. *Piaget: A Practical Consideration*. Oxford and New York 1969.

HOCHBERG, JULIAN E. *Perception*. Englewood Cliffs, N.J. and London 1964.

HOGG, JAMES (ed.). *Psychology and the Visual Arts: Selected Readings*. Harmondsworth and Baltimore 1969.

HOLLOWAY, G. E. T. *An Introduction to The Child's Conception of Geometry*. London 1967.

HUTTEN, ERNEST H. *The Origins of Science*. London 1962.

INHELDER, BÄRBEL and JEAN PIAGET. *The Growth of Logical Thinking from Childhood to Adolescence*. New York 1959.

IVINS JR, WILLIAM. *Art and Geometry: A Study in Space Intuitions*. New York 1964. (London 1946).

JAFFÉ, HANS L. C. *De Stijl*. London 1970.

JAMMER, MAX. *Concepts of Space: The History of Theories of Space in Physics*. Cambridge, Mass. 1954.

JUNG, C. G. *Synchronicity: An Acausal Connecting Principle*. In *Collected Works*, Vol. VIII. Princeton 1960. (London 1972.)

KLINE, MORRIS. *Mathematics in Western Culture*. Harmondsworth 1972.

KÖHLER, WOLFGANG. *Gestalt Psychology*. New York 1959.

—— *The Task of Gestalt Psychology*. Princeton 1969.

KOESTLER, ARTHUR and J. R. SMYTHIES. *Beyond Reductionism*. London and New York 1969.

KOZLOFF, MAX. *Cubism/Futurism*. New York 1973.

KUBLER, GEORGE. *The Shape of Time*. New Haven and London 1965.

KUHN, THOMAS S. *The Structure of Scientific Revolutions* Vol. II, No. 2. Chicago and London 1970.

LAKATOS, IMRÉ and ALAN MUSGRAVE (eds.). *Criticism and the Growth of Knowledge*. Cambridge and New York 1970.

LASZLO, ERVIN. *The Relevance of General Systems Theory: Papers Presented to Ludwig von Bertalanffy on His Seventieth Birthday*. New York 1972.

—— *Introduction to Systems Philosophy*. New York 1973.

LAURENDEAU, MONIQUE and ADRIEN PINARD. *The Development of the Concept of Space in the Child*. New York 1970.

LEACH, EDMUND. *Lévi-Strauss*. London and New York 1970.

LÉVI-STRAUSS, CLAUDE. *The Savage Mind*. London 1972.

—— *The Scope of Anthropology*. London 1967.

LÉVY-BRUHL, LUCIEN. *How Natives Think*. New York 1966.

LIPPARD, LUCY. *Six Years: The dematerialization of the art object*. New York and London 1973.

LLOYD, BARBARA B. *Perception and Cognition: A Cross-Cultural Perspective*. Harmondsworth and Baltimore 1972.

LOEWY, EMANUEL. *The Rendering of Nature in Early Greek Art*. London 1907.

MACH, ERNST. *Space and Geometry*. La Salle, Ill. 1960.

MAGEE, BRYAN. *Modern British Philosophy*. London 1971.

—— *Popper*. London and New York 1973.

MERLEAU-PONTY, MAURICE. *Phenomenology of Perception*. London and New York 1962.

MEYER, URSULA. *Conceptual Art*. New York 1972.

MISCHEL, THEODORE (ed.). *Cognitive Development and Epistemology*. New York and London 1971.

MULKAY, M. J. *The Social Process of Innovation*. London and New York 1972.

MURRAY, PETER and LINDA. *The Art of the Renaissance*. London 1971.

NAGEL, ERNEST and JAMES R. NEWMAN. *Godel's Proof*. London 1971.

NASH, J. M. *Cubism, Futurism and Constructivism*. London 1974.

NASH, RONALD H. (ed.). *Ideas of History*. New York 1969.

NIDDITCH, P. H. *The Philosophy of Science*. Oxford and New York 1971.

ORTEGA Y GASSET, JOSÉ. *The Modern Theme*. New York 1961. (London 1931.)

—— *The Origin of Philosophy*. New York 1967.

—— *Velasquez, Goya, The Dehumanization of Art and Other Essays*. London 1972.

PANOFSKY, ERWIN. *Renaissance and Renascences in Western Art*. London 1970.

PECKHAM, MORSE. *Man's Rage for Chaos: Biology, Behaviour and the Arts*. New York 1967.

PHILIPSON, MORRIS (ed.). *Aesthetics Today*. New York 1961.

PIAGET, JEAN. *The Origins of Intelligence in Children*. New York 1952.

—— *Logic and Psychology.* Manchester 1965. (New York 1957.)

—— and Bärbel Inhelder. *The Child's Conception of Space.* London 1967. (New York 1956.)

—— *Psychology of Intelligence.* New Jersey 1968. (London 1959.)

—— *Six Psychological Studies.* London 1968. (New York 1967.)

—— *The Child's Conception of Physical Causality.* Totowa, New Jersey 1969. (London 1951.)

—— *The Mechanisms of Perception.* London 1969.

—— and Bärbel Inhelder. *The Psychology of the Child.* London 1969. (New York 1969.)

—— *Genetic Epistemology.* New York and London 1970.

—— *Structuralism.* New York 1970. (London 1971.)

——, Bärbel Inhelder and Alina Szeminska. *The Child's Conception of Geometry.* London 1970. (New York 1964.)

—— *The Construction of Reality in the Child.* New York 1971.

—— and Bärbel Inhelder. *Mental Imagery in the Child.* London 1971.

—— *Biology and Knowledge.* Chicago and London 1971.

—— *Psychology and Epistemology.* New York 1971. (Harmondsworth 1972.)

—— *Insights and Illusions of Philosophy.* London 1972.

—— *Main Trends in Interdisciplinary Research.* London 1973.

—— *Main Trends in Psychology.* London 1973.

—— *The Child and Reality.* New York 1973.

—— *The Place of the Sciences of Man in the System of Sciences.* New York 1974.

Poincaré, H. *Science and Hypothesis.* New York 1952.

Pollard, Sidney. *The Idea of Progress.* Harmondsworth 1971.

Popper, Karl R. *The Logic of Scientific Discovery.* London and New York 1959.

—— *The Poverty of Historicism.* London 1961.

—— *Conjectures and Refutations: The Growth of Scientific Knowledge.* New York 1962. (London 1965.)

—— *Objective Knowledge: An Evolutionary Approach.* Oxford and New York 1972.

Proust, Marcel. *The Guermantes Way.* London 1960.

Reichenbach, Hans. *The Rise of Scientific Philosophy.* Berkeley and London 1968.

—— *The Philosophy of Space and Time.* New York 1957.

Richardson, Tony and Nikos Stangos (eds.). *Concepts of Modern Art.* Harmondsworth and New York 1974.

Richmond, P. G. *An Introduction to Piaget.* London 1970.

Rickey, George. *Constructivism, Origins and Evolution.* London and New York 1967.

Schaffler, J. and Richard Rudner (eds.). *Logic and Art: Essays in Honor of Nelson Goodman.* Indianapolis 1970.

Schon, Donald A. *Invention and the Evolution of Ideas.* London 1969.

Schrödinger, Erwin C. *Science, Theory and Man.* New York and London 1957.

Segall, Marshall H., Donald T. Campbell and Melville J. Herskovits. *The Influence of Culture on Visual Perception.* Indianapolis 1966.

Sellars, Wilfrid. *Science, Perception and Reality.* London 1968.

Senden, M. von. *Space and Sight.* London 1960.

Smart, J. J. C. *Problems of Space and Time.* New York and London 1968.

Solzhenitsyn, Alexander. *The First Circle.* London 1969.

Steinberg, Leo. *Other Criteria: Confrontations with Twentieth Century Art.* New York and London 1973.

Sypher, Wylie. *Four Stages of Renaissance Style.* Garden City, N.Y. 1955.

Tanner, J. M. and Bärbel Inhelder. *Discussions on Child Development.* London 1960. (New York 1956.)

Thomson, Robert. *The Psychology of Thinking.* Harmondsworth 1971.

Toulmin, Stephen. *Human Understanding, Volume I.* Oxford and New York 1972.

Vasari, Georgio. *Lives of the Artists* (A Selection). Harmondsworth 1971.

Waddington, C. H. *Beyond Appearance.* Edinburgh 1969.

Werner, Heinz. *Comparative Psychology of Mental Development.* New York 1948.

White, John. *The Birth and Rebirth of Pictorial Space.* London 1972.

Whorf, Benjamin. *Language, Thought and Reality.* Cambridge, Mass. 1972.

Willetts, William. *Foundations of Chinese Art.* London 1965. (New York 1958.)

Wölfflin, Heinrich. *Principles of Art History.* New York and London 1932.

Wollheim, Richard. *Art and Its Objects.* New York 1968. (Harmondsworth 1970.)

—— *On Art and the Mind.* London 1973.

Young, J. Z. *An Introduction to the Study of Man.* Oxford 1971.

List of illustrations

Where no photographic credit is given, the photograph has been supplied by the museum or gallery listed. Measurements are given in inches and centimetres, height before width.

1 Group of Three Goddesses from the East Pediment of the Parthenon, Athens, *c.* 435 BC. Marble, over lifesize. British Museum, London. (*Photo*: Hirmer Verlag, Munich)

2 MICHELANGELO *Creation of Adam* (detail), *c.* 1511. Fresco on the ceiling of the Sistine Chapel, Vatican, Rome. (*Photo*: Mansell-Alinari)

3 FRANCIS BACON *Triptych – Studies of the Human Body* (detail of right-hand panel), 1970. Oil on canvas, 78 × 58 (198 × 147.5). Marlborough Fine Art, London.

4 *Banqueter*, late 6th century BC. Bronze, probably Peloponnesian, found at Dodona. L. 4 (10). British Museum, London.

5 VELASQUEZ *The Toilet of Venus (The Rokeby Venus)*, *c.* 1649–50. Oil on canvas, 48¼ × 69¾ (122·5 × 177). National Gallery, London.

6 PABLO PICASSO *Les Demoiselles d'Avignon* (detail), 1907. Oil on canvas, 96 × 92 (243.8 × 233.7). The Museum of Modern Art, New York, Lillie P. Bliss Bequest.

7 *Daughters of Akhenaten*. Fresco fragment from the Tel-el-Amarnah period. Ashmolean Museum, Oxford.

8 TITIAN *Danaë*, 1554. Oil on canvas. Prado, Madrid. (*Photo*: Mas)

9 HENRI MATISSE *Seated Blue Nude II*, 1952. Gouache cut-out, 42 × 34 (105 × 85). Private Collection, Paris.

10 *Eos carrying off Kephalos*, *c.* 460 BC. Terracotta relief, made in Melos. Ht. 6¼ (16). British Museum, London.

11 GIOVANNI DA BOLOGNA *Samson Slaying a Philistine*. Marble sculpture. Victoria and Albert Museum, London. (*Photo*: Crown Copyright)

12 UMBERTO BOCCIONI *Unique Forms of Continuity in Space*, 1913. Bronze, 43⅞ × 34⅞ × 15¾ (111.4 × 88.6 × 40). The Museum of Modern Art, New York, Lillie P. Bliss Bequest.

13 GIOVANNI DI PAOLO *St John the Baptist Returning to the Desert*. Wood predella panel from an altarpiece, 12¼ × 15¼ (31.1 × 38.8). National Gallery, London.

14 Transcription of a rock painting of a Bushman cattle raid (detail). Cave near Wepener (Orange Free State), Republic of South Africa.

15 MARCEL DUCHAMP *Nude Descending a Staircase, No. 2*, 1912. Oil on canvas, 57½ × 35⅛ (146 × 89). Philadelphia Museum of Art, Louise and Walter Arensberg Collection.

16 *Fowling Scene*, *c.* 1450 BC, from an Egyptian tomb in Thebes. British Museum, London.

17 RAPHAEL *The Three Graces*, *c.* 1500. Panel, 6¾ × 6¾ (17 × 17). Musée Condée, Chantilly. (*Photo*: Giraudon)

18 PABLO PICASSO *Les Demoiselles d'Avignon*, 1907. Oil on canvas, 96 × 92 (240 × 230). The Museum of Modern Art, New York, Lillie P. Bliss Bequest.

19 WILLEM DE KOONING *Woman and Bicycle*, 1952–3. Oil on canvas, 76½ × 49 (243.8 × 124.5). Whitney Museum of Art, courtesy Sidney Janis Gallery, New York. (*Photo*: Oliver Baker)

20 *Hunting Hippopotami in the Marshes*, Egyptian, 4th and 5th dynasties. Tomb relief. (*Photo*: Giraudon)

21 BUNDI *Month of Sawan*, Indian, *c.* 1735. Barahmasa illustration. Victoria and Albert Museum, London. (*Photo*: Crown Copyright)

22 BOHEMIAN SCHOOL *The Glatz Madonna*. Berlin Museum.

23 *Agricultural Scenes*, Egyptian, 4th and 5th dynasties. Painted reliefs from a tomb. (*Photo*: Giraudon)

24 SCHOOL OF GIOTTO *The Church Militant and Triumphant* (detail). Church of S. Maria Novella, Florence. (*Photo*: Mansell-Anderson)

25 SCHOOL OF GIOTTO *The Church Militant and Triumphant* (detail). Church of S. Maria Novella, Florence. (*Photo*: Mansell-Anderson)

26 KANGRA *Birth of Bhéma*, Indian, *c.* 1810–25. Philadelphia Museum of Art. (*Photo*: A. J. Wyatt)

27 *St Benedict and St Desiderius*, 11th century, illuminated manuscript. Vatican Library, Rome.

28 BUNDI *Radha and Krishna Surrounded by Girl Companions Beneath a Canopy*, Indian, *c.* 1735. Victoria and Albert Museum, London. (*Photo*: Crown Copyright)

29 BIHZAD SAFAVID *Layla and Majnun at School*, Persian, 1494. Miniature from Nizami's *Khamsa*, in the Herat style. British Museum, London.

Collection Max Gordon, London. (*Photo*: Heini Schneebeli, Courtesy Lisson Gallery, London)

66 ROBERT MORRIS *Untitled*, 1966. Fibreglass, four pieces, each 12 × 48 × 48 (30.5 × 121.9 × 121.9). Leo Castelli Gallery, New York. (*Photo*: Rudolph Burckhardt)

67 THEO VAN DOESBURG *Simultaneous Counter Composition*, 1929–30. Oil on canvas, 19¾ × 19⅝ (50.2 × 49.8). The Museum of Modern Art, New York, Sidney and Harriet Janis Collection.

68 ELLSWORTH KELLY *2 Panels: Red Yellow*, 1971. Oil on canvas, 109 × 80 (276.9 × 203.2). Sidney Janis Gallery, New York. (*Photo*: O. E. Nelson)

69 BRICE MARDEN *Untitled*, 1974. Oil and wax on canvas, 72 × 48 (182.9 × 121.9). Bykert Gallery, New York. (*Photo*: Nathan Rabin)

70 LARRY BELL *Shadows*, 1967. Glass and chromium, 14¼″ cube (35.6). The Museum of Modern Art, New York, gift of the artist.

71 RICHARD SERRA *One Ton Prop (House of Cards)*, 1969. Lead, 48 × 55 × 55 (121.9 × 139.7 × 139.7). Collection George Waterman. (*Photo*: Peter Moore)

72 DONALD JUDD *Untitled*, 1974. ¾″ Douglas Fir plywood, 60 × 60 × 36 (152.4 × 152.4 × 91.4). Lisson Gallery, London. (*Photo*: Sir Geoffrey Shakerley)

73 EL LISSITZKY *Proun 99*, 1941. Oil on wood, 50¾ × 39 (128.9 × 99.1). Yale University Art Gallery, gift of the Société Anonyme.

74 ROBERT RAUSCHENBERG *Renascence*, 1962. Oil on canvas, 36 × 36 (91.4 × 91.4). Collection Sherr. (*Photo*: Rudolph Burckhardt, courtesy Leo Castelli Gallery, New York)

75 ROBERT RYMAN *Drawing with Numbers*, 1963. Charcoal, pencil and graphite on yellow paper, 19 × 19 (48.3 × 48.3). John Weber Gallery, New York.

76 KURT SCHWITTERS *Loose Rectangles*, 1928. Collage, 12¾ × 10

(32.3 × 25.4). Marlborough Fine Art, London.

77 JEAN ARP *According to the Laws of Chance*, 1916. Collage, 10¼ × 4⅞ (26 × 12.5). Estate of the artist. (*Photo*: Albert Winkler)

78 KASIMIR MALEVICH *Suprematist Painting*, 1916. Oil on canvas, 34⅝ × 27¾ (88 × 70.5). Stedelijk Museum, Amsterdam. (*Photo*: The Solomon R. Guggenheim Museum, New York)

79 EL LISSITZKY. Study for page from *A Suprematist Story – About Two Squares in Six Constructions*, 1920. Watercolour and pencil on cardboard, 10⅛ × 8 (25.7 × 20.3). The Museum of Modern Art, New York, Sidney and Harriet Janis Collection. (*Photo*: Geoffrey Clements, courtesy The Museum of Modern Art)

80 MICHAEL McKINNON *Tumbledisc*, 1968. Motorized acrylic panel filled with oil and geometric elements, diameter 36 (90). Collection the artist.

81 AL HELD *Mo-T-8*, 1971. Acrylic on canvas, 30 × 30 (76.2 × 76.2). Andre Emmerich Gallery, New York.

82 KASIMIR MALEVICH *Suprematist Painting: Eight Red Rectangles*, 1915. Oil on canvas, 22⅝ × 18⅞ (57.5 × 7.9). Stedelijk Museum, Amsterdam. (*Photo*: The Solomon R. Guggenheim Museum)

83 JEAN ARP *Tournoi*, 1949. Wood relief, 55 × 43½ (139.7 × 110.5). Sidney Janis Gallery, New York.

84 MEL BOCHNER *Five and Four*, 1973. Charcoal and gouache on paper, 38 × 50 (96.5 × 127). Sonnabend Gallery, New York.

85 MEL BOCHNER *Three Times Four*, 1973. Charcoal and gouache on paper, 38 × 50 (96.5 × 127). Sonnabend Gallery, New York.

86 KASIMIR MALEVICH *Supremus No. 50*, 1915. Oil on canvas, 38¼ × 26 (97.2 × 66). Stedelijk Museum, Amsterdam. (*Photo*: The Solomon R. Guggenheim Museum, New York)

87 KURT SCHWITTERS *Mz 600 Moholy*, 1922. Collage, 12⅝ × 9½ (32.2 × 24.1). Marlborough Fine Art, London.

88 BEN NICHOLSON *Silver Relief*, 1968. Oil on carved pavatex, 39 × 51¼ (99 × 130). Fischer Fine Art Ltd, London. (*Photo*: Prudence Cuming Associates Ltd)

89 ALEXANDER RODCHENKO, *Composition*, 1919. Watercolour and ink, 14⅝ × 11½ (36.5 × 29.3). The Museum of Modern Art, New York, gift of the artist.

90 ELLSWORTH KELLY, *Black White*, 1968. Painted aluminium, 108 (270). Sidney Janis Gallery, New York.

91 RICHARD SERRA *Untitled*, 4 Drawings, 1972. Charcoal and paint stick on paper, 25 × 39¼ (62.5 × 98); 30 × 41¾ (75 × 104.5); 24 × 28½ (60 × 71.2); 26¼ × 40 (65.6 × 100). Leo Castelli Gallery, New York. (*Photo*: Eric Pollitzer)

92 DONALD JUDD *Untitled*, 1973. Plywood, five boxes each 72 × 72 × 101 (180 × 180 × 252.5) on the diagonal. Leo Castelli Gallery, New York. (*Photo*: Eric Pollitzer)

93 ROBERT MANGOLD *X Paintings*, 1969. Acrylic on canvas, 60 × 40 (150 × 100). Lisson Gallery, London.

94 JAN DIBBETS *Perspective Correction – My Studio*, 1969. Stedelijk Museum, Amsterdam.

95 ROBERT RYMAN *Impex*, 1968. Oil on canvas attached directly to the wall, 98 × 98 (245 × 245). Fishbach Gallery, New York.

96 SOPHIE TAEUBER-ARP *Schematic Composition*, 1933. Oil and wood on composition board, 33⅜ × 49¼ (88.7 × 123.1). The Museum of Modern Art, New York, gift of Silvia Pizitz.

97 AGNES MARTIN *Starlight*, 1964. Oil on canvas, 12 × 12 (30 × 30). The Mayor Gallery, London.

98 MEL BOCHNER *Meditation on the Theorem of Pythagoras*, 1972. Hazelnuts and chalk, 12 × 12

3. Stainless steel, 96¼ × 63 (244.5 × 160). Art Gallery of Ontario, Toronto.

133 ROBERT MORRIS *Untitled*, 1965. Fibreglass with light, 24 × 96 diameter (61 × 243.8). Collection Mr and Mrs John Powers, Aspen, Colorado. (*Photo*: Leo Castelli Gallery, New York)

134 RICHARD SERRA *Untitled*, 1970. Two circles of steel, diameter 192 (487.9). Collection Roger Davidson. (*Photo*: Leo Castelli Gallery, New York)

135 JOSEF ALBERS *Homage to the Square: Silent Hall*, 1961. Oil on composition board, 40 × 40 (101.6 × 101.6). The Museum of Modern Art, New York, Dr and Mrs Frank Stanton Fund.

136 FRANK STELLA *Cato Manor*, 1962. Oil on canvas, 85 × 85 (212.5 × 212.5). Leo Castelli Gallery, New York. (*Photo*: Rudolph Burckhardt)

137 WASSILY KANDINSKY *Square*, 1927. Oil on canvas, 28¾ × 23⅝ (71.8 × 58.7). Collection M. Aimé Maeght, Paris. (*Photo*: O. E. Nelson, courtesy Marlborough Fine Art, New York)

138 MEL BOCHNER *Isomorph Negative*, 1967. Photographic paper mounted on styroform board, 21½ × 21½ (53.7 × 53.7). Sonnabend Gallery, New York.

139 CARL ANDRE *Plain*, 1969. Thirty-six pieces of steel and zinc, each 72 × 72 × ⅜ (180 × 180 × 1). John Weber Gallery, New York. (*Photo*: Robert E. Mates and Paul Katz)

140 ANDREA DEL CASTAGNO *The Last Supper*. Fresco, S. Apollonia, Florence. (*Photo*: Gino Giusti)

141 DAN FLAVIN *An Artificial Barrier of Green Fluorescent Light (To Trudie and Enno Develing)*, 1968–9. Green fluorescent light, in 48″ (120) units. Leo Castelli Gallery, New York.

142 DONALD JUDD *Untitled*, 1968. Galvanized iron, 63 × 273 × 120 (157.5 × 682.5 × 300) in thirty-nine units. Leo Castelli

Gallery, New York. (*Photo*: Rudolph Burckhardt)

143 SOL LEWITT, *49 3-Part Variations*, 1967–70. Baked enamel on steel, each part 8 × 8 × 23 (20 × 20 × 57.5). John Weber Gallery, New York. (*Photo*: Walter Russell)

144 ROBERT MORRIS *Untitled*, 1967. Lacquered cold rolled steel in sixteen units, each 36 × 36 × 36 (90 × 90 × 90). Leo Castelli Gallery, New York.

145 ROBERT SMITHSON *Alagon No. 3*, 1967. Folded steel, in twenty units. John Weber Gallery, New York. (*Photo*: Walter Russell)

146 ROBERT MORRIS *Untitled*, 1969. Steel, in twelve blocks, each 6 × 18 × 24 (15 × 45 × 60). Pasadena Art Gallery. (*Photo*: Frank J. Thomas)

147 CARL ANDRE *Spill* (Scatter Piece), 1966. Plastic and canvas bag. Collection Kimiko and John Powers. (*Photo*: The Solomon R. Guggenheim Museum, New York)

148 DONALD JUDD *Untitled*, 1970. Anodized aluminium, eight boxes, each 9 × 40 × 31 (22.5 × 100 × 77.5). Leo Castelli Gallery, New York. (*Photo*: Rudolph Burckhardt)

149 RICHARD SERRA *Casting*, 1969. Lead, 4 × 300 × 180 (10 × 750 × 450). Destroyed. (*Photo*: Peter Moore, courtesy Leo Castelli Gallery, New York)

150 EVA HESSE *Area* (detail), 1968. Rubberized wire mesh, metal wire and grommets, 240 × 36 (600 × 90). Collection J. Runnquist, Geneva. (*Photo*: John A. Ferrari)

151 PIERRE BONNARD *The Garden*, 1935. Oil on canvas, 50 × 39⅜ (125 × 98.7). Musée du Petit Palais, Paris. (*Photo*: Giraudon)

152 JACKSON POLLOCK, *Mural on Red Ground*, 1950. Oil, duco and aluminium paint on canvas, 73 × 79 (182.5 × 197.5). Sidney Janis Gallery, New York. (*Photo*: Eric Pollitzer)

153 ROBERT RAUSCHENBERG *Black Painting*, 1952. Collage on canvas, 71½ × 52¾ (178.7 × 131.8). Leo Castelli Gallery, New York (*Photo*: Rudolph Burckhardt)

154 NANCY GRAVES *Fossils*, 1970. Wax, marble dust, acrylic and steel, 180 × 312 × 36 (450 × 780 × 90). Janie C. Lee Gallery, Houston. (*Photo*: Peter Moore)

155 ROBERT MORRIS *Untitled*, 1968–9. Felt, rubber, zinc, aluminium, nickel, corten and stainless steel. Leo Castelli Gallery, New York. (*Photo*: Rudolph Burckhardt)

156 ROBERT MORRIS *Untitled*, 1969. Felt and lead. Leo Castelli Gallery, New York. (*Photo*: Rudolph Burckhardt)

157 BARRY LE VA *Studio Installation*, 1967–8. Felt and ball-bearings. Galerie Ricke, Cologne.

158 RICHARD SERRA *Untitled*, 1969. Steel plates and crop stacked, 216 × 216 × 120 (540 × 540 × 300). Collection the artist. (*Photo*: Leo Castelli Gallery, New York)

159 MARCEL DUCHAMP *3 Standard Stoppages*, 1913–14. Three threads glued upon three glass panels, each 49⅜ × 7¼ (123.7 × 18.5). Three flat wooden strips repeating the curves of the threads, averaging 45 (112.5) in length. Wooden box, 11⅛ × 50⅞ × 9 (28.3 × 126.8 × 22.5). The Museum of Modern Art, New York, Katherine S. Dreier Bequest.

160 SOL LEWITT *10,000 Lines 3″ Long*, 1972. Pencil on paper, 11½ × 11½ (28.7 × 28.7). John Weber Gallery, New York. (*Photo*: Robert E. Mates and Paul Katz)

161 ROBERT MORRIS *Untitled*, 1967–8. Felt, ⅜ (1) thick. Collection Philip Johnson. (*Photo*: Rudolph Burckhardt, courtesy Leo Castelli Gallery, New York)

162 CY TWOMBLY *Untitled*, 1970. Gouache and blue crayon, 27¼ × 34¼ (68.2 × 85.6). The Mayor Gallery, London.

Index

Illustrations are indexed by number; these numbers are set in *italic* type and appear in each entry before the page references.